RICHMOND
›✦IN✦‹
RAGTIME

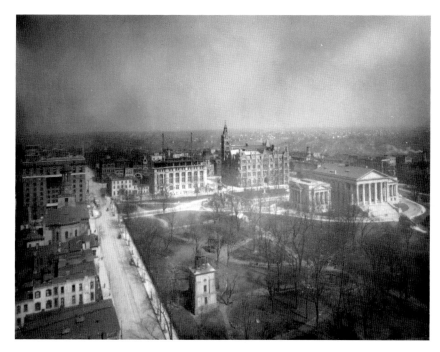

Center stage. Capitol Square, circa 1910, looking up Ninth Street toward Broad. *Clockwise from bottom*: the Bell Tower and behind the Henry Clay statue pavilion; St. Paul's Episcopal Church; Adeline Atkinson's Hotel Richmond and, across from it, J. Marshall Atkinson's Park Hotel; on Broad Street at Ninth, Smithdeal Business College; next to the Park, the under-construction General Assembly Building and just behind, the steeple-less Broad Street Methodist Church; Richmond City Hall; the Ford Hotel, where Yoder moved *The Idea* after leaving the Park; and beyond, First African Baptist Church. The Virginia State Capitol is center, and behind trees is the Executive Mansion. *Courtesy of the Cook Collection, Valentine Richmond History Center.*

RICHMOND

⟫ IN ⟨

RAGTIME

SOCIALISTS,
SUFFRAGISTS,
SEX & MURDER

harry kollatz jr.

THE
History
PRESS

Published by The History Press
Charleston, SC 29403
www.historypress.net

Copyright © 2008 by Harry Kollatz Jr.
All rights reserved

First published 2008

Manufactured in the United States

ISBN 978.1.59629.443.1

Library of Congress Cataloging-in-Publication Data

Kollatz, Harry.
Richmond in ragtime : socialists, suffragists, sex & murder / Harry Kollatz, Jr.
p. cm.
Includes bibliographical references.
ISBN 978-1-59629-443-1
1. Richmond (Va.)--History--20th century. 2. Richmond (Va.)--Social conditions--20th
century. 3. Nineteen tens. I. Title.
F234.R557R49 2008
975.5'23041--dc22
2008038821

For Amie, again, with apologies for my easy-fright mechanism.

Richmond inherited the worst of both the Old and New South.
The racism and the conservatism of life before the war became even more
embedded in the society, but much of the antebellum graciousness, noblesse
oblige, and disdain for money was gone, replaced by a materialism and
superficiality vividly perceived by Ellen Glasgow. The rights of workers,
women, and blacks were little more respected, and the need for a good public
school system, for libraries, and for other progressive features of modern
urban life were scarcely more recognized in 1890 than in 1860. The
tragedy of Richmond after the war was that its white leaders, after two
decades of flirtation with progress, returned to a cause that they had all but
abandoned and embraced the dead thing with a passion they had never felt
while it lived.
 —Michael B. Chesson, Richmond After the War 1865–1890

Erection of the eight-story Mutual Building in 1904 launched the
"skyscraper movement" that not only accentuated Richmond's skyline but
altered irreparably the internal order of the center city...
 Within the next two generations, nearly all traces of the Old South
"walking city" were wiped from the face of Richmond. In its place arose
the shell of a modern city. Throughout the nineteenth century virtually all
of Richmond's cultural, commercial, governmental and residential functions
mingled together within the restricted confines of the core city. The city's
growth after 1900, however, produced a more differentiated and a dispersed
physical structure, and, ultimately dissipated of the synergism previously
generated by the commingling of various urban activities...
 ...Although blacks concentrated most heavily in the Jackson Ward
area, virtually the entire city possessed some black representation. Indeed,
the existence of twelve of the city's twenty-two black churches outside
the boundaries of Jackson Ward denied the existence of any single black
ghetto in Richmond in 1900. To achieve truly separate residential patterns
required either consolidation of predominantly black areas or controls on
black expansion outside the city's core. In the following decades, Richmonders
would attempt both strategies.
 —Christopher Silver, Twentieth-Century Richmond: Planning,
Politics, and Race

All change is not growth; as all movement is not forward.
 —Ellen Glasgow, Richmond novelist (1873–1945)

In such disconnected fashion, as hereafter, I record the moments of my life…
For it is possible only in the last paragraphs of a book…to look back upon
an ordered and proportionate progression to what one has become; in life the
thing arrives with scantier dignity; and one appears, in retrospection, less to
have marched toward any goal than always to have jumped and scrambled
from one stepping-stone to another because, however momentarily, "just this
or that poor impulse seemed the sole work of a lifetime."

—*James Branch Cabell*, The Cords of Vanity:
A Comedy of Shirking, *1909*

Contents

Foreword

I t says something about Richmond as a city—and if you are a Richmonder, it says something you already know too well—that if you boil *Richmond in Ragtime* down to its essence and examine what is there, you'll see just how precious little this city has changed in the last hundred years. After all, that's the way we like it here in the River City. The good, the bad and the ugly—as long as it doesn't change, we'll take it. Then we'll swell with pride when we tell you how hard we fought to keep things from changing, lying down in front of the bulldozers, railing at city council meetings against new construction and referring to everything by names that were officially retired decades ago—and Harry Kollatz will be there with pen in hand to hear us reminisce.

As a lifelong Richmond resident, I have been an ardent fan of Harry's "Flashback" column in *Richmond Magazine* since its inception because, like most Richmonders, I am pathologically nostalgic, but also because most of the Richmond institutions on which Harry flashes back were previously known to me only through family stories, handed down, quite possibly embellished and definitely transformed a little or a lot through generations of retelling. Harry's painstakingly researched Triptiks through Richmond history have allowed me to separate the fiction from the fact, put dates and occasionally faces on the yarns that have been spun and have finally convinced me that yes, there *was* a psychic horse that resided on Jefferson Davis Highway, by God, my parents were not just screwing with me to see what I'd believe.

This latest jaunt through Richmond's lesser-known alleys and avenues takes place in a tightly concentrated chunk of time and an even tighter amount of space—a Richmond where Roseneath Road was the edge of town and Woodland Heights and Highland Park were suburbia's farthest outposts, promising freedom from city life and granolithic sidewalks to boot.

The names will be mostly unfamiliar to all but the most dedicated Richmond historian, but the places remain the same, as do an uncanny number of the events making news. From bars getting busted for serving to minors to faulty sewer lines, gang violence, suburbs that seem to pop up—and populate—overnight and girls hanging out of the windows around Grace Street exposing their breasts "below the danger line" (seriously, does that *ever* get old?), Richmond is Richmond no matter the century. Add a murder trial involving old money and a young lady, some socialite suffragettes and a banjo-strumming pharmacist intent on remaking slavery's image and by gum, you have a story—replete with a reform-minded muckraker to thread all of the elements together. That story is *Richmond in Ragtime* and I'm sure you will enjoy it.

And, as a footnote to my theory that the Richmond of today is essentially the Richmond of a hundred years ago, as I finished typing this foreword to Harry's tale of Richmond in ragtime, the *Times-Dispatch* online edition graciously informed me that absinthe is now available in the commonwealth. Get the Buick and pass me my feather turban; I'm headed out to the Park Hotel.

<div style="text-align: right">

Anne Thomas Soffee
July 21, 2008

</div>

Preface

S tories choose you like a lover. Circumstances you couldn't have foreseen put you in a certain place at a particular time, and an individual you might not have even considered becomes the forehead-slap, heart-swelling obvious. The muse moves and there is nothing you can do but give her room to work.

So it was in 1985, when I was engaged in a detailed historical investigation of Chesterfield Apartments, completed in 1904 at the corner of West Franklin and Shafer Streets. This elegant, Italian Renaissance–inspired seven-story building was Richmond's first residential high-rise and began a West End craze for vertical luxury living.

My friend Joe Johnson and I got permission to rummage in the old place's attic, and in the summer heat, shirts off and sweating, we found the actual proverbial trunk that contained a trove of letters and official correspondence. The documents almost went to the back-of-the-envelope drawing of industrialist J. Scott Parrish's concept for the Chesterfield. All that, as they say, is another story.

I utilized the wonderful city directories to track the comings and goings of the Chesterfield's residents. Using yellow legal pads filched from the *Richmond Times-Dispatch* newsroom, where I was then a copy clerk (sorry, Media General, about the office supply theft), and in precise handwriting that seems now to have come from someone else's far less harried hand, I listed the newcomers and the departures, their occupations and other tidbits I somehow had the time to obsess over.

In 1911, one J.C. Hemphill, editor of the *Richmond Times-Dispatch*, came into the Chesterfield. I wanted to get the then-address of the newspaper and other pertinent information, and in turning back into the "Periodicals" section of the directory my eye fell on something called *The Idea*, 1106 Capitol Street, run by Adon A. Yoder, publisher/printer, residing at 303

Minor Street. The moment of discovery is jotted in the margin. I thought perhaps I'd made a Really Important Discovery, a heretofore unknown literary magazine.

I looked into the standard reference texts and found tantalizing clues; Christopher Silver in his groundbreaking study *Twentieth-Century Richmond* mentions him as an example of a persistent civic reformer, and W. Asbury Christian's *Richmond: Her Past and Present*, published much closer to the events, in 1912, gives this assessment:

> *Adon A. Yoder came to the city and began publication of a weekly pamphlet called* The Idea. *He wielded a caustic pen, and began criticism of many of the city officials, charging them with the responsibility of abuses that existed in the city. Several brought suit against Yoder and his publisher and obtained a judgment. He was also charged with libel, and not being able to prove his statements, he was convicted and punished. With the exception of the reconstruction period this is the second time a writer has been sent to jail in Richmond, Callender being the first.*

Christian did not outright say that Yoder was wrong about the "abuses that existed in the city," but intimates that his approach for correcting them was what got him into legal difficulty. He was a troublemaker eager to stick it to The Man. Well, sort of—his motivations were more complicated and contradictory than that, as I learned.

The archives of the Library of Virginia had surprised me before, housed then in its art deco edifice with lobby furnishings and fixtures that reminded me of the *Normandie*. I found that the library possessed three complete bound volumes of *The Idea*.

In those days these books were allowed out of the library, and I spent hours taking notes and hunched over copying machines. I didn't have an ultimate goal for all this effort. It just seemed a good idea at the time, pun intended. The more I studied Yoder and his milieu, the more fascinated I became with his little muckraking endeavor and that period in Richmond.

Yoder believed he was making some form of history, and with dutiful responsibility he fulfilled a request by the state librarian in 1910 for copies of *The Idea*. In the fall of that year, the pamphlet had suffered one of its two near-death experiences before its final illness. When Yoder gave copies to the library, *The Idea* was assumed gone for good. On stationery describing Yoder in poetic terms as "Sometime Publisher For The Idea/Printer To The Public," he apologized to the librarian for not getting this to him earlier, due to pressures at work—his own business. "I send herewith the complete Richmond edition of 'The Idea' to date, which I have at last succeeded in getting together."

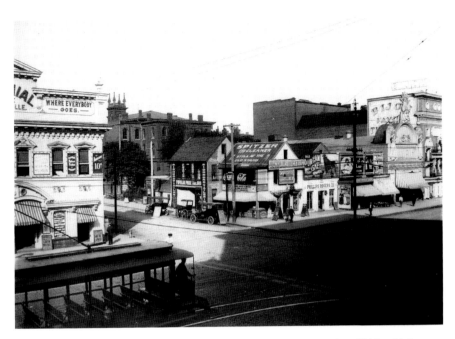

"The bad side." The northeast corner of Broad and Eighth Streets, circa 1910, with its proliferation of vaudeville and legitimate theatres, nickelodeons, motion picture houses and saloons. *Courtesy of the Valentine Richmond History Center.*

Evening Journal writer and "Idle Reporter" columnist Evan Ragland Chesterman, like Yoder a Richmond College alum (and credited with naming the school's sports team the Spiders), also gave a volume to the library. The November 6, 1909 issue, with an illustrated cover featuring Chief of Police Lewis Werner pressed under the thumb of corrupt police commissioners, also contains the infamous "Reign of Crime" article. In what appears to be Chesterman's hand, at the bottom of the offending page is written, "Yoder was prosecuted for criminal libel for writing this article and was fined $100 and sentenced to 15 days in jail by Magistrate J. Wilbur Griggs, sitting in the Police Court, Dec. 7 1909."

My interpretations of the Yoder saga appeared in various now defunct publications, the *Richmond Review* and *Virginia Cavalcade*, and the still going concern, *Richmond Magazine*. Along the way, I picked up assorted odd stories, contemporary to and reflected back through Yoder's observations, like the Beattie murder. And there was more, so much more, thanks to the chatty nature of newspapers then and the fact that there were three, and at one point even four of them, in addition to other publications.

Barbara Tuchman, a favorite historian of mine, in the foreword of her iconic pre–World War I study, *The Proud Tower*, admits her enforced

selectiveness in choosing her topics. She wrote, "I am conscious on finishing this book that it could be written all over again and under the same title with entirely other subject matter, and then a third time, and still again, without repeating." Granted, Tuchman's subject was all of Europe and several decades, and mine is Richmond, Virginia, and three years, but the stories I could have included would have swollen this slender volume to a heft of Taftian proportions. Like Tuchman, though, as I reach the end, the faces and voices of all that I have left out crowd around me.

There could be sections on the nascent social services movement that created the state Board of Charities and Corrections (headed by the tireless Dr. Joseph T. Mastin), horrific tales of neglect and the rescue of children and young women from destitution and depravity. There could have been a section on the gubernatorial politics and the music organizations like the Wednesday Club that tried to add culture to the city and got a pipe organ into the City Auditorium; the baseball teams, the whirl of the German socials and the 1910 opening of the Country Club of Virginia's new West End building and the Women's Club moving in 1909 to an old building, the 1858 Bolling Haxall House at 211 East Franklin Street; or Colonel John Cussons in Henrico County's then-distant Glen Allen, building his crazy resort with its screeching peacocks and dreaming of a hand-picked white enclave until his notions of road improvements caused the locals to sue, and he began offering land to blacks in honor of their antebellum service. Then there was the construction of the Marshall Street Viaduct; the incredible 1910 theft of $85,000 worth of stamps from the temporary post office, which earned the two thieves a decade each in the federal pen; the destruction by fire in January 1910 of the University College of Medicine and the 1911 Larus & Brother tobacco factory fire.

Likewise, another portion could have been devoted to the literary career of the almost forgotten *Times-Dispatch* editorial writer Henry Sydnor Harrison, who rose to national prominence and raised the city's literary stock higher with his 1910 novel *Captivating Mary Carstairs* and, in 1911, the Richmond-set *Queed*, which drew comparison—from *The Nation*—to Mark Twain. Most of a book could be devoted to the Richmond Police Court antics of Justice John Crutchfield. Another section could be the dramatic 1909 lingering deathbed testimony of Robert Torrence, shot by saloonkeeper James Conway outside a saloon, due to Conway's involvement with Torrence's wife. The incident delivered to anti-saloonists, like Yoder, an indelible image for the evils of drink.

There is, too, the gruesome swiftness and numbers of criminal executions. This includes a series of April and May 1909 electrocutions of five black men from Powhatan County. "The Powhatan Horror," as the press termed

the brutal slaying of Mrs. Mary E. Smith, an aged woman, and her caretaker, Walter O. Johnson, involved an attempt at burning the house to conceal the robbery and murders. The five were undone in part by one of their number, who claimed visions of Smith, saying she knew that the other four committed the heinous deeds. The men received death sentences within a month of their alleged crimes. The court ordered the execution of all five on the same day, April 30, but Governor Claude A. Swanson wanted to avoid "overtaxing the death machine" and spread the executions over three days. Instead, on that grim morning, father and son John and William Brown went to the chair within twelve minutes of each other. The newspaper noted this as a state first. In May 1910, another group of five blacks, this time from Arlington, were set to die, and when a delay occurred the *Times-Dispatch* headline sniffed, "Not One of Condemned Negroes Will Die in Electric Chair To-Day."

This is a time when the automobile is seen more often on Richmond streets, when a visit by an airplane is exotic and the phrase "long-distance telephone" conveys a sense of immediacy and urgency. Law and tradition

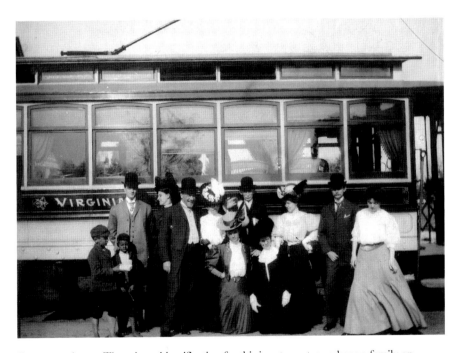

Streetcar sojourn. There is no identification for this jaunty party; perhaps a family on a summer excursion or visiting a new suburb, like Virginia Place, north of Ginter Park. Richmond's electric trolleys are supplied their motion by Virginia Passenger & Power (later VEPCO, then Dominion). Note the barefoot youths at left, at least one of whom is African American. *Courtesy of the Valentine Richmond History Center.*

separate the races and classes, and the day's pure racism is bottomless. If you are predisposed to think that early twentieth-century Richmond was a quieter, easier and somehow more moral place, prepare for surprises.

Though years have passed, I have to acknowledge for their assistance Patricia Yoder Garrity, Colonel Robert A. Yoder (retired) and Woodrow Wilson Siegfried Yoder, along with three of his children from a later-in-life second marriage and Dorothy Yoder, wife of Adon Jr., from his first. They provided me with invaluable memories, sheaves of his poetry and photographs.

This book would not have been possible without amplifiers of that time who came before me: Tim Crowder, who made a personal quest of the Kline Kar and spent hours talking to me about Jimmy Kline's effort, though his arrival in Richmond comes at the cusp of this study's conclusion; Bill Jenkins, who brought needed light on the work of Ferruccio Legnaioli; and Doug Seroff and Ken Flaherty Jr., whose rescue from obscurity of Polk Miller's career is a true treasure. Online research tools, like Ancestry.com—making a search of the 1910 census as easy as pushing a few buttons—and the Library of Congress's "Chronicle of America" newspapers project, which creates a searchable database of long-ago newspapers, proved revelatory.

The archives and staffs of the Valentine Richmond History Center, the Library of Virginia, Virginia Historical Society, the National Park Service Maggie L. Walker Historical Site and the main and Belmont branches of the Richmond Public Library were vital to this work—and I think all the overdue books are returned. I'll have to look again.

My partner-in-art-for-life, Amie Oliver, exhibited her customary patience at my prolonged absences into another century. She knew when to enter my time travel portal with iced coffee and forehead massages.

Thanks to my colleagues at *Richmond Magazine*, in particular the editorial team of Susan Winiecki, Chad Anderson and Jack Cooksey, who put up with my more than usual erratic behavior and varying schedule. Mollee Sullivan provided last-minute scans. And I'd be remiss not to mention that rambunctious gang of mine at the New York Deli, and Can Can, for that perfect front table by the magazines and the window.

My commissioning editor Laura All at The History Press, who must've considered this whole project a chancy nail-biter but never said so, and the final courageous editor Hilary McCullough are true heroines of this story.

Now, time to party like it's 1909.

Richmond, Virginia, 1909–1911

You are embarking on a journey into a foreign land called Richmond, Virginia, in 1909–11. While people here may seem familiar, their traditions, even their language, are those of a distant place.

You are soon to meet the muckraking socialist Adon A. Yoder and three novelists exploring their craft: Ellen Glasgow, whose fictions go against contemporary Southern romanticism; James Branch Cabell, whose ultimate desire is to write with perfection about beautiful happenings; and Mary Johnston, whose groundbreaking historical fictions about the Civil War prove provocative.

Activists Lila Meade Valentine and Anne Clay Crenshaw, writers Glasgow and Johnston and artists and partners Adele Clark and Nora Houston are among the women gathering in private salons to discuss securing the vote for women, as well as other political reforms.

You will admire the creativity of Italian-American sculptor and decorative architect Ferruccio Legnaioli, whose first public commission is about to be unveiled. And, south of the James River in the city of Manchester, Henry Clay Beattie Jr., the son of a prosperous merchant, whose upcoming marriage to Louise Owen is compromised at the outset by a flibbertigibbet named Beulah Binford.

The banjo music of pharmacist Polk Miller may entertain you, though he is quite the man of his times. Miller is an unreconstructed Confederate who nonetheless relishes the stories and songs he heard from his family's slaves before the war. Miller's passion is the preservation of antebellum music and mirth. He's formed the Old South Quartette and, as a white man playing in a band with blacks, sets a precedent not equaled until rock and roll.

Richmond, Virginia, in 1909–11 is filthy. Tobacco's musty tang hangs in the air, as does the earthy stench of fertilizer plants. Heat-baked dirt streets littered with horse dung exude their own special odor, alleys reek with offal

and the river from which many Richmonders draw their drinking water—unless they are near natural springs or wells—is often tinctured and tainted with foul, untreated effluent.

Day and night, lumbering freights and crowded passenger trains roll into one of Richmond's six stations. The vaunted electric streetcars, implemented here as a world first in 1888, clatter along the city's streets. Despite recent and bloody labor disputes, track realignments and squabbles about line ownership and transfer arrangements, the system works. A streetcar stops during peak hours every twenty-four seconds at Seventh and Broad Streets by Theatre Row.

The automobile is becoming more common on the dusty thoroughfares, but Richmond's public transit is overcoming the city's historic geographical divisions of hills and ravines and spreading the white middle and upper classes away from the central city. This new mobile bourgeoisie rides the cars to clangorous amusement parks in the West End's Idlewood and Southside's Forest Hills and Bon Air. These places are devised by land developers for encouraging visitors to stay, ride the wooden roller coaster, dance with their sweethearts in the pavilion, watch an outdoor movie with musical accompaniment and buy a pristine subdivided plot for a new brick Four Square or Craftsman cottage.

What these suburbanites are leaving behind, immigrants and blacks are moving into. While blacks live throughout Richmond, most of them have gathered around the churches, fraternal meetinghouses and businesses of what is called Jackson Ward. Among the prominent residents is the revered community organizer and businesswoman Maggie Lena Walker, who in 1901 earned the distinction of being the first of her gender or race in the country to be founding president of a financial institution, her St. Luke Penny Savings Bank. Here, too, is John Mitchell Jr., the tempestuous editor of the weekly *Richmond Planet*. When younger, Mitchell devoted tremendous energy and time to fighting the epidemic of lynching and false imprisonments. He would strap on a brace of pistols, get on a train, head for the trouble and write about his experiences. Somehow he never became a victim of mob violence, no matter how often he courted the possibilities. These days, his time and attention are devoted to his various commercial enterprises. Still, Mitchell's got some fights left in him.

If it is not enough that Richmond is divided by geography, race and class, some younger residents also view their parts of the city as turf to be protected from the abuse of outsiders. They organize as gangs, and when a perceived slight warrants, they battle each other using fists, bricks and whatever comes to hand, which may on occasion be a knife or a pistol. For the most part, it is mere hooliganism rather than organized violence, a rite of passage instead

of a path to crime. These days, a boy is called a cat, and the various gangs take colorful names associated with their neighborhoods.

The Butchertown Cats and Shockoe Hill Cats, for example, fight over the flats between them. These Butchertown boys originate both from the district also known as Shedtown, where tradespeople live, and Union Hill. Both are smaller neighborhoods north and east of Church Hill, beginning at about North Seventeenth and Venable Streets. A chronicler of their activities notes, "The Butchertown boys said [the flats] was theirs because the territory was not on the hill; while the Shockoe Hill boys contended that it was theirs because it was on their side of the [Shockoe] creek; which are arguments as sound as those that are used by the most powerful nations of Europe."

Richmond's government consists of a Board of Aldermen and Common Council, numbering fifty-six white men, who try running the city through twenty-five standing committees. Separate commissions manage the fire and police departments and the schools. The mayor serves as a basic ribbon-cutting figurehead. The result confuses and frustrates Richmonders.

Adon Yoder, in his *Idea* pamphlet, blasts the system as "an awkward, cumbersome machine." He is not the lone person in Richmond to think so; headline-blaring corruption charges against the city's handling of the streetcars and utilities and indictments of councilmen on bribery charges related to city contracts rile public sentiment. Council began studying the issue of straightening itself out in 1907. The Special Joint Committee releases some findings in 1909, praising the high character of the members,

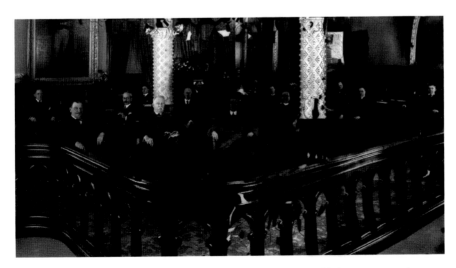

The good burghers. These are the men socialist muckraker Adon Yoder goes up against, in their natural habitat: the Richmond Board of Aldermen in their city council chamber. None of them are identified. *Courtesy of the Foster Collection, Virginia Historical Society.*

but describing how the city legislature is just too large to exert effective authority. The best way to effect the needed change is an overhaul of the entire city charter. The committee recommends the formation of an administrative committee to handle the city's affairs—the exact suggestion that Yoder makes between the colorful covers of *The Idea*.

View from a Dirigible

If you went aloft on a crisp spring morning in a personal dirigible like the one at the 1911 Virginia State Fair, and hovered above the river's rapids looking north, you would see upon the backs of curving hills a cluster of brick and stone, a jumble of brick commercial storefronts and warehouses. Soaring church steeples and several high-rise office buildings and hotels pierce the sky. Dark acrid smudges of smoke hang along the river where factories, mills and the hydroelectric plant function as Richmond's industrial engines.

Catching the eye, from the right—the east side—the Beaux Arts splendor of Main Street Station and its iconic clock tower…the colossal column of the Confederate Soldiers and Sailors Monument high upon Libby Terrace…the gleaming white temple of democracy designed by Thomas Jefferson as the Virginia State Capitol and with matching wings added five years ago. Nearby is the symphonic declaration of municipal power of the High Victorian Gothic city hall.

Vivid hand-painted advertising signs decorate the brick walls of the commercial buildings, and the city's streets blare with colorful exhortations to smoke Cuban cigars, furnish the porch with Sydnor and Hundley wicker sets and wear Battle-Axe boots.

Richmond began in the Shockoe Valley, though gradual westward migration has left this part of town somewhat bereft. Here, all around the First Market on Seventeenth Street and the main train station, is the controversial vice district established in 1905, where are clustered cheap saloons and "assignation houses." Richmond's officials established this quarter to better control these particular crimes. Ever since, it has provided a constant source of annoyance to the city's clergy and civic reformers— like Adon Yoder—who see the "segregated district" as a vile hellhole that promotes festering municipal corruption and spreads disease.

Above the clamor and grit of Shockoe is Church Hill, the city's oldest and most genteel neighborhood. The city mansions south of Broad Street perched upon the great bluff present their three-story verandas toward tumbling gardens and the river. Workers north of Broad live in smaller, simpler houses.

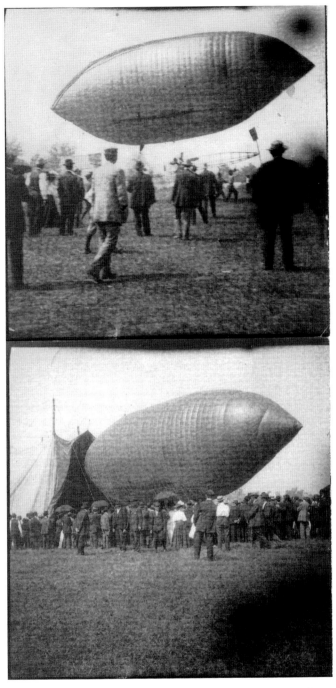

The strange machine. At the 1911 Virginia State Fair, Toledo, Ohio promoter Charles J.
Strobel displays for the curious this rudimentary dirigible piloted by Evan Jenkins Parker.
He'd flown since 1908, and Parker retired to earth-bound pursuits after this exhibition.
Courtesy of the Cook Collection, Valentine Richmond History Center.

No paper, no plastic. The 1700 block of East Franklin Street, near First Market, in 1911. *Courtesy of the Cook Collection, Valentine Richmond History Center.*

Going to market. The 1700 block of East Franklin, near First Market, circa 1911. *Courtesy Cook Collection, Valentine Richmond History Center.*

Below, along the riverfront, Mayo's Island is home to the Virginia Boat Club that sponsors annual rowing regattas. Situated nearby are the vast brick factories of American Tobacco and Larus & Brother Tobacco. A lattice of railroads services these and other manufacturers.

The city wharves at Rocketts do not receive the number of oceangoing vessels from even just a decade prior, due to the greater viability of railroads and the size of modern ships. Richmond's seeking of federal funds to dredge the river for greater access is an annual effort. Still, the blasting horns of passenger steamers echo against the hills as they put into port, with regular routes running between Norfolk and Baltimore, and during the summer provide regular moonlight excursions to the bluffs of Dutch Gap about ten miles south.

Two of the most traveled vessels are the steamers *Pocahontas* and *Berkeley*; the latter is one of more than a dozen civilian and military vessels built by the William R. Trigg Shipyards of Richmond. The ambitious enterprise, organized by industrialist Trigg, was founded in 1899 on Chappel Island, a sliver of land between the James River and the Kanawha Canal. The yards employed some two thousand laborers and occupied fifteen buildings that sprawled a mile along Dock Street. The concern faltered due to labor difficulties, greater competition from deep-water ports and Trigg's failing health. When he died in 1903, the business stumbled into receivership and the property and machinery went to auction in 1905, but legal wrangling with the bondholders continues even into 1909 and beyond.

Shipbuilding is the early twentieth-century way for a city to prove its strength and resourcefulness. Deprived of the Trigg yards, Richmond Chamber of Commerce recruiters seek the next big development of modernity and technology: the motorcar. A delegation of Richmond businessmen in 1911 visits York, Pennsylvania, to see the factory of Baily, Carroll & Kline (BCK). James A. Kline is general manager and chief designer, and the firm operates out of Samuel Baily's carriage works. BCK builds its Kline cars almost from scratch and produces limousines, touring cars and racers. A fifteen-acre factory site is selected in Scott's Addition along North Boulevard (where the Greyhound bus station is today), with a rail line running into the open end of its letterman jacket "U." Speculation is that the plant will manufacture more than two thousand cars a year and employ almost one thousand men. The problem is that BCK is no more able to support the present York factory than the giant pillar-porticoed plant that is dreamt of in Richmond.

But Richmond at this time is all about the big plans.

Running your eye leftward, going west, you will see the eight-story Mutual Assurance of Virginia building that arose in 1905 and attested to a new city ready to thrust itself from the earth and overturn the old one. A few blocks away

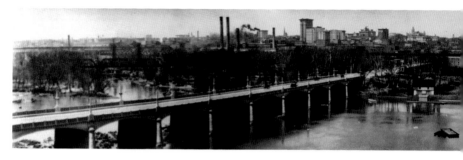

The city of Richmond, around 1915. At left is the new Mayo's Bridge. In 1910, following the annexation of Manchester, Richmond bought the old span for $112,000 and proceeded to build a handsome link to the southside community. *Courtesy of the Foster Collection, Virginia Historical Society.*

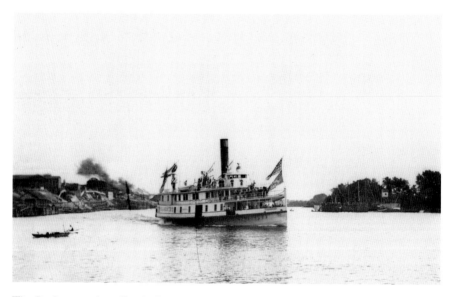

The *Pocahontas* cruiser plies the James River and inland waters, coming into Rocketts, the city's East End docks. *Courtesy of the Cook Collection, Valentine Richmond History Center.*

is the elaborate, Edwardian Italianate twin bellevue-towered fantasia of the Jefferson Hotel, reopened just two years after a complete renovation following a disastrous 1901 fire. The Jefferson is known for its great lobby lit by a massive stained-glass skylight, a palm court where alligators loll in marble pools and Edward Valentine's sculpture of Thomas Jefferson. The hotel is regarded as the finest in the city, or most anywhere, and hosts visiting dignitaries.

Not far away, at the foot of Gamble's Hill and powered by the river, is the venerable Tredegar Iron Works, with some six thousand laborers making the firm Richmond's largest employer. On the crest of the hill is a fine residential

Kline Kar, such a fine car. James Kline and his family by the North Boulevard Kline motor works. Kline, a hands-on mechanic, doesn't like Ford-style mass production. Kline vacates the huge plant during World War I, announcing "Patriotism Before Profit!" though there is little profit and the factory is mostly empty. Kline moves to Seventh and Cary Streets to continue desultory operations until 1923. Some 2,500 Kline Kars are built. James Kline becomes a respected Richmond racing official and head of the regional branch of the American Automobile Association. *Author's collection, from Tim Crowder.*

neighborhood with houses known for their wrought-iron balconies and porches. At Third and Arch Streets stands crazy Pratt's Castle, with a center turret rising fifty feet. The antebellum house was designed by artist William Pratt out of rolled sheet iron scored and painted to resemble stone.

Through an antique arrangement of property ownership zoning, adjacent to Gamble's, just over a ravine covered in railroad tracks, loom the dour walls of the Virginia State Penitentiary, parts of which were designed in the late eighteenth century by architect Benjamin Latrobe.

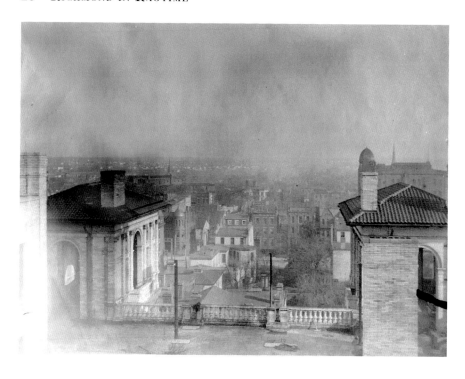

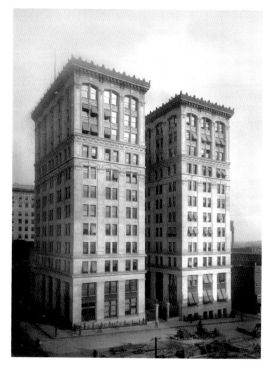

Above: Richmond looking north from the roof of the Jefferson Hotel, 1910. This view is across Franklin Street past Broad into Jackson Ward, with Steamer Company No. 5 station (now Gallery 5) in the center and Ginter Park on the horizon. Note the lumber, a jacket and a pickaxe strewn about the terrace floor. The Jefferson is still recovering from a damaging 1901 fire. *Courtesy of the Valentine Richmond History Center.*

Left: The Mutual Building, designed by Clinton & Russell architects, was the earliest Richmond high-rise, as headquarters of the Mutual Assurance Society. Note the window signs for Cutchins & Cutchins in the seventh-floor corner windows, where young attorney John A. Cutchins arrives after spending summer evenings on the river. *Courtesy of the Cook Collection, Valentine Richmond History Center.*

Across another deep gully is Oregon Hill, where many Tredegar workers reside. The neighborhood's name comes from the days when living this far west seemed tantamount to moving into remote territories. Alongside Oregon Hill is rolling parkland punctuated by obelisks, headstones, sculptures of weeping angels and a ninety-foot pyramid that is the Southern shrine of Hollywood Cemetery. Here are held ceremonies of remembrance for Confederate Memorial Day.

Past scrims of trees are the fast-developing residential properties of the West End. The installation here of sidewalks and sewerage is not keeping pace with the city's growth, and municipal dallying feeds public ire vented by Adon Yoder and his *Idea*.

Richmond's galloping suburban expansion indicates to city boosters dizzying possibilities and a claiming of the capital of the New South mantle. All around, however, are physical representations of a major interior contradiction. The central city suffers from a want of renovating older buildings, growing poverty and lack of proper water, curbs and sidewalks.

No mechanism governs the sprouting of suburban enclaves, nor does any city authority address the center city's decline. There are flickerings of a parks and playground movement, nascent historical preservation and moribund city studies about real planning. But there is a sense that other matters preoccupy those in Richmond who should care about such eventualities.

Along the city's forming westward boulevards, in parks and public buildings, the civic religion of the Lost Cause impels the erection of statuary, the installation of brass plaques and other memorials honoring the struggle of the Confederate South. The sentimentalizing of the war causes the building of bulwarks in bronze and marble to break against onrushing currents.

"Bellicose Intention after Breakfast in Jail"

Witness said that he had heard RICHMOND was among the rottenest places on earth. "And it was such a reason," inquired [prosecuting attorney] *Mr. Smith, "which induced you to make this city your home."*
"I did not say I believed it."
—Richmond News Leader, *February 12, 1910*

On Saint Valentine's Day 1910, the Law and Equity Court of Richmond, Virginia, sentences thirty-one-year-old rabble-rouser Adon Allan Yoder to fifteen days in the city jail and a fifty-dollar fine. His crime is the libel of police commissioners Douglas R. Gordon and Christopher Manning, and the redoubtable Police Court Judge John Jeter Crutchfield. Yoder accused them

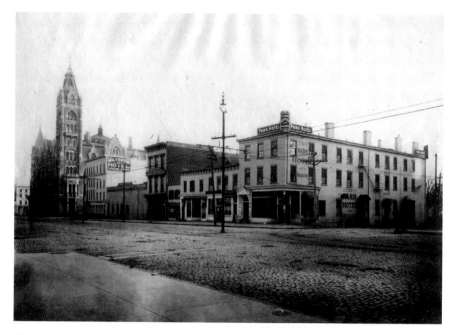

Center of everything. The southeast corner of Broad and Ninth Streets around 1910. *From right*: the Park Hotel, Life Insurance Company of Virginia and Richmond City Hall. *Courtesy of the Valentine Richmond History Center.*

all of general corruption, but in specific, criminal conspiracy while exhibiting preferential leniency for Sophie Malloy, a white woman who operates an "assignation house," while meting out harsher punishment for the same charges to Maggie Lee, who is black. Their race is one matter, but Yoder also charges that protection rackets prevent proper enforcement of law in the city's vice district.

Since arriving from Lynchburg in the spring of the previous year, Yoder has sought to puncture Richmond's social and civic order with his weekly pamphlet, *The Idea*. Richmond's blithe acceptance of outright wrongdoing or the lackadaisical application of moral rule and civil law annoys his sense of justice and fairness.

Once established in Richmond, he skewers the Board of Aldermen and Common Council, the police department, the courts, the streetcar company and even the state fair. He styles himself as a "radical revolutionist tho' conservative."

His outright naming of names and aggressive stance against political wrongdoing and social hypocrisy rankles mannered Richmond. The same approach gains him initial support among the clergy, working men and women. Pharmacist and businessman A.H. Robins and staunch anti-saloonist and business educator George M. Smithdeal advertise in the pamphlet, and on occasion they have stood Yoder's bail. One Eugenie notes on the battered

orange cover of the January 1, 1910 *Idea*, "The Editor of this paper is a spunky fellow. I wish there were more like him."

Some two weeks of exhausting back-to-back trials serve more as purposeful public humiliation and high melodrama than actual legal proceedings. A defamation of character suit brought by Clyde Saunders, a printing company executive and the powerful head of the city's Democratic political machine, demands $20,000 in damages. He sues Yoder and the Williams Printing Company, which produced *The Idea*. The court decided Saunders should receive $1,600, the largest award of its kind in Virginia until that time. Yoder no more possessed that amount of money than the $50 he is ordered to give at the conclusion of the second trial that sends him to jail.

For both decisions, "spectators piled into the courtroom until every inch of it was filled." Yoder and his able defender, Charles V. Meredith, "the prince of the Richmond bar," come day after day to undergo rigorous questions from the merciless attorney Harry M. Smith Jr. and a battery of prosecutors. Smith's hyperbole compares Yoder to the pirate Captain Kidd, who was at least merciful, because rather than torture his victims, Kidd killed them outright. Meredith states in his conclusion for the second trial, "I know of no such case in which the gamut of villaination has run to such lengths."

Curious Richmonders watch a parade of their elected officials and political appointees, some known for their lack of scruples and never getting caught in their missteps. The salacious center of the entire sensation is the "Probing Into Scenes in the Underworld," meaning the Shockoe Valley, the city's east side red-light district

Unless one came in person to the chambers within the great gray High Victorian Gothic city hall to hear the testimony, one could not otherwise feel assured of a complete accounting. Testimony by one city commissioner refers to subject matter that the *Evening Journal* felt "could not be told in this or any other sinful paper." Those other sinful papers include the morning *Times-Dispatch* and the *Evening Journal*'s competitor, the *News Leader*.

City Sergeant John L. Satterfield, vigilant in trying to maintain order, at times seems about to pound a hole through his table. The onlookers also come to be satisfied of whether Yoder maintains his character as an idealistic reformer or, as the prosecutors insist, as a crass opportunist.

The trials cause revelations about Yoder's personal life and his motivations. One prosecutor describes the editor as a "sneaking hypocrite who masqueraders as a preacher." Yoder, perhaps more through gullibility than duplicity, becomes a cat's paw.

He has carried on with a frantic energy as though searching for the right board to pull that would cause the whole rotten structure of Richmond's government to teeter and collapse into a foul heap. The furor raised by such

an event would better obscure his motivations. And so Yoder and the city's authorities joust, Yoder calling them buzzards and boodlers, and police officers beating him up in the street and at periodic intervals tossing him in jail. If the city is not as corrupt as I say it is, Yoder argues, why are they after me? The aggrieved officials defend themselves with a rebuttal that is, in essence, they are not really as bad as Yoder claims. Then they sue him, again. Yoder has endured coarse bullying and humiliation, and he has written about these experiences in a tone of righteous injury surpassed in vehemence by those who protest Yoder's damage to their proud reputations. The forces arrayed against *The Idea* want not to make a martyr of the writer, just to teach him a final lesson, shut down his annoying little pamphlet, end his indignant prating and get him out of town.

More significant than a stellar array of city officials and even the formidable United States Congressman Carter Glass becomes a front-page repudiation of Yoder's methods. The Reverend Tilden Scherer, a major *Idea* supporter, wrote a public letter denouncing his association—yet within days retracts the statement. Scherer claims that Glass duped him about a dispute between him and Yoder in Lynchburg.

But the trials accomplish their goal. Yoder is made ridiculous before the public, whose interests he claims to be serving. He comes across as self-centered and arrogant; reference was made to his wife's illness and his three small boys, one suffering from burns and the other pneumonia. And Yoder, for most of the month, is either in court or jail.

The jury takes thirty-seven minutes to pass Yoder's sentence. After Judge Thomas W. Harrison gives the verdict, a city detective named Atkinson steps forward to take Yoder to jail. Yoder's pastor at Immanuel Baptist Church whispers words of encouragement.

The bystanders packed into the courtroom and gallery remain steadfast in their silence. On the lower floor, spectators congregate to watch Yoder walk from city hall. He passes by the quiet faces alongside his brother Claude and Detective Atkinson. The hush prevails as Yoder walks from the building.

Sergeant Satterfield instructs First Deputy Lord to see that Yoder be given every consideration and courtesy while he remains in his second-floor cell. "Make him feel as comfortable as regulations permit," Satterfield says, "but treat him as you would any other prisoner."

Yoder's first midday meal in jail consists of two fried fish, a square of cornbread and coffee. Lord serves him with a band-new dinner tin.

Satterfield allows the *Idea* man to meet family members, friends and journalists in a private room on the jail's main floor. Interviewed by a Richmond *News Leader* reporter, Yoder takes a position of defiance, not defeat, thus exhibiting the spunk Eugenie so admires.

He expects to get out another issue of *The Idea* even while locked up. He's not anywhere close to suspending publication. The reporter asks if Yoder wouldn't have a difficult time finding a way to get the pamphlet printed. Maybe he should just leave.

"I shan't leave Richmond," Yoder declares. "I am going to stay right here. I've been fighting a long time and I'm going to keep it up."

"Then you are not going to Newport News?"

"I'm going nowhere, I tell you. I'm going to stay right here and fight."

Did Yoder know about an apparent petition to the governor on his behalf undergoing preparation by Reverend Scherer—a supporter, then denier and now supporter again?

"I have not been advised of such a movement afoot. Anyhow, there must be a mistake about Mr. Scherer's connection with that position."

During his sentence, Yoder manages to edit the current issue of *The Idea* and see to its distribution. He receives letters, fruit, flowers and messages of condolence and sympathy. Responding to the kindnesses of Richmonders gives him little time to read the daily papers.

In the March 5 issue, Yoder announces: "Last week and this week *The Idea* has been handicapped by the incarceration of the editor. Next week, we'll be back to normal. Be sure and get these numbers. Subscribe to *The Idea* today, only $2.00 a year, $1.00 for six months."

"I Got Too Drunk to Go Home"

On Saturday evening, January 9, 1909, Jennie Moran, sixteen, leaves the house on Semmes Street that she shares with her sister and her husband, R.T. Dobson. Jennie worked with R.T. at the Columbia Shoe Company.

Jennie says she is staying overnight at the Church Hill home of her friend Annie Gregory, in Richmond's East End. The Dobsons don't see anything unusual with a couple of young girls wanting to spend time together. Young Jennie has something other than a sleepover in mind, though.

At seven o'clock by the Globe Store, at Seventh and Broad Streets, she meets twenty-year-old Barton Heights resident Frank Luck. Frank and Jennie had "scraped" together an acquaintance the weekend before.

This evening, they go down to the rathskeller of the small Park Hotel at Ninth between Broad and Capitol Streets, its entrance facing on Capitol Square. Years earlier, the place was the urban mansion of the renowned Valentine family. The domestic parlors were remade into two cozy dining rooms. A pool hall and the rathskeller, a public room where younger people come to socialize, now share the basement.

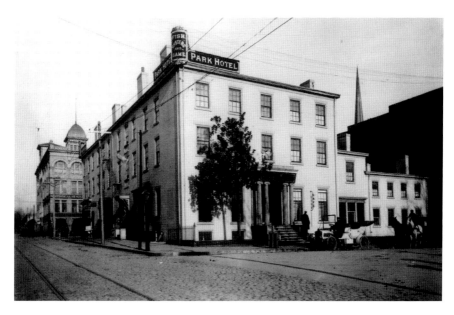

Where the trouble began: the Park Hotel, around 1910. The rathskeller where Jennie Moran got tipsy with her friends was entered from one of the two basement stairs on the building's left side. The hotel's manager and disbarred liquor dealer J. Marshall Atkinson brought Adon Yoder and his family to Richmond to first set up *The Idea*. Smithdeal Business College is across the street, scene of some confused anti-saloonist fisticuffs. *Courtesy of the Valentine Richmond History Center.*

Here, Jennie and Frank enjoy a light supper with drinks. Then they stop in at the Majestic Theatre, a nickelodeon at 23 West Broad Street. There they meet Lucas Flood and Annie Gregory, whom Luck doesn't know.

The four return to the Park to continue their evening. Luck orders several rounds of beer, though Jennie prefers gin rickies. Flood drinks from his whiskey, but Luck declines. Flood also has a half pint of blackberry wine that he pours into Jennie Moran's glass. Annie Gregory seeks her refreshment upstairs, though she returns to the rathskeller for a round with her friends.

The more the four drink the rowdier they become, and they spend down their money. The three dollars with which Luck started his Saturday night is now ten cents. The youths wear the nerves of the rathskeller staff. Luck pesters waiters and the manager M.W. Krebs to buy them drinks, even offering to put down fifteen cents and the promise of a dollar next weekend. Flood, with fifteen dollars on him, doesn't offer to defray their evening's merriment. Krebs tells the four that they are not fit to be served. Jennie Moran wants to start breaking glasses. If they do not get out of his place, Krebs says, he is going to call the police.

The quartet of young revelers, out of cash and the rathskeller's good graces, stagger up the basement stairs. The boys are tipsy but not, by police standards, drunk. Jennie, however, is experiencing trouble remaining upright.

The four veer toward Capitol Square and stumble into the arms of Richmond Police Officers Sherry, Herbert Copeland and Sergeant Sowell. Jennie Moran is arrested for public intoxication and, with her friends, escorted to the nearby First Precinct lockup.

At two o'clock on Sunday morning, J. Marshall Atkinson, the proprietor of the Park Hotel, gets served a warrant for allowing the serving of alcohol to minors in his establishment. "I have not been able to find out if they were in the rathskeller," Atkinson tells the *Times-Dispatch*, "and will not be able to do so until my employees have seen them." Atkinson recounts the extent of what he knows: that the four had come to the Park for dinner and had called for drinks, but in time they were unable to pay.

"I shall certainly be able to prove that they did not buy drinks at the Park, and while I am endeavoring to elevate the standards of the hotel, it should appear to everybody that I would not be so lacking in business sense as to violate the law and thereby forfeit a saloon license and injure my reputation and that of the house."

Atkinson retains the services of the sleek Gilbert Pollock, an attorney known for his sharp dealings and a member of city council from Madison Ward.

From her confinement, Jennie Moran confesses to the newspaper, "I got too drunk to go home and the next thing I knew about it I had been arrested and brought here. I don't know why I got drunk, but I do know there were a good many people there, I thought Luck was drunk, too."

She doesn't seem too perturbed about her predicament, at least until Sunday afternoon, when she starts crying, "I'm tired of this place! Will you please let me out!"

Jennie, tears streaming, asks for Father Coleman of her parish church. Soon afterward, she is dismissed but held under $300 bond as witness for the commonwealth against the hotel management.

The Dobsons learn of Jennie's arrest when a *Times-Dispatch* reporter shows up at the door of their rented 801 Semmes Street house. As far as the Dobsons knew, Jennie was still on Church Hill. Dobson explains, as given in a rather stilted manner by the newspaper, "When she did not return we were not surprised and did not think anything unusual until you brought us this distressing news."

Dobson sees Jennie in her First Precinct house incarceration, but he cannot gain release of his sister-in-law because he is not a property owner.

Police Court Judge John Jeter Crutchfield, the scourge of Richmond scofflaws. His cavalier treatment of statutes rankles reformer Adon Yoder and inspires career vaudevillian Walter C. Kelly, who for his popular "Virginia Judge" routine portrays in dialect both Crutchfield and the unfortunate accused. The entertainer is actress Grace Kelly's uncle. *Courtesy of the Valentine Richmond History Center.*

The irascible Police Court Judge Crutchfield will decide the issue. His more than twenty years on the bench have made him into the "Great Dispenser." He always wears a turned-down collar and string tie, often spits tobacco and carries an uncompromising dislike for lawyers and blacks from North Carolina. Crutchfield dismisses cases with the wave of a hand and a smile; he forbids prisoners to speak on their own behalf and either berates or ignores them according to his own whimsy. He levies penalties with little regard for consistency, and he once issued a fine by calling the alleged perpetrator over the phone at the baseball field.

His eccentric (or cavalier) interpretations of city statutes are a practical running column in the papers. Audiences attend his cases as they would a show at one of Broad Street's nearby vaudeville theatres. Hotel guests ask clerks for directions to his courtroom as an entertainment not to be missed.

The city's racial and social schism is displayed while highlighting the attraction of Crutchfield's court in this squib from the January 15, 1909 *Times-Dispatch*:

DECENT POLICE COURT
Justice Crutchfield Sends Idle Crowd Away
From Daily Meetings

Justice Crutchfield, following an order issued by the Board of Health, yesterday discarded from the Police Court all negroes who did not have business there either as witnesses or principals.

The board's opinion is that it is unsanitary for so many people to gather in the basement room in which the court is held. Bailiff Gibbons stood at the entrance, and each man as he entered was asked whether or not he had come for curiosity. Building Inspector Beck, who has charge of the City Hall, also got busy, and when a person was turned from the Police Court he was not allowed to stop until he had reached the street. This rule will be strictly enforced in the future.

The Park Hotel rathskeller matter causes Justice John to express horror of this case on his docket, along with another of a black man accused of attacking a young woman on her way to early Mass. The two instances move the judge to observe that they demonstrated the "frightful evidences of depravity to which humanity can descend."

During the Monday afternoon session, Crutchfield rules against William Beasley, guilty of beating his wife, to work six months on the public roads. Blake Stewart, a black man on whom a pistol was found, gets a $100 fine and twelve months in jail.

Commonwealth's attorney Minetree Folkes prosecutes the Atkinson case. Fair, bespectacled Mayor David Crockett Richardson and the rotund, mustached Chief of Police Major Lewis Werner are in court during the hearing, and there is frequent consultation between them and Folkes.

Jennie Moran, a little girl in short dresses, testifies in a composed, cool manner. She is of ordinary figure, her nose "decidedly retrousse and her forehead rounded forward like a child's." Her cheeks flush but her brown eyes stay steady, their color matching her hair and clothes. Her concession to a fashionable attitude is a white feathery turban hat.

Luck gives his version of the Saturday evening's events. And at that dramatic moment, the commonwealth's attorney is summoned to another case in the hustings and this trial is postponed until four o'clock Tuesday afternoon.

Jennie Moran's infraction is no small matter. Tightening regulations on alcohol sales are part of a vehement clash between the "Wet" supporters of saloons and the "Dry" detractors of alcohol distribution. Virginia has outlawed the selling of spirits in counties and, as a compromise measure, capped the number of liquor licenses granted in cities. Richmond, for example, may license just 150 places for liquor sales. A few years earlier, Richmond counted some 300 alcohol dealers and taverns, almost equal to the number of churches.

Thus, the Park Hotel case is an important test of the ordinance. If Atkinson loses on appeal, his liquor license will be revoked, or passed on to another more worthy seller. Restrictions on the licensing of alcohol distributors

create jostling and jockeying among those who want to retain their permits and those who desire a piece of the profitable trade.

An Appeal to Sentiment, Not Reason

Tuesday's testimony resumes with Jennie Moran. Her face reddens with embarrassment but, her voice firm, she points toward two waiters, Winston Payne and another identified as August, attesting that they had served her and her companions alcohol. Moran's words carry conviction into the hearts of the courtroom crowd despite the repeated denials of the Park staff members present.

Lucas Flood testifies that he was among their company and that they'd gone to the Park. They were served three bottles of beer and they shared the last one. He packed a half pint of wine that he poured into Jennie's glass while her back was turned, and she drank it. Pollock, Atkinson's attorney, tries to identify the bottle as a particular kind of liquor, but it looks like any other half pint.

Toward the end of the hearing, four more boys give successive testimony from the witness chair without adding anything. Then comes the fifth witness. He is nineteen-year-old Whitnell Bynum.

Commonwealth's attorney Folkes asks if he had any drinks at the Park that Saturday night. He replies that it was so.

"I object!" exclaims Pollock, jumping to his feet. "My client is charged with selling to these other four people, and Mr. Bynum's statement that he bought drinks in the Park Hotel that night is not evidence in this particular case."

Crutchfield rules that the warrant contained no names, but accuses Atkinson of selling liquor to minors on Saturday, January 9, 1909. Pollock then argues that Folkes is not discharging his full duty for the defendant in admitting Bynum's statement.

Pollock's ploy provides an opening for Folkes to use his eloquent rhetoric to dazzle the crowded courtroom. He declares that at stake is not only the honor of Virginia's children but also the interests of liquor dealers. The single question is whether minors had been sold alcohol and all evidence affirmed that, indeed, this occurred. He points to the waif Jennie Moran, who had left the rathskeller drunk, when he refers to how she'd been wronged. When describing the night she spent in jail, she weeps, as do many in the audience.

Folkes then congratulates Officer Sherry on his handling of the case. Pollock criticizes Folkes for an appeal to sentiment when his remarks should

have been an appeal to reason. But Pollock must have known that Judge Crutchfield was not liable to accept such a weak defense, and he does not. He fines Atkinson $100 and places him under a $500 security bond for the following twelve months. Pollock takes an immediate appeal. His client again goes to police court on January 15, on charges of having sold intoxicating beverages to Bynum.

The *Times-Dispatch* notes that Atkinson's conviction "met with the approval of the other liquor dealers, for they could hardly avoid recognizing the fact that a continuation of the evils with which the Park Hotel stands charged would do more damage to their interests than the loss of a dozen licenses. The case, however, will be fought to a conclusive finish in the Hustings Court."

Duo of Defective Detectives

James Marshall Atkinson, forty-three years old, is identified in the newspapers as the brother of Samuel Atkinson, whose family manages the popular Richmond Hotel, diagonal from the Park on Ninth Street. The Richmond Hotel is the operation of experienced hotelier Adeline Detroit Wood Atkinson, mother of both men. Her gracious place is known for a sumptuous marble lobby illuminated by stained glass. A rooftop terrace for dancing distinguishes the Richmond from the superlative Jefferson Hotel farther uptown on the elite residential blocks of West Franklin Street. The Jefferson lost its rooftop gardens and cabaret due to the 1901 fire and was rebuilt without the lofty entertainment. The Richmond, situated amid the centers of government and commerce, and next to verdant Capitol Square, enjoys pleasant views.

Adeline Atkinson's Richmond Hotel is the capstone in a career of managing successful hostelries that started in her hometown of Lynchburg. She embarked in the business after the Civil War, when her husband John was unable to earn enough money as a bricklayer to maintain their family of five. Atkinson parlayed misfortune into opportunity by taking in boarders.

During the 1880s, the Atkinsons moved to Richmond, where Adeline indulged her predisposition to take on projects. She turned around the ailing Saint James Hotel and then took over the American Hotel in 1889 at Twelfth and Main Streets, changed the name to the Lexington and made this a desirable house. Within a decade, Adeline realized her ambition of starting her own hotel from the ground up, but she began by tearing down the old Saint Clair at Ninth and Grace Streets.

When banks refused her startup money for the Richmond, she finagled a meeting with visiting capitalist John Pierpont Morgan. Morgan didn't give her the money outright, but vouchsafed her a loan, and with the full faith and credit of the renowned financier behind her, Atkinson built herself a fine hotel. Later, she argued with city officials about appropriate taxes for the building, and threatened to leave town if not given a rate she thought equitable.

She hired Carriere and Hastings, a New York architecture firm, to realize her vision. This team had designed the fanciful Jefferson and the masculine Commonwealth Club. The Richmond was from the beginning frequented by the powerful and those who sought their favors. Within a few years, an addition was required and *the* Mrs. Atkinson selected Norfolk, Virginia architect John Kevan Peebles for the task. He would later conceive of the neoclassical wings for the Virginia State Capitol and the Virginia Museum of Fine Arts.

J. Marshall Atkinson conducts business almost in the shadow of his respected relations. The Richmond Liquor Dealers' Protective Association rebukes Atkinson—although he is not a member. A number of those in the organization seek a resolution requesting Judge Witt not to renew Atkinson's license. Others consider this too radical an act. The group's bylaws state that any member known to have violated liquor laws should undergo censure, and the individual's activities be reported to authorities. The bylaws elaborate that this rule would apply to nonmembers "whose violation of said laws is brought to the attention of the committee on laws."

The dealers consider hiring counsel to assist in prosecuting Atkinson, but commonwealth's attorney Folkes has the case well enough in hand. Besides, an abundance of evidence exists to prove the charges.

Bolling's Blunders

The accusations around Atkinson and the Park Hotel may provide diverting reading and conversational grist for Richmond's autocrats of the breakfast table. But other kinds of drama occur during these first months of 1909.

Chronicler W. Asbury Christian describes how Richmond had longed for clean water ever since 1832, when the cool fresh springs of Capitol Square and Chimborazo Hill gave way to a city water supply using twelve miles of pipe. The nineteenth century faded into history without Richmonders able to enjoy clear water. Citizens gritted their teeth and drank the river's muddy water, and when bathing, felt no closer to cleanliness than godliness because of the questionable effect of the clay-colored liquid. The city built a settling basin for $300,000 in 1906, but it sat unused.

With the usual dilatory methods of the city government, and despite the protests of Superintendent Charles Bolling and City Engineer Wilfred Cutshaw, Richmond City Council delayed awarding the contract for the flume until after the basin was finished. The vagaries of weather, high water, Cutshaw's 1907 death and assorted delays prevented building the flume.

In 1908, Richmond at last hired the Crouse Construction Company at more than $60,000 for flume construction. Water began flowing through on September 10, and Richmonders were supposed to enjoy the effects within the following ten days. But the flume's walls failed to withstand the pressure of water passing through and sprung leaks at almost every joint.

Water Committee Chairman Morgan Mills declared the flume a complete wreck, and wrong from beginning to end. The city's Committee on Investigation, chaired by attorney Gilbert Pollock, called hearings on the basis that contractual agreements were not met, the apparent collapse of the city's supervision of the concrete mixing and the utter failure of the tube to hold water even under ordinary pressure. In late January, the committee issued its findings, and its proceedings were recorded with diligence in the newspapers.

City Engineer Bolling appointed incompetent and inexperienced inspectors. This included J.C. Clifton, who said Bolling hired him without asking for his recommendations. Clifton wasn't even an engineer, and possessed no experience with reinforced concrete. Bolling was supposed to make sure that procedure was followed; Clifton said he didn't feel as though he had authority to make objections even when he observed improper work. He came to the construction just four times in two months.

Another inspector, a young Charles Mann, demonstrated total ignorance. Testimony revealed that the contractor, the Crouse Construction Company, used concrete that had gotten wet and then hardened. Crouse employees told of how they witnessed wide departures from the plans, to the extent that they weren't followed at all.

The Committee on Investigation's final report enters the public record in February, amid calls for Bolling's resignation. But the Common Council, after two hours of ardent debate, votes twenty to nine to retain the engineer out of respect for his thirty-four years of service to the city. Council instead drafts a substitute resolution faulting the Crouse Company and resident engineers, although Bolling receives stringent criticism for his lack of proper supervision over the project. An appropriation of $62,000 is made for another flume.

An exasperated Richmonder reading of the gross dereliction by city employees might appeal to a higher authority than Mayor Richardson for swift resolution—and clean water.

"Jesus Wants Me!"

Prayer is given ample opportunity during three weeks of January 1909, when the city's faithful are revived by the massive evangelistic enterprise of Indiana-born evangelist John Wilbur Chapman in tandem with gospel singer and choral director Charles McCallon Alexander. Chapman's method of spreading the good word is characterized by almost military precision. Rather than holding services under one big tent, as conducted by his mentor Dwight L. Moody, Chapman splits cities into sections and holds simultaneous services under assistant preachers and choir conductors, with an evening central mass meeting in a public hall.

The Chapman-Alexander team includes twenty-one ministers and music directors. Five churches in Richmond join this most comprehensive and united effort known by the city's Protestant congregations: downtown's First Baptist, Union Station Methodist on Church Hill, Broadus Memorial Baptist and Central Methodist of Manchester and Fulton Baptist in the East End.

The major evening service is held at the glass cupola-capped City Auditorium at 911 West Cary Street. The big brick building started as an attempt to establish a third city market during 1891–1905. Failure to compete with the First Market in Shockoe and the Second along Sixth Street precipitated the building's major 1907 conversion into a public gathering space for an audience of five thousand. Steel girding was installed in its upper reaches during late 1908.

The vast structure presents an acoustic challenge, but City Councilman Robert Whittet Jr., who chairs the committee on grounds and buildings, pronounces the steel ceiling's service as satisfactory. He takes a seat in back and hears every word of Chapman's sermon. Other members of Whittet's group take seats in different parts of the house and hear with ease. "The intense quiet shows that everyone in the house could hear," Whittet reports. Further, the waves of coughing that erupt throughout the house at the end of Chapman's illustrations occur in paragraph-break pauses rather than in mid-thought, indicating the attentiveness of the audience and the desire not to interrupt.

Despite cold, rain and sleet, the City Auditorium and the five satellite churches throughout the city are often filled to overflowing. Chapman gives rather simple, strong preaching of Christian essentials with "direct man-to-man appeals for higher ideals." Despite his lack of flourish, Chapman holds his audience spellbound.

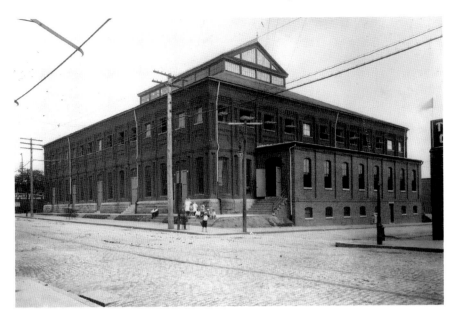

City Auditorium at Cary and Cherry Streets. Designed by Marion Johnson Dimmock as a market for the growing West End around 1890, it never caught on, and the city repurposed it for mass assemblies and as such it was in constant use for political gatherings, religious services and performances. The acoustics seemed to vary per listener and position in the hall. The building is today a Virginia Commonwealth University athletic center. *Courtesy of the Cook Collection, Valentine Richmond History Center.*

The great meetings move at least a few of those who attend in a felicitous direction, if not a divine one. Early on during the series, a black woman, bent and broken with years of travail, approaches a white man who appears to have done well for himself in the world. She asks the man if he could donate a dime toward the relief of her distress. He pauses and takes account of the woman, whose hair is almost white and her aged face an obliteration of youth. She must have known the days of slavery. He says, "Aunty, I know you are a good woman; I know you are one of the old-time darkies, and you can have every cent I have."

He presses a five-dollar bill into her palm. She thanks him, but insists that this is too much, and that he needs to take back the money. He looks at her with kindness, pressing the note again into her withered hand, saying, "You have earned your reward, and may God bless you." The old woman mumbles something and, clasping the bill, she walks on until she stops and meets the glance that the man has turned to give her. She kisses the money and then hobbles away.

Toward the end of the Chapman-Alexander mission, a heavy package with nineteen cents postage due arrives at the office of police detective

Captain T.J. MacMahon. The opened parcel reveals a large quantity of silverware and a printed note with the urging, "Find the owner," but no names or indication of the sender's identity from the address printed on the back.

MacMahon has not received any reports matching that of the silver, a majority of spoons and forks, each piece wrapped and tied with care. Some of the spoons are marked "A.E.W.," others "J.L.B." and several "W.W." There are also a number of teaspoons with no hint of what service they once graced. The collection includes a pair of eyeglasses, a souvenir spoon, a wire bracelet dangling with beads and an antique brooch. Captain MacMahon offers his opinion that the sender was a thief whose conscience was stricken by attending the Chapman-Alexander meetings.

Chapman and his team of preachers know that the Wet and Dry "local option" question occupies people's minds. The extreme "Dry" faction demands prohibition of alcohol throughout the state, and the moderate "Wet" group prefers that municipalities determine when and where spirits should be sold.

Evangelist William Asher brings the word to those he regards as having the greatest need: the denizens of Murphy's Hotel bar and its Tuxedo Pool Room at Eighth and Broad Streets. Asher, with his wife close behind him, strides into Murphy's at 8:30 p.m. on January 8, greeting the gathered with a cheery, "Good evening, gentlemen. How'dy, Charlie. This looks mighty good to me, fellows." He carries with him a small case that resembles a drummer's grip and holds a small organ that Mrs. Asher plays.

The minister, grasping the Protestant New Testament in one hand and the Catholic in the other, states his purpose to the capacity crowd. This is a public resort and if he is to reach the men, he must go where they go. He offers a caveat: "Dr. Chapman said to me today, 'Asher, this is not a temperance or a local option move, but an evangelistic move.'"

The preacher determines by show of hands how many in the gathering attended the auditorium meeting. One hand goes up. Asher then requests that the bartenders Jack and Skinner, who have nothing else to do, help distribute hymns. He tells his impromptu congregants to get the ice out of their shoes. "We want to do some singing tonight," he says.

Mrs. Asher accompanies on the organ an attempt to sing "Nearer My God, To Thee," which comes across with more earnestness than melody from the assembly unaccustomed to both the tune and the words. She then presents "The Mother's Prayer," which brings tears to many eyes.

Asher's message is, "For God so loved the world He gave His only begotten Son that Whosoever believeth in Him should not perish, but have everlasting life." He speaks of the text's great love and its promise. He finishes, "Fellows, I

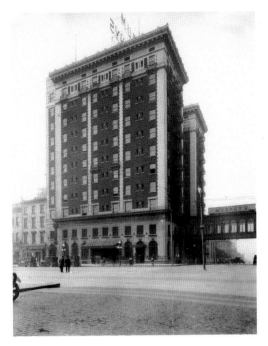

Murphy's Hotel would have been the new Murphy during this period, around 1911, having replaced an earlier structure. The landmark pedestrian bridge leads to an annex. Murphy's was designed by John Kevan Peebles, architect of the Virginia State Capitol's neoclassical wings and the Hotel Richmond addition. The hotel is later pressed into service by the state and demolished during 2007–08. *Courtesy of the Valentine Richmond History Center.*

want to tell you that a prayer from Colonel Murphy's bar is just as acceptable in Heaven as one made from a church or a cathedral."

Asher returns three days later, making a pool table in the Tuxedo Club his pulpit. He and Mrs. Asher sing the same tunes, and the crowd joins in with similar zest. The *Times-Dispatch* writer notes, "Both meetings have been characterized by the greatest attention of the audience and absolutely no show of disorder."

The Chapman-Alexander evangelism proves too powerful for Church Hill machinist Charles Gary, who, on the afternoon of January 25, runs screaming out of the shop where he works at Nineteenth and Cary Streets. He cries, "Jesus wants me! Jesus wants me!" And he believes the quickest way to see Christ is through the muzzle of a revolver.

The sermons he heard at Union Station Methodist had persuaded Gary of the notion that he was not as good as he needed to be. A husband and father of a large family, Gary is considered a solid Christian man but one who suffers occasional attacks of "melancholia and religious depression." A party of boys finds him in the woods behind Oakwood Cemetery and gets him home to 820 North Twenty-eighth Street. There, a physician prescribes opiates, and the deranged man falls into needed sleep.

"Not Guilty of Resorting to Such Measures"

As if matters against the Park Hotel are not going badly enough, in early March the manager of its pool hall, D.K. Hagler, is arrested on a kidnapping charge. The case provides something of a tangle for Judge Crutchfield.

Hagler is the apparent father of sixteen-month-old Gladys Jackson, whose mother, Mamie Jackson, had some time earlier left the infant in the care of a colored family on Ross Street in Shockoe, amid one of the city's poorest and roughest neighborhoods. Ross is not quite a mile down the hill from the Park and within sight of the state capitol.

Mamie Jackson moved to Norfolk. Once settled there, she telegraphed the couple requesting the child. The surprise response was that "some strange man had come to take the child for a drive and had not returned."

In police court, Hagler refuses to name where he placed the child, but officers found her with another colored family on Byrd Street. Byrd, running along the river, fronts on factories and railroad tracks. Mamie Jackson does not seek prosecution of Hagler; she just wants her Gladys back.

Little Gladys rests with bliss at the city home, unaware of adult disputes. The child makes her first ride in a police automobile, dangling in the arms of a sturdy officer, and she appears interested in the sights of the city during the journey from city hall. Gladys makes frequent questions of the officer but, having forgotten baby talk, all he can do is chuckle.

Then, on March 17, Atkinson finds himself arrested again but bailed for $500. His brief detainment is the direct consequence of the apprehension of James T. Disney, the treasurer and manager of Murphy's Hotel, and George McD. Blake, operator of the George A. Hundley Grocery Company. Blake was accused of selling ardent spirits to William A. Bohannon and Disney of selling to Richmond College student T.W.R. Wright. One M.N. Johnson swore out the warrant—not a police officer.

The series of accusations soon turn confusing. William Bohannon bought the now infamous quart bottle of liquor from Hundley and "had the perfect right to do so," as Bohannon wrote in a signed statement. He reached twenty-four years on March 22, making him legal to drink in Richmond by three years' worth.

Following some searching, M.N. Johnson is located at 405 North Fifth Street and brought into conference with commonwealth's attorney Folkes and Chief Werner. Johnson claims to be a private detective, but who hired him becomes the big question.

Reverend J.D. McCallister, the Anti-Saloon League's field secretary, denies that his organization had anything to do with Johnson. The league "would not be guilty of resorting to such measures in the furtherance of its work." McCallister's denunciation mollifies an indignant Blake, whose name is plastered across the front of the newspapers. Disney is at first unavailable to reporters, and then ill.

Witnesses describe Johnson hanging around barrooms trying to gain the confidence of younger people. He was seen at the Jefferson Hotel but most often at Murphy's. One Murphy's witness said Johnson passed money under the table for him to get a round of drinks for a group in the bar.

Johnson was a printer, or rather, a former printer whom three weeks prior had made the acquaintance of a man named Denton, staying at the Richmond Hotel. Denton purported to be a New York private detective. They met in the offices of the Richmond National Detective Agency. Denton expiated at length about the chances and prospects of investigative work. Johnson agreed to go into Denton's employ for three dollars a day, plus expenses. Denton received ten dollars a day for his services. From whom, though, Johnson says he doesn't know.

"I Did Not Pay for Anything that Night"

Reporters inquiring at the Richmond Hotel cannot find anyone who has heard of Denton. Johnson is quite sick of his newfound fame. He did not expect to be called in the cases at all, and now he bears the brunt of public inquiry. Johnson wants to retire from playing detective and intends to find a print shop where he can resume his proper trade.

The accusation against Atkinson stems from the selling of alcohol to T.W.R. Wright. Johnson recruited Wright and several boys into his scheme of entrapment. The Park Hotel's night clerk, Percy Jones, is implicated, and therefore, Atkinson.

Jones has left town for North Carolina to—he says—be at the bedside of his ill mother. Disney and Blake are curious about the inspiration behind Jones's machinations that incited all this public trouble. They are not to learn anytime soon.

By March 30, 1909, when the Jennie Moran matter comes before hustings Judge Samuel B. Witt, the court has no reason to look with kindness upon Atkinson's dealings. The preponderance of evidence against him and the Park Hotel is such that Gilbert Pollock does not even try to introduce refuting testimony. On the stand, Jennie Moran gives clear, concise testimony until describing how Officer Sherry took her into his custody, when she collapses.

The jury takes less than ten minutes to return a decision. Clerk Walter Christian no sooner reads the verdict then Pollock makes motions for a rehearing of the case. Witt responds that he would hear Pollock's argument next session.

The following day, April 1, Witt grants 11 more liquor licenses. The total permissions number one fewer than the 150 accorded by city ordinance. License 149 goes to a new applicant, William P. "Dutch" Leaman. He receives a permit for a saloon at 701–703 Brook Avenue (now Road), just northwest of downtown Richmond. Leaman, a boilermaker, serves on the mighty Richmond City Democratic Committee and is a vigorous participant in the politics of Madison Ward.

The license for Clarence H. Hopkins causes some differences. He wants permission to sell spirits at 1105 North Twenty-fifth Street, in Church Hill. Hopkins got around complaints from a year prior, as they centered on the property next to this one. The judge construes the law to mean that the violation of selling to a minor does not just suspend the liquor license of an establishment, but that no other license would be issued to that place.

The final license goes to D.A. Blankenship for 2429 East Main Street.

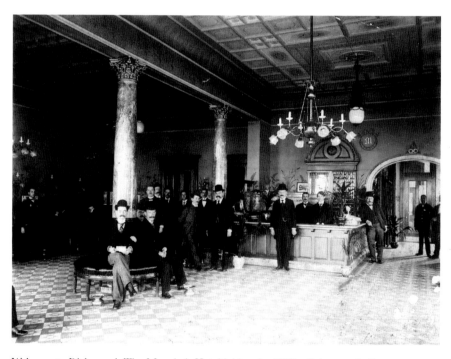

Welcome to Richmond. The Murphy's Hotel lobby; the 1909 religious revivalists, numerous pool sharks and University of Virginia football enthusiasts enter here. *Courtesy of the Valentine Richmond History Center.*

Atkinson's prior city licenses for the Park expired January 31, while state licenses retain their force until April 30. The state regulation is plain: if a seller of alcohol is convicted of selling to a minor, pending appeal and reversal, then the Richmond Circuit Court may revoke that license. Atkinson continues operation between the lines of the law by not yet having had his liquor license suspended. The city police claim no authority to close the Park Hotel saloon because this has become a state matter.

On April 8, Judge Crutchfield dismisses the charges against George McD. Blake. The one-named Denton remains unaccounted for, despite diligent efforts. The case against Disney of the Murphy Hotel will not receive hearing until April 30.

The Park Hotel's saloon closes for a day's interval, but keeps dispensing its spirits to willing customers through early April. The *Times-Dispatch*, pointing to this lapse, cites Section 27 of the 1908 Byrd law that requires anyone found guilty of a second violation "shall be fined $100 and shall be confined in jail not less than two nor more than six months, and shall forfeit his bond previously given."

By April 13, Atkinson's dodging and weaving tactics fail to get around Judge Crutchfield. That morning, the proprietor is fined five dollars for operating a saloon without a city license. He goes before Crutchfield again two days later to answer charges of selling liquor to T.W.R. Wright. The hearing gets postponed until May 15.

By afternoon, the large denim screen with firm fastenings that encloses the Park's bar and fixtures delivers an uncompromising message. The saloon is closed and will stay that way for the foreseeable future.

A few evenings later, the Richmond City Council's Committee on Ordinances, Charter and Reform takes up the responsibilities of the city chemist and creating the position of matron for the police department, for searching female prisoners brought into the station houses. Also on the agenda is an amendment to the local Dabney liquor law to fix a penalty of not less than $100 and no more than $500 for any unlicensed seller of alcohol, whether in violation of state or city law. City Attorney H.R. Pollard cites the Park Hotel case. Another amendment stipulates that a potential licensee needs to make application thirty days prior to the effective date, as opposed to the current five days.

The celebrated Richmond liquor cases in the spring of '09 arrive at a dramatic dénouement with the testimony of Johnson, the printer *cum* detective in Crutchfield's courtroom. How did he come to be in the Murphy's Hotel bar on the night of March 10?

Mr. Denton, who had employed me, told me to be on hand at that place as some boys would be there, and would buy something. He said he had

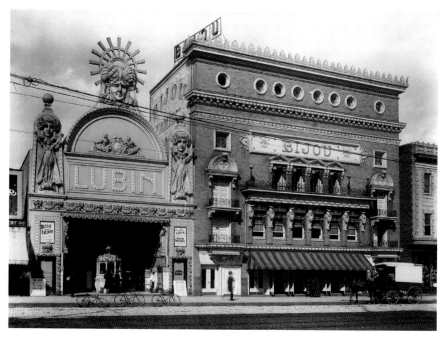

Almost like Broadway. Lubin (1908) and Bijou Theaters (1905), under an assortment of names and redesigns, provide entertainment for most of the twentieth century. The Lubin of this period features a wild, electrified façade and the colossal head of a woman. Its nighttime invitation to adventure and escape opens into a rather plain interior but symbolizes Broad Street's sometimes gaudy allure. *Courtesy of the Cook Collection, Valentine Richmond History Center.*

received information that something would be doing in the liquor line at Murphy's that night.

I went there, and sure enough, the boys were there. I saw them served drinks, and on information received from investigating the matter, swore out the warrant against Mr. Disney, the treasurer of the hotel.

Johnson explains how almost the same tactic was used in conjunction with the charges that were levied against Blake at the Hundley store.

The twenty-year-old Richmond College student T.W.R. Wright testifies of his strange night out, instigated by the now disappeared Percy Jones, the Park Hotel's night clerk. Wright met Jones on Broad Street. Jones held six tickets to the nearby Bijou Theatre.

"He invited me to accompany him to the Bijou with a party of friends, which I did," Wright tells. "Of course, I had no idea what was going to happen, nor did I know Jones was trying to get evidence against any of the hotels."

The show at the Bijou, 810 East Broad Street (now the site of the Library of Virginia), was *Busy Izzy's Boodle*, headlined by the "the funny little man," the stout vaudevillian George Sidney. His act includes dancing girls captained by Carrie Webber, the off-stage Mrs. Sidney. Between the parodies, songs and even ponies, Jones led his new friends to Murphy's and ordered drinks.

"I did not pay for anything that night," Wright emphasizes. "Mr. Jones said we were his guests and that he was treating the crowd."

After enjoying *Busy Izzy's* zingers and the reciprocating legs of Miss Webber's girls, the men repaired to the Murphy's dining room, where they partook of sandwiches and more drinks. Wright goes on, "When the waiter brought the check, Mr. Jones reached under the table and gave it to me with the money for it. I did not know why he did this, but I did not really think of it seriously at all."

A member of the party on March 8 was Middlesex County native L.S. Bennett. He knew Wright quite well, and also Jones. The Park's clerk approached Bennett several times to ask if Wright was underage. "I told him plainly several times," Bennett says. "At the time I thought it was a little peculiar that he should have asked me the same question so many times, and so I was very careful to answer him so he could not possibly misunderstand me."

The last unanswered question is the identity of the scheme's prime mover, Denton. All sides of the case contend that Denton must still be in Richmond, though nobody can describe or identify him, not even his pawn, W.N. Jones.

Judge Crutchfield characterizes the efforts to defame Disney and Blake as a gross conspiracy and denounces the perpetrators. The preferences against Disney are dropped.

Over at hustings, in the Moran case, Judge Witt rebuts attorney Pollock's appeal to dismiss the jury's decision of levying a $100 fine against his client, J. Marshall Atkinson.

The *News Leader*, sounding both sarcastic and amused, concludes its account with how the entire Denton-Johnson-Disney-Blake-Atkinson-Jones affair has ended "in a labyrinthine tangle which the police and detectives seem utterly unable to dissolve."

Typical of Richmond's circumspect nature, the likelihood is that any number of people are aware of Denton, although none volunteer information for fear of public attribution causing private retribution. Further, perhaps those who know Atkinson and his business feel that he deserves his punishment.

Atkinson expresses his decision to the press to quit his business at Capitol and Ninth Streets and, furthermore, his intention to sell the building. What he says, though, and what he is otherwise proposing, are two different things.

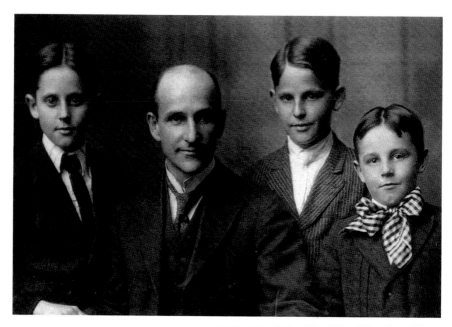

My three sons. Adon Allen Yoder with (left to right) Frank, Harry and Adon Jr., a few years after his Richmond adventures. Yoder later opened a successful Chicago advertising agency with Harry and Frank that ended during the Depression. He became a legendary sales representative for Cable-Watt agricultural publications. Yoder moved west, marrying twice more, and started a second family in California. *Author's collection.*

"Abusing People in Sensational Ways"

Not long after Atkinson made much of leaving the hotel business, he travels to his family's hometown of Lynchburg. There he knows, and is perhaps kin to, Annie Marshall Yoder. Annie's husband is Adon Allen Yoder. His *Idea* pamphlet, first published in Lynchburg, stirs the locals and annoys the status quo. Yoder—a thirty-year-old native of Lynchburg, Richmond College Class of 1900 graduate and former Baptist minister/school principal/ bookkeeper/publisher—lives with Annie and their sons: Harry, five; Frank, four; and the infant, Adon Jr.

Yoder's personal agenda includes getting the vote for women, battling for equal treatment of blacks before the law, exposing corruption in high places and promoting grass-roots socialism, alcohol prohibition and government fiscal responsibility.

"*The Idea* is published," he declares, "because of a demand for a fearless and outspoken paper against the evils of the hour. This demand comes from everywhere—the mechanic, the doctor, the lawyer, the preacher, the teacher, and poor and rich, those who work and hope for better things."

Roanoke Times editor Alfred Williams a couple years afterward provided a somewhat unflattering accounting of Yoder's activities:

> *Mr. Yoder is an amiable person who seeks to earn a living by abusing people in a sensational way and reforming things. He finished reforming Lynchburg. When he had induced this city to quit selling liquor to Danville and buy from Roanoke, doubtless he felt this task was completed and he turned the town over to the* Lynchburg News, *which is trying to take up the mantle of Yoder and force its constituency to slake its thirst at Washington, Baltimore, and other remote points out of the state so that the fluid may have the chance to ripen before reaching its destination; for* The News *knows that after it arrives in Lynchburg its life is a matter of moments.*

Yoder came by his missionary's zeal through blood. His Pennsylvania Mennonite father, Jacob Yoder, founded the first school for blacks in Lynchburg as part of the post–Civil War Freedman's Bureau. "He was an articulate intellectual, a visionary, and a dreamer of big dreams," a business associate described him many years later. "He was an extrovert with a colorful personality, not to be deterred by the limitations of logic."

Atkinson approached Yoder about bringing his wild muckrake to Richmond. He told the pamphleteer that while he intended to set up the undertaking with a loan, he expected his bankrolling not to affect the content of the publication. He "suggested that since Richmond was more corrupt than Lynchburg politically, *The Idea* could be a self-sustaining paper there and accomplish more good," Yoder recalled. Yoder had been thinking of locating to Richmond, though at first he was leery of an offer that sounded far too simple and easy. Atkinson persisted.

Could Yoder have been so naïve as to think Atkinson's largesse was not without some purpose? Had Lynchburg been made so uncomfortable due to his sparring with the rich and powerful that he moved as a means of survival? As the head of a growing household, did a paid move to Richmond seem a kind of promotion?

Whatever the case, Yoder first accepted $50 from Atkinson, but the needs of self-publishing ballooned that into $432. In the spirit of missionaries, Adon, Annie and their young sons set forth for corrupted Richmond.

The Yoder family, circa mid-1890s. Adon Allen, future muckraker, is second from right; father Jacob Eschach and mother Anna Whitaker Yoder are in the center. The other Yoder sons, not identified, were Wayland Whitaker, Edward Eschbach, Claude Colegrove and Rozell Roland. Not pictured are daughters Eva and Annie. *Author's collection, from Patricia Garrity Yoder.*

A Son of Jacob

He was one of seven children of Jacob Eschbach and Anna Whitaker Yoder: Eva, Annie, Wayland Whitaker, Adon Allen, Edward Eschbach, Claude Colegrove and Rozell Roland. Adon was born August 14, 1877.

Jacob's efforts in the education of recently emancipated blacks and work among the poor earned him a distinctive niche within the small Lynchburg community. Jacob's children, having a father who was an advocate for blacks, received unwanted attention. Rocks were thrown at them; they were spat upon and called "nigger lovers."

The Yoders learned to toughen their resolves in the face of personal adversity. Jacob Yoder's entire career was thus trivialized by the *Richmond Evening Journal* in February 1910, when trying to make sense of the perceived errors of his son:

> *Mr. Yoder, senior, apparently regarded himself as a missionary to the newly-made colored freemen, and while he was evidently an earnest man, his actions occasioned a good deal of comment in the Hill City, and for some years he associated with the colored element in a way that was more or less resented, but finally realized that he had made a mistake, and set out about establishing himself with the white people.*

Still, young Adon grew to maturity within this environment and was influenced at least as much by it as by the rigorous instruction of his parents and church. While he advocated equal treatment of minorities and the disadvantaged before the bar of justice, social equality remained problematic.

Yoder recalled his Lynchburg youth as idyllic but informed about those individuals around him who were less fortunate. Yoder, as a youth, was struck by the disparities of a social system that, in his view, failed to provide adequate reward to working people for their labor. He recalled watching the toilers of the tobacco, shoe and cotton factories trudging to and from their labors, "with their sunken cheeks and thin faces and emaciated forms and stooping shoulders and weary and saddened countenances and lustreless eyes and slow and tired walk."

He wished to be a millionaire so that he would be able to give to the poor. Yoder even imagined that he had a bachelor millionaire uncle who would bequeath wealth upon him; he planned how he would best use the money for good. He contemplated the nature of Jesus Christ, born into poverty, and the teaching to the rich man to "get rid of his money by giving it to the poor, not because giving the money was the thing, but because while he had the money he could not do much service, the money was the evil in the way."

Yoder concluded that if Jesus had needed no money to do good in the world, then Adon Yoder didn't, either. "So I looked again at the sorrows of the poor, and told myself I would do what Jesus did, give my life to the conflict of right against wrong." Yoder possessed a passion for the pulpit and the lectern. He enrolled at Richmond College.

The Scholar

The thirteen-acre, park-like main campus situated between Ryland and Lombardy, Franklin and Broad Streets was nestled within a growing residential community. The sloping mansard roofs and towers of the exquisite Victorian main hall rose above all other nearby buildings.

The college boasted of its physical location on hills near the falls of the James River that freed the campus of the scourge of Tidewater's malarial air and the pulmonary and enteric diseases of the Piedmont. For thirty years, there had been just four deaths at the college and few other serious cases of sickness. The infirmary wasn't used at all during the session of 1896–97.

Yoder, however, experienced a different environment from that described in the college catalogue. During March 1896, measles and mumps afflicted

The alma mater. The eastern Grace Street approach to Richmond College, from about Harrison Street. Present-day memorial columns at Lombardy and Ryland Streets on Grace mark the location. *Courtesy of the Valentine Richmond History Center.*

him, and in January 1898, Yoder experienced a smallpox outbreak and later contracted malaria. The March 1900 death by typhoid fever of Kennon Hening, son of a prominent Powhatan County physician and superintendent of the schools, seems to have been a defining moment for Yoder. Later that summer, in time for graduation, he contracted malaria.

Hening also sold books on campus, and when he fell too ill to handle his business, Yoder stepped in. The morning after Hening died, a half-holiday was given, allowing his classmates to see the body off at the train depot. The Philologian Society, of which Yoder and Hening were members, voted that Yoder should accompany the deceased on his last trip home, an honor he accepted, in part because he arrived dressed in one of his few good suits. He and three other boys rode to Maidens, thirty miles outside of Richmond, and then with a gentleman of the town took turns sitting up all night in the dining room with the corpse.

Yoder managed the bookselling until the end of the session. His often-harried letters to relatives are full of descriptions of an active intellectual and physical life. Yoder participated in basketball, football, tennis and track and field events. He was the secretary of the Spider Association, president of the Mission Board, chairman of the Mission Committee, on the Hall Furnishing Committee and an officer in the Philologian Society.

Young Adon Yoder was short and spry, though somewhat bowlegged, and weighed around 130 pounds. He was balding by his college days, and in combination with an imperious nose—his "eagle beak," of which he was quite proud—his face carried a character of astuteness or even intellectual snobbery. His eyes were deep-set and brown, his voice powerful and speech eloquent and full of wit. Yoder radiated self-confidence and maintained a charming, polite air, though never frivolous. What he lacked in an impressive physique, he made up in charisma. Women enjoyed his company.

His classes included history, Greek, chemistry, ethics and geology. A class in psychology proved Yoder's most difficult, raising his anxiety that it would undo his graduation chances. He often attended public speeches. Yoder heard, as part of the Thomas Lectures, a speaker who became one of his greatest personal heroes: Woodrow Wilson.

He wrote and declaimed poetry in salons. One long poem, "Mystery," was close to his heart, and he would reprint it in various publications throughout his life.

"Mystery" is on one level the typical ruminations of an introspective college-age youth, but one who has experienced injustices and death. This is a dreamy consideration of cosmological and spiritual questions. One friend told him it was the equal of William Cullen Bryant's "Thanatopsis." Yoder sent it on to the *Atlantic Monthly*.

The lengthy poem is framed as the bubbling, questioning mind of a young person meditating upon the eternal questions at midnight along the bank of a stream.

O Mystery! cold Mystery!
Deep is thy stream and black
As black as night and cold;
Broad are thy banks and far between
Thy fall is slow,
And slow they onward flow;
So weird art thou, and secret, too,
That none may know
Whence thou hast come
Or whither thou wilt go.

"A Short Lecture on Wire Pulling"

Yoder's sincere appreciations of poetry inspired him to write many others during his life. But none of them graced the pages of the *Atlantic Monthly*. If

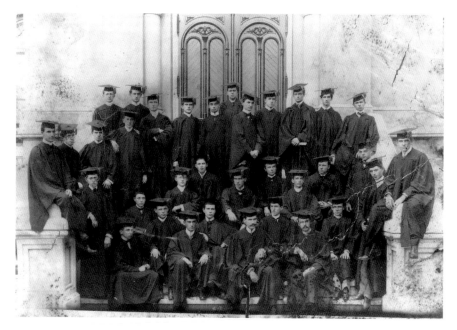

School's out forever. The Richmond College Class of 1900; Adon Yoder is perched prominently, at left. *Author's collection.*

he had become interested in socialism or the question of women's suffrage, there is no mention. His view toward the political process is reflected in two incidents involving Richmond College student clubs.

A dispute arose between editorial staff of the school's annual, *The Spider*, which had decided that only organizations would get editors, not classes. The Law Class, which previously had an editor, was this time denied one and the representatives asked that *The Spider* editors reconsider. "We refused on the grounds that they had more representation than other students already," Yoder said. The Philologian Society would instead have an editor. The Lawyers "got up in the neck" and sought to have *The Spider* editors turned out so that new ones could be elected. The Philologians and the Lawyers convened a heated meeting. Yoder "spoke in defence [*sic*] of our action for almost 15 minutes in a very conservative and unimpassioned way but they lost their heads and in consequence lost their object and we were honorably retained." Even the men who opposed his views complimented him for his action.

A month later, a friend sought to nominate Yoder as president for the Richmond College student government. Another classmate told the friend he'd better "lectioneer" for Yoder because someone else was favored. Yoder requested that the friend not do anything on his behalf because he "did not want to be running for any office." Yoder had heard of another fellow

making the run and that a canvass was being made for him. Yoder wouldn't be elected unless he chose to exert influence by "acting politician," which he would not do for any of the offices. He regarded campaigning and the attempt to win votes as "scheming," and he was surprised that other ministerial students didn't see anything wrong in it.

Yoder's name was put forward, he said nothing and his opponent won by two votes. Friends wanted to know why he didn't tell them he was running. He replied by giving them "a short lecture on wire pulling."

"Professor Yoder of Cascade High School"

After graduating from Richmond College, Yoder ended up teaching in a two-room brick schoolhouse in Cascade, Virginia, a crossroads village near the North Carolina border. The tenor of his letters during that time is effusive. He was a new Richmond College graduate in a small town where a university credential and a preacher's bearing made him a local star. In few other descriptions of his personal views is Yoder more poignant than those from his Cascade residence of 1900 through mid-1901.

He roomed with a retired physician, Dr. Estes, and his family. Yoder paid rent of nine dollars a month and exercised by chopping and carrying his own wood. The air was balmy, the girls pretty and work not looked down on—although he had more of it than he would prefer. He was at school until nearly sundown every day. Yoder wrote rapturous descriptions of Cascade's nature and bountiful wildlife, including abundant partridges, field larks and hill doves, wild geese, ducks, hawks and owls. Yoder was a traditional Southern sportsman who had dogs, horses and guns at his disposal. He hunted fowl and rabbit, rode horses, played with the Esteses' beautiful shepherd dog and enjoyed himself and his place in the small community.

In his manner that both elevates and deprecates, Yoder writes, "I am Prof. Yoder of the Cascade High School and quite a respected and dignified personage of course…People delight to favor the professor and preacher you know." Ever the social creature, Yoder belonged to the Epworth Literary group, coached Little League baseball, sang in three church choirs and preached when asked, even under strenuous circumstances.

During one Sunday service, a dog, an escaped mule and some talkers in the congregation threatened to break up the proceedings. Yoder finally had the dog put out and people went to catch the mule. Despite all the excitement, a young woman gave her public profession of faith.

Yoder taught twenty-five students in his classroom and they sat three to a seat. He gave instruction on everything from arithmetic and algebra to

history and physics to dictionary and reading. While hurriedly setting up his curriculum, he asked his mother to send down some thirty schoolbooks that either he or his father had used. The titles included Latin and German grammar manuals and dictionaries; geometry, algebra and arithmetic guides; *Tarr's First book of Physical Geography*; *Montgomery's Leading Facts of English History*; and *Maury's Manual Geography*.

He asked his father for advice on keeping daily grading books and if he could send one to him, "unless I should ask the Co. Supt. for same. I have lost my fountain pen." He wrote, "Send also wash rag & small hat brush," and then, "Had to break in the school this A.M. Keys lost." Yoder was Cascade's absent-minded professor.

"I'm Conceited Enough to Believe It"

"I am at last quite acclaimed and the school is moving along smoothly," Yoder exulted in mid-November 1900. "No cursing or swearing has been heard. A remarkable neighborhood it is. We boys play baseball...Some are almost as old as I am. No trouble to manage as get through. I make no rules and give no orders. All seem to mean business."

By the new year of 1901, however, the resort qualities of his Cascade idyll darkened as his malaria flared and he could not maintain his pace. He taught for a day or two, until massive headaches and other symptoms forced him to stop by mid-February.

The day came when Yoder told his little scholars that he must suspend leave. He didn't say half of what he wanted before the children began crying and he changed the subject. He hated to give up teaching, but in justice to the school there was no other choice. Yoder was told many times that he was the best educator the school ever had, "taffy of course," he wrote, "but of course I'm conceited enough to believe it."

Dr. Estes began prescribing for him and administering quinine and later arsenic. This course seemed to do Yoder good, although he was doubtful, because in Richmond quinine had made him even more ill. He battled the illness for weeks and came close to jaundice.

He kept planning to return home to Lynchburg, but throughout April and most of May he was delayed. On May 8 he wrote his mother, "I would have been home however long ago but something has always been planned for each week and I have stayed for that." After all, his expenses were low and the entire community seemed concerned about his well-being. He even managed to teach some of the locals the fundamentals of tennis.

Forever young. Annie Sarah Marshall, in
1899, an angelic fifteen years old. Adon Yoder
proposed at a church picnic and then married
her in 1903. She died in his arms in 1915. His
poem, "To Annie In Heaven," begins, "Annie,
when in my dreams last night you came to
me/ And lifting up your radiant face to mine
you smiled on me/ as my lips met with yours
in holy kiss." *Yoder family photograph, from Patricia
Garrity Yoder.*

"A Rebel Yell"

When he returned to Lynchburg, Yoder began bookkeeping at People's
National Bank of Lynchburg and later the lumber concern of Massie &
Pierce. He married Annie Sarah Marshall in 1903 and his father died in 1905.
He seems to have preached, but Yoder later said that certain denominational
tenets did not agree with him. He tired of his congregation paying him to
tell them "that they were grand rascals, even if they were."

A family story has it that Yoder visited his mother and found her weeping
and praying to God to cure the alcoholism of her son Rozelle. Yoder decided
that any god that compelled his mother to beg for divine intervention on her
knees, and did not give a subsequent proof of supernal power at work in the
life of man, was no god of his. And though he was a man of faith, it was
an aspect of his heart with which he struggled his entire life. He sought to
correct injustices out of fairness and charity to all creatures, man and animal
alike. Adon, a son of Jacob and with an alcoholic sibling, gave full-hearted
support to the Women's Christian Temperance Union.

He reasoned that a newspaper could convey opinion and information
better than the combined pulpits of Lynchburg. While at Massie & Pierce,
after hours, he began publishing a pamphlet titled *The Idea*. The first issue
came out on July 4, 1906. He called it "A Rebel Yell," but the contents would

have startled most former Confederates, as the pages contained attacks on respected figures and one issue included a lengthy definition of socialism by Norman Hillquit, a famous New York City proponent.

Yoder declared, "This little magazine is not afraid of the Devil Himself (or Herself). Don't the little yaller thing beat the Devil anyhow!" The first issue was anonymous, but thereafter he proclaimed himself as "Adon A. Yoder Editor and Publisher."

The July 4 issue set the tone for what came afterward. Yoder told of a recent speech "Honorable Carter Glass" had made in Richmond, where Glass made the proud boast that no scandal had ever fouled the political atmosphere of Lynchburg. Yoder took exception by recounting a purchase by the city council a few years earlier of a corner lot on Court and Tenth Streets, on which to build a new high school.

Glass, whom *The Idea* man called "a member of the Council at the time," purchased in secret this lot from the council for a lower price than was initially paid for it. Yoder said that the deed went unrecorded at the time, to conceal the deception. Glass's ownership became known only some months later when Glass sold the land at a great profit. If Glass didn't own both of Lynchburg's papers, Yoder argued, this shady dealing would be public knowledge. "So now we have the space that might be used for good breezy editorials given over to such articles as 'How to Keep Baby Cool in Summer' and 'The Latest Creation in Hats for the Fair Sex.'"

Yoder reported that *The Idea* was receiving subscriptions from throughout Virginia and from states as far as Colorado and New York. (In a bit of advertising sleight of hand, this could have been referring to Yoder's relatives.) One Lynchburger who didn't favor *The Idea*'s content was his publisher, J.P. Bell, who was an acquaintance of Glass and even endorsed for him a note for $3,000 when Glass paid Bell for the purchase of the morning newspaper "because Mr. Glass did not have the money." Bell tried to intervene with Glass after *The Idea* hit the streets and distance himself from Adon's criticism, but Glass wouldn't see or speak with Bell. On July 15, through the *News*, Glass published his intention to sue Bell's company for $25,000 "for publishing a 'pamphlet making scurrilous references to Mr. Glass and other well known citizens.'"

Yoder wrote to Glass on July 17, apologizing for describing Glass as a member of the city council when then he was only its clerk. He didn't retract anything else. Bell explained to Glass that his only connection with *The Idea* was printing it, like any other job.

Glass fired a letter to the *Idea* man, stating that his correction was the least of the injurious statements made, to which Yoder replied, "I have nothing further to retract." Glass told Bell that he accepted "your explanation and expression of regret."

On August 26, Glass stated in the *News* that Yoder's letter retracting one of his statements was refused publication in his paper because the withdrawal of one of several charges "amounted merely to a reiteration of the rest." This confusing series of events, including whether Bell's explanation amounted to an apology, would figure prominently in subsequent Richmond libel trials.

By September 1906, Yoder was crediting *The Idea* with the *Lynchburg News* being moved to criticize the Traction and Light Co. for its bad lights and poor quality of furnished gas, the arrests of prostitutes and the raiding of unlicensed saloons. During one Sunday alone, "three sermons were preached on civic righteousness from the pulpits of the city…a wholsome [*sic*] public sentiment has been aroused." Yoder even sent Roycrofter Elbert Hubbard a copy of *The Idea* and Hubbard replied that it struck him as very good stuff and extended a hand grasp over the miles.

Slippery but Principled

Yoder began his Lynchburg campaign to ensure the proper installation of fenders on trolley cars, which would knock people out of the way rather than have them be run over or killed. He also took the Lynchburg electrical utility to task for failing to replace burnt out streetlamps and the city engineer for incompetent road repairs. At the bottom of almost all these difficulties, Yoder saw either the direct machinations or casual neglect of Carter Glass.

Similar to Yoder, Glass idealized Thomas Jefferson, Andrew Jackson and a time when a smaller government had served the people on a modest scale. According to a historian of Glass's early career, he was "ready to use legislation to restore a more equitable relationship between agriculture, labor, business and finance." But Glass resisted the more extreme measures of Populists. Nurtured by the circumstances of Reconstruction and Readjusterism, he feared uncontrolled working-class protest movements and was convinced that the majority of blacks were unfit for participation in democracy. He was a major participant in the rewriting of the Virginia Constitution of 1902 that deprived most African Americans, and 30 percent of the state's whites, of their voting rights.

Contemporaries regarded Glass as a slippery political partner but a man of unflinching principles. He admired Woodrow Wilson and eventually worked in his administration. Glass would participate in New Deal legislation but become disenchanted by what he viewed as its excesses. Yoder, on the other hand, supported Franklin Delano Roosevelt at first, but reconsidered when he felt Roosevelt did not go far enough.

This attitude was one engendered within even the more enlightened Southern communities. Yoder fit the mold of Southern progressivism and would with frequent vehemence complain about the mistreatment of blacks and minorities at the hands of police and corrupt justices. After observing court proceedings in Richmond, he pointed out harsher sentences meted to minority offenders for similar crimes committed by whites. "The law should know no difference in rich and poor, bond or free, black or white or yellow," he proclaimed. But at the same time, he printed dialect jokes concurrent with the mainstream of his day (perhaps to fill out pages with text) and made references to "superstitious negroes" susceptible to the evils of gambling.

The City of the Future

In 1907, the Chamber of Commerce proclaimed Richmond "the Most Important Financial, Commercial and Manufacturing City in the South Atlantic States."

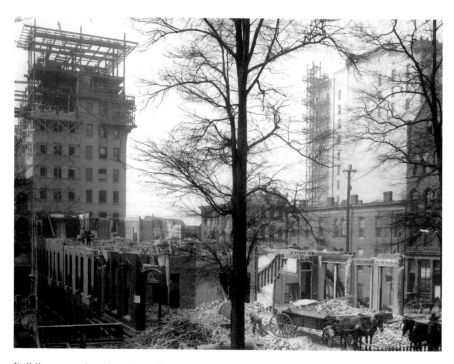

Building up and tearing down. Looking from Bank Street toward Main around 1910, showing buildings at Tenth getting demolished to make way for enlargement of the post office. The American Bank Building at Tenth and the Mutual Building at Ninth are under construction. *Courtesy of the Cook Collection, Valentine Richmond History Center.*

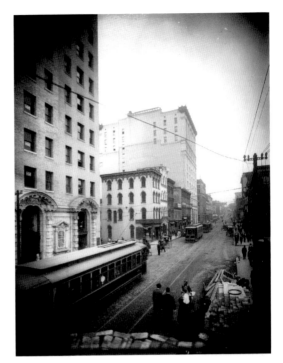

Life in the city. East Main between Ninth and Tenth Streets. The American National Bank Building at left is designed by Wyatt, Nolting and Charles K. Bryant & Associates, Architects, and completed in 1909. Construction work is underway on the post office expansion at right. The American Building, remodeled several times, today contains residences. *Courtesy of the Cook Collection, Valentine Richmond History Center.*

The *Times-Dispatch* with enthusiasm proclaims at 1909's outset that the problems involved with sudden growth are being met as they arise and that "larger sums of money than ever before in the government of the city have been provided from the current revenues and bond issues for carrying on of great public works from which the city of the future will reap the benefit."

Richmond is home to more than 100,000 people, served by thirty-three theatres and public auditoriums, four newspapers and several periodicals, one of which is published in German. Most of the saloons are on East Main Street between Fifteenth and Eighteenth Streets. Several also sit on the north side of Broad among a cluster of theatres and gaming arcades. Behind them are the majority black communities of Jackson Ward and Navy Hill. The combination of lurid entertainments and the potential for racial interaction makes north Broad known as the "wrong" side.

The proliferation of picture show houses is causing concern among parents and crowd control problems for police. Broad Street is lined with them, and they extend into Main and the working-class East End community of Fulton. They go by names like Colonial, Lubin, Bijou, Dixie, Gaiety, Majestic, Theato and Empire. In 1909, fourteen nickelodeons open in Richmond, including the Gem, Idle Hour, Orient and the Cozy Corner and on Hull Street in Manchester, Wonderland. The *Times-Dispatch* describes how waiting

congregations outside the picture shows require frustrated police officers to keep them in order and the sidewalks free for other pedestrians.

A movement among "progressive business men and citizens" works to make Richmond a great city, with the ultimate purpose of reaching 200,000 in population. The recent annexations provide room for factories, residences and parks. Property values are undergoing rapid advancement.

The iron and tobacco industries dominate the city's working life. Tobacco employs some four thousand unskilled wage earners—many of them black—in thirty plants. About six thousand laborers operate the renowned Tredegar Iron Works. Tredegar is Richmond's biggest employer, but not its single iron factory. By this time, though few Richmonders are aware, their city's edge in the production of iron is slipping away to Pittsburgh, Pennsylvania, and Birmingham, Alabama.

The Richmond branch of the American Locomotive Works is bustling and expanding, and soon counts more than three thousand men on its payroll. The Chamber of Commerce boasts that Richmond Cedar Works of Fulton, with twelve hundred workers, makes it the world's largest woodworking factory. The Cedar Works fashions objects ranging from barrels and crates to ice cream churns.

While Richmond is a United States port of entry able to collect customs duties, that status is undergoing a strong challenge from the deep-water port of Norfolk. Richmond routinely petitions the federal government for assistance in making the James River more accessible to oceangoing vessels. That aid is not forthcoming.

Railroads buttress Richmond's commercial advantages. By the early 1900s, six separate lines run sixteen thousand miles of track into interior markets. Richmond is the busiest regional transportation center between Baltimore and Atlanta.

The city is a thriving member of the sorority of comparable Southern cities. An average of sixteen thousand people live in each square mile. The 1910 census indicates that Atlanta, to which Richmond aspires, has just six thousand people per square mile, and New Orleans counts a mere two thousand in each square mile.

A statute enacted by the state legislature in 1904 and upheld by the courts in 1906 made annexation of adjacent county lands a prerogative of the city, provided just cause could be shown in a special annexation court. Between 1906 and 1914, Richmond annexes almost twenty-two square miles of territory that expands the city's size by about 400 percent. The city administration, eager to add square miles, is far less adept at weaving these new sections into the city's fabric. Richmond lags far behind on street paving, curbing and sewer installation within its old boundaries. Black communities are overlooked as a matter of routine.

Richmond lacks a master plan to unite these disparate communities. The city relies on the vagaries of the city engineer's office and the streetcar system that, while providing public transit, also propels the whims of developers. Streetcars are a marvel to many residents who have relied on horses or their feet to get from one quarter of the city to another. The roomy, open summer cars allow those courting to take rides to Westhampton Lake, Reservoir (Byrd) Park, Lakeside and enjoy the entertainments of Forest Hill Park. The rides are rolling social events, and the conductor meanders along the step that runs the length of the car, sharing amiable conversation with his charges.

"For the past year and more these suburbs have been rapidly growing and more and more people use the cars each day," Adon Yoder remarks about the trolley system in February 1911. "And yet the same schedule is maintained that was in force more than a year ago."

The citizens of Richmond's northwestern suburbs have for some time complained about the inadequacy of their car service, in particular during the morning and evening workday rushes. Barton Heights residents must stand up, Yoder describes, "sandwiched in a squirming mass of black and white, but when they get to 1st and Broad the cars are already crowded and they must either submit to another half mile of mashing or walk to their business." Yoder wonders why the traction company cannot do something to alleviate the discomfort of strap hangers from Barton Heights, Ginter Park and the Lakeside region.

Service did not improve fast enough to please Yoder, or others, in the East End, either. During the miserable hot summer of 1911, Yoder reports how on Saturday, July 4, a party wanting a return to the city on the Seven Pines Line tried to stop four different trolleys heading west. Yoder complains, "Each car was crowded with negroes and each motorman refused to stop for white passengers including two ladies, all of whom had to walk the two miles to Richmond."

The pedestrian's relationship with the streetcar is at times a dangerous one. An unnamed "old railroad official who has traveled all over the United States" declares in the *News Leader* of August 16, 1909, "Richmonders risk lives recklessly in front of moving cars in a way that often makes my heart almost stand still." He describes the apparent inability of Richmonders to stop and look both ways prior to crossing trolley tracks as "the worst in the country."

One such incident occurs around seven o'clock in the morning on March 18, 1909, when eleven-year-old Robert Hillsman Sahnow, of 1210 West Main Street, dashes into the street near Beech and Main. Differing accounts suggest that in avoiding pursuit by other young boys, he jumps onto the back of a passing wagon but, missing his handhold, falls backward into the path of an oncoming streetcar. The impact tosses him several feet. The boy gets carried unconscious to 1104 West Main Street, where he revives and is taken home.

"The City Will Lose Its Peculiar and Unique Attractiveness"

Richmond's eagerness to build new and get bigger, as trumpeted by the Chamber of Commerce, has little regard for the preservation of historic structures and sites. A July 12, 1909 *Times-Dispatch* editorial advocates vigilance in safeguarding Richmond's past. At issue are disputes between city council, the school board and the Association for the Preservation of Virginia Antiquities (APVA) about rescuing the John Marshall House from conversion into a heap of brick. The new, columned John Marshall High School, "a modern people's university" designed by Charles K. Bryant, is rising on Marshall Street between Eighth and Ninth Streets, adjacent to the former residence of the great United States Supreme Court chief justice.

"One historic edifice after another has been torn down in Richmond with small regard for its sentimental and historic value to the city," the writer observes. The Swan Tavern, where Aaron Burr stayed during his treason trial and where Poe came during his final visits to Richmond, was demolished for a theatre. The house where Confederate cavalry commander J.E.B. Stuart died gave way to modern residences.

The editorialist wonders aloud about how many Richmonders know the site of the Bell Tavern, which provided a social gathering place for Revolutionary War–era citizens and a recruitment site during the War of 1812. (The Bell gave way to the St. Charles Hotel, where slave auctions occurred. No mention is made of that history.) The location was wiped clear by the 1901 construction of Main Street Station.

"If this reckless destruction is continued," the editorial laments, "there will soon be few memorials of the city's past remaining."

The APVA's recent efforts marked the site of Revolutionary War–era lawyer and educator George Wythe's residence and installed a plaque to note where on Shockoe Hill once stood the New Academy, meeting place for the Virginia Convention of 1788 that ratified the United States Constitution. Patrick Henry, in his last major public address, argued for amending the Constitution with the Bill of Rights. The APVA in 1911 saves the Stone House on East Main Street, built in the mid-eighteenth century, and the oldest dwelling house in the city.

The editorial compares and contrasts how Europeans regard their buildings of antiquity, suggesting that a man in Weimar, Germany, would

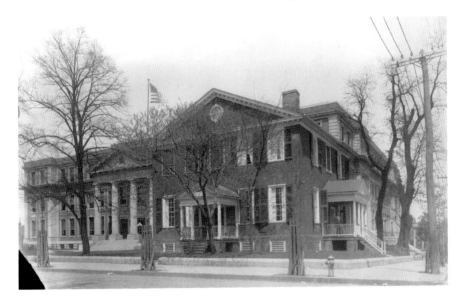

Schoolhouse block. The John Marshall House by the new John Marshall High School, around 1910, came from the insistence of reformers, and though sited near majority black neighborhoods, was white only. The residence built and lived in for more than thirty years by U.S. Supreme Court Justice John Marshall was saved from demolition by an array of preservationists. Few, if any, places affiliated with Richmond's black history were accorded such importance. *Courtesy of the Valentine Richmond History Center.*

put his life at risk if he caused damage to Goethe's house, and if the town council of Wittenberg should suggest slight alterations to the house of Protestant reformer Martin Luther, mobs would form. Like the older cities of foreign nations, Richmond attracts many tourists each year to see its places of interest.

The editorial summarizes, "But manifestly if our historic buildings are removed, and if our memorials of great men are torn down, the city will lose its peculiar and unique attractiveness." City council should appropriate whatever amount is needed to stabilize the Marshall House. "If the location of the building obscures the façade of the High School, so much the worse for the High School. But sentiment and reverence for the past, to say nothing of more practical considerations, demand that the old building be preserved as it was in the days of the great Chief Justice."

"Cool, Dry, Untainted…"

Richmonders receive hyperbolic encouragement from advertising to leave the central city for the suburbs. Realtors vie with persuasive superlatives to

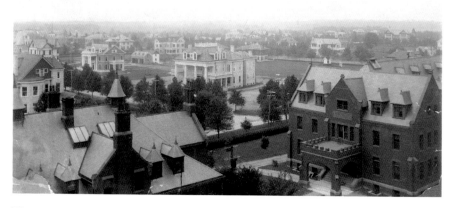

The new frontier. Ginter Park around 1910—a planned community of city mansions on Richmond's North Side, away from the hussle and hassle of the center city—is reached by a streetcar initially implemented just for the purpose of transporting residents back and forth. *Courtesy of the Valentine Richmond History Center.*

extol the advantages and amenities of these communities, most of which are designed as exclusively white, upper- and middle-class enclaves. Within the fine jingling descriptions of these communities is the implication that the older central city is, at best, lagging in the conveniences one should expect, and at worst, cramped and foul.

Woodland Heights, on the James River's south bank, boasts of free sewage and granolithic sidewalks. A resident will get "A Square Deal" and drink "Famous Chesterfield water" while enjoying the "Magnificent views of the city and river. Superb location but a few minutes' ride from the centre of the city; one fare to all point and a car every fifteen minutes."

The Plateau, located in the heart of the north Richmond community of Highland Park, is "80 feet above Broad and Fifth streets, where you will find cool, dry, untainted air. On your own lawns you may have flower beds and shrubs" and room to plant a garden to grow fresh vegetables for the family table. "Stop and Think: Of a suburb 12 minutes from Broad and Seventh Streets, with sewerage, sidewalks, beautiful shade trees, elegant homes, wide avenues, churches, school…and splendid trolley service, on terms to suit." Another Plateau advertisement asks if you would rather struggle amid the disagreeable conditions of a flat or apartment? "Are your children as brown and strong as your playmates were in the old days? Then don't you think it your duty to give them benefits of outdoor life, good air and sunshine?"

Fun and games. Idlewood Park, in the West End (about where the Round House in Byrd Park is now), is an entertainment venue created for the public reached by trolley into parts of town where new houses are under construction. Come dance with your sweetheart, see a movie and think about starting a family. *Courtesy of the Cook Collection, Valentine Richmond History Center.*

The North Side planned community of Ginter Park is opening new sections, and prospective residents are urged to take the quick and direct fifteen-minute car ride to experience the shady macadamized streets.

Lee Park is a blossoming West End community, bounded by Grove Avenue to the north, Kensington Avenue to the south and Roseneath Road and Tilden Street to the west and east. These are the newest properties around the city and they are already outpacing other neighborhoods with gas, water, electric lights, sewer mains and those granolithic sidewalks. "Beautiful shade trees adorn the lots—pure air, pure water and none of the noise and confusion...Lee Park adjoins Lee Annex, and in two or three years (the city is now growing faster) Lee Park property will sell higher than Lee Annex does now. Be one of the dividend reapers by becoming an early buyer of one or more lots."

Yoder, in *The Idea*, holds a contrary view of Lee Park—that of a real estate deal at the expense of city tax payers. In the September 18, 1909

Idea, the writer points out that the realty company of Green & Redd is selling these properties and that Green is a city councilman. Yoder calls this a scheme, "with acres and acres of unimproved open fields between it and the city proper."

Taxpayer funds are being used because, Yoder says, Green and Councilman Pollard, of the realty firm Pollard & Bagby, are directing the street committee to serve their private business interests. The committee approved the expenditure of $3,050 on the flimsy pretext that if they did not open the streets now they might have to pay more later and run the risk of damaging houses already in place.

Yoder summarizes, "Now the point is this: that favored interests can get their property improved, with city money, way out in the country, while unfavored poor people, in almost the heart of the city, must wade in and out of dust for lack of a few hundred dollars of necessary and long-overdue improvements and pay high taxes for the benefit of country land booms."

The Richmond Board of Aldermen concurs with the Common Council on April 13, 1909, and adopts an ordinance forming a committee to speed the consolidation with Manchester. The decision, five years in the offing, comes over the objections of Council President Robert Whittet Jr., head of a large printing concern and staunch proponent of city improvements. He opposes council forming yet another committee to study future annexations. "The appointment of such a committee," Whittet says, "will only result in the creation of a false public sentiment and pressure will be brought here… to force us to adopt matters which the public do not really want." Whittet wants the city first to extend proper services to the newest parts, improve parks and playgrounds and construct a city library.

Whittet is a minority moderating voice. Annexation enthusiasts want Richmond to be bigger, if not better, than ever. A sense of urgency, as though Richmond is on the verge of losing a race, crackles in accounts of civic and business meetings. The newspapers at the beginning of each year present long recitations of Richmond's achievements in factories built or stores expanded; hotels added onto; the total manufacture of hats, shoes and locomotives; and the profits of companies and holdings of banks. Every dollar earned, each rivet driven in, brings Richmond closer to an apprehended illustrious tomorrow.

Not every Richmonder feels the rush to grow is such a good idea, in particular those who are in the recently annexed sections. On September 15, 1909, Charles H. Bull of 3224 West Cary Street, "a constant reader and admirer" of *The Idea* and Adon Yoder, writes of his profound dissatisfaction with the city engineer, whose recent plan is for a roadway from Gamble's Hill Park to Byrd Park. Bull writes, "There are streets in the West End of the

Fountain of youth destroyed. The Manchester Equestrian Fountain at Hull Street and Coweardin Avenue, adorned by a figure of Hebe, the Greek goddess of youth, carrying a jar in her right hand and holding out a bowl in her left. The landmark provides refreshment for both man and beast until it is considered a hindrance to automobiles and scrapped. *Courtesy of the Cook Collection, Valentine Richmond History Center.*

city, annexed territory, that are in horrible condition. The tax payers have to keep their windows down day and night to keep dirt out of their homes; they cannot sit on their porches on account of dust kicked up by passing automobiles. Then we have no sewerage, water, gas or electric lights, nor any other improvement whatever."

Bull describes how after a short rain the streets turn to mud. If the city engineer wants to prove his ability, he should purchase an extra hundred mules and carts and put several hundred idle men to work grading the streets and installing curbs, gutters and lights. Bull concludes, "Then when these necessities are done it will be time enough to build a driveway and annex Manchester."

Another correspondent to *The Idea* complains that after the city spent $40,000 to put a street through the West End's Sheppard property, no improvements followed. The writer explained,

> *The people from the Boulevard on Cary Street to the county line have no light at night and no sidewalk and are always in danger of breaking their limbs slipping in the mud in wet weather. Not over two weeks ago a lady was chased from the Boulevard and Cary Street to Mrs. Leibs grocery store*

by a negro. It is really dangerous for our wives to go out of their homes at night in this wilderness of darkness and still with all this our city wants to take in Manchester to help improve that poor city...I would respectfully invite the Manchester Committee to look over this territory before they jump into the fire.

Yoder opposes the proposed Manchester merger as nothing more than a "big land boom of the Bryan boys who own the *Times-Dispatch* and control the Woodland Heights Land Co., which desires to have Manchester annexed so as to help sell their land. Manchester has nothing to gain and all to lose." Yoder's last word on the subject for that issue is, "Do not this foolish, unwise thing lest in coming years you be cursed by God and posterity."

One of Manchester's prime citizens and former postmaster Henry Clay Beattie Sr. has a good retail commercial trade established. The sturdiness and prosperity of his enterprise is memorialized by a row of storefront buildings in the 1100 block of Hull Street that bear the inscription incised in stone, "The Beattie Block."

"A Crazy Thing"

Despite Beattie's professional successes, these years nevertheless offer their own tribulations. Between 1898 and 1901, his twin daughters die and then his wife, followed by his sister. His hair turns white. Beattie's son, Henry Jr., in line to inherit the business, clerks at the store and receives no salary, but a stipend goes to him and his brother Douglas. Henry Jr. consults with his father about buying a Buick touring car, but the senior Beattie never questions how his boys spend their allowance. He tries impressing upon them the importance of upright living and of always remembering that their name means something in this town. In old Manchester, a man's character is his credential.

Henry Jr. is a guitar-playing, motorcar-driving ragtime Lothario. In August 1907, while driving his Buick down Broad Street, he caught the eye of thirteen-year-old Beulah Binford. She liked cars and how Beattie looked driving one, and he gave her a joyride. Friends warned him about Binford. Despite her young age, she was, as the saying went, "a woman of the town" and had already received treatment for a venereal disease by a West Grace Street doctor. Beattie rented a room for them at May Stuart's assignation house in Shockoe, where they met often during several months. When Binford and her mother Jessie moved to Washington, D.C., Beattie paid for her schooling at St. Mary's Academy in Alexandria.

The woman in the case. The
flibbertigibbet Beulah Binford,
whose on-and-off affair with
Henry Clay Beattie Jr. has fatal
consequences. *Author's collection.*

But Binford couldn't be kept within the school's confines. By the spring of
1909, she is back in Richmond and again running around with boys. At age
sixteen, she is pregnant with Henry Beattie Jr.'s child. Jessie Binford writes to
Beattie and demands money for paternity. Laywers sort out the details, and
Beulah is sent to North Carolina with a sum of money to have the child and
to get out of Beattie's life.

The Binfords make a temporary return to Richmond. When Beulah gives
birth to a boy on July 25, she names him Henry Clay Beattie and places the
infant in Jessie Binford's care. Beulah then runs off to Danville in pursuit of
a baseball player.

Peter N. and Mollie Trout of 403 West Marshall Street are seeking a child
for adoption, though they are already parents of three children, two sons and
a daughter. Peter Trout is an automobile mechanic. Their daughter Madeline
hears from their washerwoman about the child in the care of Jessie Binford.
Mollie Trout goes to see her and later expresses her shock by the poor conditions
and the child's bad health. Trout thought better of taking the baby in.

Jessie Binford calls Henry Beattie Jr. to ask for help in the matter. He visits
Mrs. Trout and, while standing outside her door, says, "I am here on ticklish
business and I would prefer to speak with you inside."

When inside, Beattie asks if Mrs. Trout has seen the child, and she replies that she had, but that the baby is too sickly to adopt. He explains how "they" got him mixed up in the business because he is "soft." Mrs. Trout responds that the child resembles him too much for him not to be the father. He then makes elaborate promises for assisting in the child's support. His earnestness seems genuine enough to Mrs. Trout that, despite her misgivings about the child's health, she relents to his persuasion. Madeline fetches the child with a baby carriage, despite a heavy snowstorm, and the infant is swaddled in blankets. The boy is named Henry C. Trout.

Beattie touches the child but once while the Trouts have him. He measures a finger for a diamond ring he promises to give. The little one does not thrive and requires constant care. Beattie ignores calls about medical bills until at last he answers Mrs. Trout, snapping about the child, "Now you have adopted it, and it's yours. I've cut it out."

Beattie has moved on; or rather, moved back. He brags to acquaintance W.E. Gill, of the Gill Brothers coal firm, that he's gotten himself a pretty trick of a girl named Beulah Binford. Henry declares that she won't let him alone and that he likes her a lot. "It's a crazy thing," he says to Gill. "And I don't want to keep this up with her. It might make trouble."

The baby, Henry C. Trout, contracts cholera and dies on July 9, 1910, at age eleven months and sixteen days. A funeral home manager tracks down Beattie and brings him to the Trouts' house. Mr. Haight, of the Richmond Burial Company, recalls Beattie saying, "This is one of the grandest things that ever happened."

Beattie arranges for the funeral and pays about twenty-four dollars for the tiny casket. The child is buried on July 11 at Shockoe Cemetery. The papers report that this is the city's first funeral procession consisting of all motorcars. There is no hearse due to the small coffin. The baby's burial is listed as "C.B."

In the meantime, Beattie proposes marriage to a lifelong acquaintance, twenty-one-year-old Louise Wellford Owen, a member of a prominent Manchester family. Her parents, Robert Vernon and Etta, and most of her five brothers had moved to Dover, Delaware. The wedding is scheduled for August 24, 1910.

Just before the wedding, Beattie pays a call to his future mother-in-law. He expresses some hesitancy about the upcoming nuptials. Etta Owen, in response, points to a room full of wedding presents and demands that he make a decision. Henry Beattie Jr., in a strange monologue, acknowledges that he's been a pretty bad sort of chap and that the planned wedding has brought happiness to his old father. Maybe, Beattie says, marriage will change him.

The wedding commences at 7:00 p.m. on August 24, 1910, in Manchester's Central Methodist Church, officiated by Reverend H.C. Pfeiffer. Louise wears a gown of white messaline embroidered in pearl. The newlyweds settle in at the Beattie family manse at 1529 Porter Street.

Louise is adorable, poised and cultured. She is aware of her husband's past and his mercurial temperament. She confides to a friend that she allows him to do almost anything he wants, in the hope that he will not tire of her.

Oxford-on-the-James

Richmond College, like the city nearby, is making plans for great improvements. The institution is one of the few public places west of Lombardy Street. The campus, composed of an assortment of buildings built for the college or pressed into service, occupies a rectangle formed by Franklin, Broad, Lombardy and Ryland Streets. The houses of professors line the western, Lombardy side; a dormitory faces north, along unpaved Broad.

A 1906 conference of prominent Richmonders sought the establishment of a University of Richmond, composed of the Medical College of Virginia and the (rival) University College of Medicine, the Mechanics Institute,

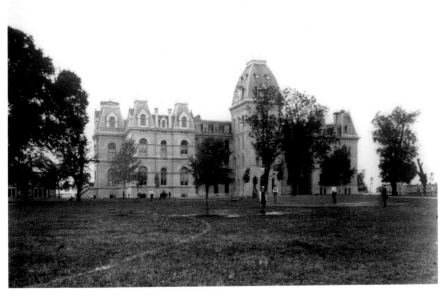

Tennis anyone? Athletic-minded students on the lawn of the Main Hall. The north wing burns on Christmas Day 1910. *Courtesy of the Valentine Richmond History Center.*

Richmond College, the Women's College, Randolph-Macon College in Ashland, Union Seminary of Northside's Ginter Park and Hampden-Sydney College in Farmville, Virginia. These schools would be brought together and create an Oxford-on-the James. The concept didn't take root, but the need for enlarging the school was made clear.

Standard Oil founder John D. Rockefeller in 1908 pledged $150,000 to Richmond College if the institution raised $100,000. The college's president, Dr. Frederic Boatwright, could announce by year's end the promises of $108,900.

The 1909 enrollment of 325 students is the largest in the college's history. Some of the young scholars must seek accommodations in the city because no room is available on campus. Boatwright and his board contemplate lakeside lands in Westhampton, on the grounds of a defunct amusement park, where the streetcar now runs.

At Christmastime 1910, most of the college's three hundred students are away, but in the pre-dawn hours of Christmas Day, thirteen people are residing in various rooms among the upper stories of the Main Building's north wing. Members of four fraternities who have quarters on the fourth floor hold holiday "splashes" and give receptions in their rooms that last well into the night. A possible lighted cigarette or cigar stump continues smoldering after the jollification has ended. Steam heat from a central plant warms the building on this cold night.

At about 4:29 a.m., three ministerial students return to their rooms: West Virginian W.M. Hall, George W. Cauthorn of Appomattox and Washingtonian J.A. George. They see fire and smell smoke, and their cries alert someone on Broad Street, who dashes a block to No. 10 Engine House at 1609 (today's Firehouse Theater). Captain Thomas H. Davis pulls the box for assistance, and when he arrives at the college he orders a second alarm.

Three white-robed figures are descending the fire escape, which was installed not long ago and was thought to be a disfigurement to the building. Other students, dressed in haste or not at all, shiver in the freezing air while neighbors and professors gather around the now blazing wing.

The conflagration summons ten of the city's twelve engines and, because of the fire chief's expectation of holiday fireworks, a general alarm is not sounded. In third-floor room numbers fifty-two and fifty-three, the announcement comes with banging on the doors and shouts of, "Fire! Fire!" by A.R. Hawkins. He drags Walter Beverly from bed, and the commotion awakens his roommate, Stillwell, and their guest, Rowland. Beverly tries to pull on clothes, until Stillwell, "a poet of impulsive temperament," yells at Beverly "in blank verse" to just get out of the building. Beverly takes his trunk but does not think to put anything inside. A red, burning eye of fire in the coin

of walls and ceilings above the radiator tells the students there is no time to delay to prevent their cremation while alive. They follow Rowland out.

A large and enthusiastic audience gathers on the campus as industrious fire engines snort around Ryland Hall. The heavy ladder truck from Station 10 gets mired several times while trying to turn its ladder into a water tower. Grim firemen begin the battle of fire and water. Beverly soon sees Rowland, moody and silent as the typewriter he is carrying from the water and smoke of the president's office. A tower topples and falls. The sad, sick-faced moon looks down on a scene "grand, gloomy, and peculiar."

Dr. Boatwright runs into the administrative offices on the north wing's first floor to retrieve faculty and alumni documents, but cannot bring out his letter files. Fire officials restrain the college president from entering again, for fear of the roof collapsing.

Flames make a rapid run under the roof and threaten the entire building. Fire Chief Joynes orders the removal of all valuables from the south wing. Here, Boatwright uses an axe to smash the library's door and leads a charge of volunteers to remove the fifteen thousand volumes, portraits and statuary.

Brought from the building, too, is the three-thousand-year-old mummy of Egyptian princess Thi-Ammon-Net. During the course of the fire, she rests upon a bed of books, contemplated by a bust of Cicero and a plaster reproduction of the Venus de Milo. Around dawn, students bear the princess's mortal remains to the president's nearby Lombardy Street house, where the mummy is slid underneath the Boatwright family's Christmas tree with tender care.

The fire does not consume more of Ryland Hall, though the north wing is destroyed and residents there lose everything. A collection begins at once to replace their materials. The university is insured and could rebuild, but the college is planning for a Westhampton campus within three years. The fire may hasten the move.

Among the fortunate occurrences this night is that the preliminary plans for several of the new buildings from the architectural firm of Cram, Goodhue & Ferguson came to the office that day, but the express man mistook them for Christmas presents and delivered them instead to Boatwright's Lombardy Street house. Thus, the plans are spared the fate of several preliminary drawings. Not so the Greek societies that lost valuable furniture and "collections which were highly prized," as the *Times-Dispatch* described.

Firefighters battle the blaze most of the morning. Ice covers them from head to foot. Neighbors come by with steaming pots of coffee, and more than a few residents bring bowls of eggnog to bolster morale. The fire is out by eleven o'clock on Christmas morning. Thousands of the curious wander by

the campus, and among the students, rumor spreads that an overturned lamp was the cause. All agree, however, that no campus in the world experienced a more glorious holiday bonfire and that no Egyptian princess had received a more imposing or expensive funeral.

Boatwright praises the firefighters who combated the fire in adverse circumstances, and in fine spirit, and prevented the destruction of the entire building. He contributes $100 to the Firemen's Relief Fund. The finance committee notifies all students that the college will reopen as scheduled on January 3, 1911.

"Financial Loss and Odium"

On the boulevard is Lee Camp Number One, a home for destitute Confederate veterans (the future site of the Virginia Museum of Fine Arts). The Home for Incurables is past Robinson near Broad. Closer in, about where Boulevard and Broad intersect, on the northwestern side, lay the state fairgrounds and the Old Hermitage Club. The club's busy attractions include a nine-hole golf course and tennis courts. The younger set attends the dances each week, as well as the big Christmas party.

The Old Hermitage's fifty-seven acres are next to the Stephen Putney Shoe Company, manufacturers of the Battle-Axe boot. One of the firm's executives is Lewis Blair. Blair is unusual among Richmond's upper crust in that he isn't a member of a fashionable men's club like the Westmoreland or the Commonwealth; he has no interest in golf or gambling. Blair doesn't drink, smoke or attend church, but busies himself with his family, collecting art and antiques, reading and writing.

Blair served in the Confederate army, and using his good family name could have pulled a commission. But he started and finished the war as a private. He got into fights and spent time in stockades. A case of typhoid kept him from active duty until war's end. He considered "the more than three years wasted in the vain effort to maintain that most monstrous institution, African slavery, the real, tho' States' Rights were the ostensible, cause of the War."

In the ruined Richmond of 1865, his mother gave him twenty dollars, which he used to start a store and auction business in Amelia County. His 1867 union with Alice Wayles Harrison resulted in six boys and a girl. He got into the Richmond grocery trade, profited by real estate investments and by 1878 joined the Putney Company.

His first book, in 1886, condemned high protective tariffs. *Unwise Laws: A Consideration of the Operations of a Protective Tariff Upon Industry, Commerce and*

Society was reviewed with general favor. Blair's observations came during a crucial juncture in Virginia's sociopolitical history. The Readjuster Party, under former Confederate general and railroad executive William Mahone, dominated the state during 1879–83. The Readjusters enacted wide-ranging reforms, in particular among schools and prisons, while seeking an alliance between the black and white working classes. Then the 1883 U.S. Supreme Court declared the 1875 Civil Rights Act unconstitutional, while the "Lost Cause" movement gained powerful momentum in Richmond to memorialize "the glorious dead" with pyramids, plaques and statues.

In the summer of 1887, Blair submitted to the New York *Independent* a series of articles about his socioeconomic views. Apart from a few urban centers, Blair showed that the South was stagnating, not prospering, and was little improved from its position at the outbreak of the Civil War.

He deemed it "the height of folly" to insist upon segregated schools that couldn't be well maintained. The split social order wasted money and bequeathed to the South a generation of ill-educated and therefore useless workers and voters, both black and white. He stated that blacks should be "inspired with self-respect, their hope must be stimulated and their intelligence cultivated."

The book version of the articles was published in 1889 as *The Prosperity of the South Dependent upon the Elevation of the Negro*. Blair later wrote, "It brought me both [financial] loss and odium at least at home in Virginia, tho' it spread my name favorably from Maine to California."

He met his words with deeds. The Richmond School Board in 1893 purchased sets of the *Encyclopedia Britannica* for the white schools. Blair sent the *Britannica* to black schools as Christmas presents. Two years later, Blair gave $100 to John Mitchell Jr., the *Richmond Planet*'s crusading editor, to assist in the defense fund of an illiterate black laborer named Samuel Brown, who had been accused of crimes he didn't commit. Blair urged Mitchell to get the *Planet* read by more white people.

Blair's wife died in February 1894. He kept writing letters to the editor and handwrote a 357-page autobiography that emphasized his progressive philosophy. In 1898, however, he married his secretary, Martha Redd Field, who was less than half his age. His liberal views were anathema to her. They had four daughters. Blair proceeded to alter and retract all previous public statements and writings.

Between 1898 and 1915, Blair composes a 270-page untitled manuscript in which he endorses making the Negro a "ward of the nation" and repealing civil rights for blacks. A 349-page, typed rewrite of his autobiography bears no resemblance to the first. He explains in a letter that his previous anti-segregationist philosophy was extrapolated from faulty premises.

In 1907, on the intersection of Davis and Monument Avenues, the imposing Jefferson Davis Memorial was unveiled. Prominent is the figure of Confederate President Davis, sculpted by Edward Virginius Valentine. Valentine is Virginia's and Richmond's aesthetic conscience, whose good fortune allowed him to sit out the war in Berlin while he studied art. In 1913, Blair builds a columned Colonial Revival mansion at 2327 Monument Avenue, within sight of the monument. Davis's right hand is outstretched in supplication toward Blair's house, as though receiving him into the Lost Cause. Blair dies in 1916.

"Legacy of Treason and Blood"

New houses march westward from Lombardy Street throughout the first decade of the twentieth century in what is Richmond's West End. The profound financial and real estate depression of the mid-1890s is past, and middle- and upper-class families are on the move. The 1906 annexation from Henrico County of almost five square miles brought the limits of the city from Lombardy Street south of Grove Avenue and from the Boulevard north of Grove to near Roseneath Road.

The high point years of residential construction for east–west streets between Meadow and Robinson are 1909–11, with 485 houses. Hanover and Stuart Avenues, possessing just three houses between them in 1901, number 259 by 1911. Park Avenue and Grace Street now resemble long pantry halls lined by tall Edwardian sideboards.

The West End is delineated and defined during the first decade of the twentieth century by Monument Avenue, which becomes the preeminent Richmond address. The urbane boulevard began in the mind of Colonel Otway Slaughter Allen, a Confederate veteran and owner, along with his three sisters and their fifty-eight inherited acres along Richmond's western side. Since the 1870 death of Robert E. Lee, a movement among Confederate women and another of veterans had sought to honor Lee's memory somewhere in Richmond. The two groups squabbled about the memorial's location, its size and fundraising until they were fused together in 1886 by Lee's nephew, Virginia Governor Fitzhugh Lee. He became the head of the new Lee Monument Association. The governor was a friend of Allen, who was also a Richmond alderman.

Lee could see considerable tax advantages to annexing the Allen tract and developing, as Allen thought, a grand urban boulevard opened by a circle in which a Lee Monument could stand. Allen hired a consulting architect whose train of names resembled an architectural firm: Collinson Pierrepont Edwards Burgwyn. His solid credentials included birth on a North Carolina

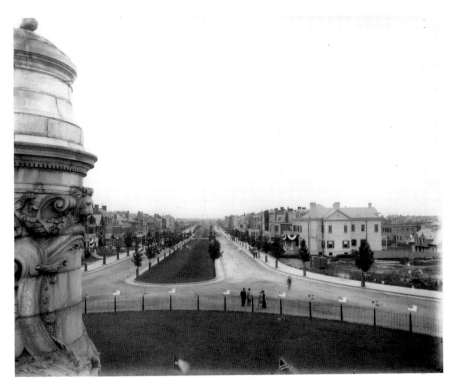

All for Dixie. Monument Avenue looking west from the Lee Monument, on Confederate Memorial Day. *Courtesy of the Cook Collection, Valentine Richmond History Center.*

plantation, a boyhood in Richmond, Harvard and engineering school degrees, a return to Richmond and assistance on the construction of Richmond's symphonic municipal declaration, city hall.

Burgwyn, in 1887, created a vision for the entire Allen tract, with cross-axial avenues and a center circle for the placement of a Lee memorial. The proposed tree-lined avenue connected to Franklin Street, at the eastern end of which was the Virginia State Capitol, with Thomas Crawford's equestrian George Washington before the capitol and, inside, Houdon's full-length from-life Washington. This Lee Monument would pay tribute to a man thought by his admirers as an equal of the nation's founder.

Though many Richmonders were intrigued by this proposal, groups throughout the South expressed annoyance that the money they contributed to building a Lee Monument would instead go toward a Richmond real estate scheme. Black members of city council refused to appropriate funds for either the 1887 cornerstone laying or the final unveiling.

John Mitchell Jr., then a Jackson Ward alderman, had plenty to say in some characteristic blistering *Planet* editorials. He wrote, "The men who

talk most about the valor of LEE, and the blood of the brave Confederate dead are those who never melt powder or engaged in the battle. Most of them were at a table, either on top or under it when the war was going on." The recent proliferation of Lost Cause adornments throughout Richmond angered Mitchell, and he insisted that a Lee statue would bequeath to the future a "legacy of treason and blood." This was a weight that Richmond would carry for a long time. In a further wrinkle, African American workmen helped build the pedestal and place the statue upon the base. Mitchell suggested that the black men who helped put up the statue should, if that time came, be present to take it down.

None of those objections mattered on May 30, 1890, when Marius Jean-Antonin Mercié's Lee statue was unveiled for a concourse of spectators that may have reached 150,000 people—many more than Lee ever commanded in the Army of Northern Virginia.

That October, Richmond blacks organized their Emancipation Day event. They sought to capture for themselves the pomp and excitement of the Lee Monument spectacle. Mitchell, as the chief marshal, resplendent in a black suit, cream-colored sash and a light-colored slouch hat, rode upon an iron gray horse. Following him for two miles through the middle of Richmond came black militia organizations and members of more than forty fraternal orders. *Washington Bee* writer W. Calvin Chase, covering the event for his paper, observed with certain pride and awe, "Mr. Mitchell looked as if he was governor of Virginia."

A Frenchman memorialized Lee, but the subject of Isle of Guernsey–born New Yorker Frederick Moynihan, at the joining of Franklin and Monument at Lombardy Street, was the flamboyant cavalry commander General J.E.B. Stuart. The traditional controversy about Monument Avenue statues attended this one, from location to the size of the horse relative to Stuart to Moynihan cribbing from English colleague John Foley's equestrian of General Sir James Outram in Calcutta, India. Ceremony overcame all when the Stuart unveiling inaugurated a weeklong Confederate reunion.

Though ostensible celebrations of a heroic—and, by now, almost mythic—past, a funereal quality accompanied the massive occasions. These commemorations honored dead men and a lost war, and those blunt facts remained unaltered no matter how many thousands paraded or chorused "Dixie."

Four days after the Stuart unveiling, another paroxysm of Confederate triumph and tragedy occurred with the public presentation of the Jefferson Davis Monument. The crated bronze statue of Davis, cast by the Gorham Company of Providence, Rhode Island, got hauled up Franklin Street by

three thousand schoolchildren. Thousands of spectators witnessed a two-hour march of twelve hundred Confederate veterans and their sons.

Virginia's chief architect, William Churchill Noland, designed the curved, eastward-facing monument in a way that looks as though it is an emphatic closing statement—the grand avenue ends here. Although, since large property holders continue subdividing their lands and more statues are in the offing, the grand boulevard does not terminate at this roundabout.

The Davis Monument is bold and impressive. Davis stands before a protective screen of thirteen Doric columns representing the Confederate states and Kentucky and Missouri, which contributed soldiers but did not secede. Summations of Confederate feats, quotes from Davis's oratory and Latin verities are incised into the stone and on the bands girding the sixty-foot Doric column that is the monument's most dominant feature.

Atop the column stands a robed, classical female figure. Neighborhood wags dub her "Miss Confederacy." At her left side is a shield embossed by the Confederate Stars and Bars. Her name is Vindicatrix. She rises above the world's ambiguities and nuances and represents unapproachable ideals. She holds up her right index finger in an attitude that conveys reproach, hushing dissenting opinions about the war. She also indicates that attention must be paid: this is our statement on the memory of this conflict. And there is an element, too, of her determining a favorable change of direction in the winds of history.

"The Most Exciting, the Liveliest, the Most Human Place in Richmond"

At the center of downtown is the Sixth Street greens and meat market, which, during 1909, is undergoing refurbishment as part of the long-awaited Blues Armory construction. The castellated, fortress-like structure, designed by the Washington, D.C. architects of Averill & Hall, symbolizes protection from enemies without, but also perceived dangers from within, such as the transit workers strike of 1904 that led to bloodshed and, a year later, the boycott of the segregated streetcars promulgated by *Richmond Planet* editor John Mitchell Jr.

The long, brick meat market, its pilasters adorned by some forty terra cotta–painted concrete bulls' heads, stands along Sixth and Marshall Streets. Writer Marie-Louise Pinckney years later described the marketplace's bustling quality:

Mister, flower for the missus? A 1920s image conveys the character of the Sixth Street Market flower vendors. *Courtesy of the Cook Collection, Valentine Richmond History Center.*

Few Richmonders escaped Sixth and Marshall: The housewife shopped, the farmer sold, the soldier drilled and in time the police locked up across the street. It was a wonderful place, full of smells, sounds, color and motion, but most of all, it was full of people. Mixed in with the Hanover tomatoes and Chincoteague oysters were big and little people, black and white, rich and poor. For some the Market was the city-man's link with the country, for some it was a pageant of flowers and fruit, and for a few like me, it was…the most exciting, the liveliest, the most human place in Richmond.

The flower vendors, who are for the most part elder black women, sit scrunched on boxes or short leg stools on a snow-laden Saturday prior to a holiday, clustered tight around an old lard tin or iron kettle, from which heat radiates from whatever fuel can be found. The women often smoke short-stem corncob pipes, and the curl of smoke indicates that the vendor is in business. The women wrap their legs in old bed quilts and horse blankets, while they also wear all the clothes they may possess, including men's coats and vests. A battered felt tops the ensemble or straw hat, from underneath which dangle pigtails decorated by red or white braids.

Near the market are commercial establishments whose names will endure in Richmond's consciousness after some of the businesses are long gone.

On Broad at Fourth are C.M. Steiff Musical Instruments and Hofheimer Brothers Shoes. The next block is door-to-door dry goods stores: Kaufman & Co.; F.W. Woolworth & Co.; and Fourquerean, Temple & Co. Clustered along Broad's south side are tobacconist Clifford Weil and C.G. Jurgens Furniture—perhaps the inspiration for fabulist James Branch Cabell naming the protagonist of his future infamous novel, *Jurgen*. Meyer Greentree's Men's Furnishing Store operates on the southeast corner of Broad at Sixth, and in this block are the Richmond News Company and, on the north side, the Valentine Auction Company.

Richmond's retail colossi stand next to each other: Thalhimer's at the southeast corner of Broad and Sixth, and then Miller & Rhoads. Between Broad and Eighth are H.W. Rountree & Bros. Trunk and Bag Co., Jacobs & Levy Men's Furnishings and Sydnor & Hundley furniture. Across the street—on the "bad" side—is the popular Sparks & Black Saloon.

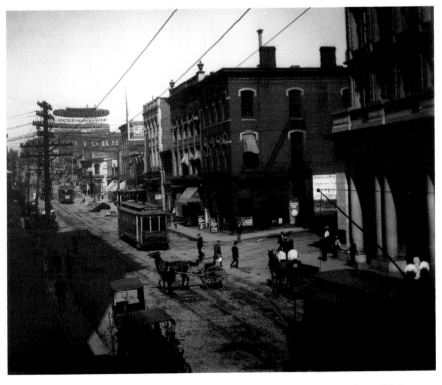

View of bustling East Main from Twelfth. A banner for the 1910 Virginia State Fair hangs across Main and mid-distance, at right, a sign for Stumpf's restaurant. *Courtesy of the Valentine Richmond History Center.*

Freshest fare in town. Frank T. Anthony, with Albert G. Anthony, owner of the renowned
Commercial Café, 912 East Main Street, circa 1900. Prior to the commonplace
convenience of the automobile, businessmen stay downtown for extended lunches or
take the streetcar home for lunch and domestic rejuvenation. *Courtesy of the Cook Collection,
Valentine Richmond History Center.*

"Where Is Mr. Kain's Saloon?"

The average male office worker on Main Street takes a two-hour lunch. The
midday mealtime provides a miniature vacation. If they are members of one
of the clubs like the Westmoreland or Commonwealth, they may take their
lunch there. Those who are able take the trolley home for their meal and
then a nap, or whatever else they prefer. They run errands, meet a friend for
a julep or enjoy a restaurant lunch, with time left over for coffee and cigars.

Its proximity to Capitol Square and the financial center makes the bar
in William Rueger's Hotel a popular place for the city's deal makers. This
watering hole, established at the southeast corner of Bank and Ninth Streets,
is resplendent with dark carved wood, mirrors and globe lights of. One enters
the bar from the Bank Street side, and two commercial buildings on Ninth
Street's east side have been fitted out with comfortable dining rooms. Patrons
collect at the long mahogany bar, where bartenders serve drinks, oysters on
the half shell and other seafood.

E.A. Stumpf's Café is operated in the new hotel at the northwest corner of Main and Eighth Streets, built to seven stories—impressive for 1909 Richmond—and designed by busy downtown Richmond architect Carl Ruehrmund, who a couple of years earlier created the sophisticated, six-story Shenandoah apartment building at Allen and Monument Avenues. Stumpf's is a favorite lodging for drummers, or traveling salesmen. The Eighth Street entrance to Stumpf's bar is presided over by a "well-known and popular man of color," known only as Chris.

Also patronized by the business class of downtown are G.E. DeLarue's at 910 East Main and the next-door Commercial European Hotel and Café.

Down in the village of Fulton, on the other side of the tracks to the east of town, Irish immigrant John Francis O'Grady runs his saloon on the now-vanished Louisiana Street. It could be a rough neighborhood, with fights sometimes involving chickens or dogs. O'Grady's ebullient son John became known as "Richmond's Irishman." In 1911, he will start leading a one-man St. Patrick's Day parade from Church Hill throughout town, accompanied by ducks, pigs, foxes, goats, skunks and, on occasion, even snakes.

Not every saloon grabs attention. James Kain's establishment at 19 West Broad is "a strictly one-man outfit with a full stop at seven p.m." located between the Cohen and Faulkner & Warriner dry goods stores. During a review of bar licenses, Judge Samuel B. Witt summons E.T. Faulkner to the hearing to ask whether Kain's place is objectionable. Faulkner, without any noted irony, replies, "Where is Mr. Kain's saloon?"

The roster of saloonkeepers has a poetic, even operatic quality. Their ranks include Louis Baldacci and Agostino Gillio, proprietors at 312 North Seventh; Joseph Carnicelli, 128 West Broad; Joseph Cartopassi, 1309 Hull between Thirteenth and Fourteenth Streets of Manchester; and Andro Donati, 1716–1718 East Franklin.

Raphael Francione's place is among a cluster of saloons in the 900 block of East Broad. Francione's attracts Yoder's attention in June 1910 after *The Idea* receives condemnation by officials because of detailing the conditions of the Shockoe Valley red-light district. Yoder wonders why the police are not as concerned about the two large "obscene pictures" in Francione's. One, ten feet by five feet, shows a nude woman holding a large snake in her arms and entwined about her body. The other, about four feet by eight feet, features a woman in a gauzy veil reclining on a couch.

The Murphy's Hotel bar at Broad and Eighth Streets brags of the longest brass rail in town. Murphy's serves as the informal headquarters of Virginia politics and the owners are the most ardent supporters of the University of Virginia football team.

Young lawyer John Cutchins, during the summers of this time, combines the pleasure of an evening out and the commute each day. Cutchins and good friend John H. Guy catch the five o'clock Accommodation Train on the James River Division of the Chesapeake & Ohio Railroad at the Main Street Station, along with many others who come up to town from deep in the counties.

Cutchins and Guy disembark at Westham Station, proceed to the riverbank with their "supplies and other purchases" and retrieve a rowboat from under the trees. Together they row to Gray's log bungalow high above the James River, located off what becomes known as Cherokee Road. No bridge yet unites the two banks of the river this far west. The next morning, the two take the skiff across to the other side and catch the 8:15 a.m. train for Richmond. They are refreshed and ready for business in their Mutual Building offices at 9:00 a.m. The trip both ways is an enjoyable social gathering for many friends who are commuting to places in the country away from city heat.

"Old Fulcher and Old Bumgardner's"

Richmond's central business district is transitioning from the nineteenth-century quality, when small businesses stood next to residences and lodging houses, into one dominated by high-rise offices made possible by structural

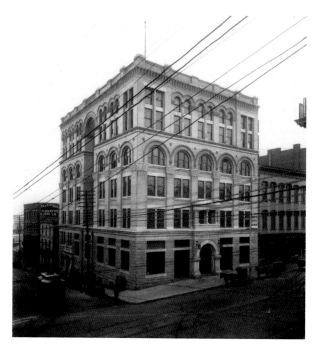

Chamber of Commerce building, southwest corner of Ninth and Main Streets, replaced by First & Merchants National Bank in 1913. The arch and columns were incorporated into the Zincke Building on Governor Street, east of Capitol Square. *Courtesy of the Cook Collection, Valentine Richmond History Center.*

steel, reinforced concrete and Chamber of Commerce enthusiasts eager to match Richmond's skyline with Atlanta's. The city's primary life is carried on within the commerce of Broad, the finance and professional offices of Main and the government center around Capitol Square.

Along the brow of the Gamble's Hill is a park where, in 1907, to commemorate Virginia's 300th anniversary, the APVA placed a metal cross upon piled river stones to mark the supposed site where Christopher Newport proclaimed the land for England in 1607. The view from Gamble's couldn't quite be called scenic by the conservationist standards of later decades; though the rocks and rapids of the James River compose part of the southern panorama, so do ironworks, mills and railroad yards. To the immediate west looms the state penitentiary. The park is nonetheless frequented by later afternoon promenades.

Grace Street, from Fourth Street east, is characterized by an assortment of urban mansions and rows of brick town houses, with the exceptions of Grace Street Presbyterian and Centenary Methodist Churches, the elite Westmoreland Club and, at the southeast corner of Sixth Street, the Greek Revival St. Peter's Cathedral and the columned, steepled temple of storied St. Paul's Episcopal, where Lee and Davis worshiped.

Franklin Street, east of Third Street, is also residential, and 707 East Franklin Street, where Robert E. Lee lived for a brief time following the Civil War, is the 1909 headquarters of the Virginia Historical Society.

The Richmond Young Men's Christian Association, upon completion of a $200,000 building campaign, in March lays the cornerstone for a headquarters to be built by Philadelphia architects Davis & Davis at the corner of Seventh and Grace Streets.

The great antebellum Greek Revival house of the Nolting family dominates the southwest corner of Fifth and Main Streets. A massive, three-story brick mansion with triple facing windows seems more a public building. Behind is a grand, two-story Doric-columned piazza facing the gardens and the river.

Across the street rises the distinctive curved corner of the Virginia Building, designed for apartment living and indicating both a change in lifestyle for those dwelling in downtown Richmond and the altering of this part of the city's purpose. Fifth Street is commanded by the towered battlement of the 1847 Gothic Revival Second Presbyterian Church, where Stonewall Jackson prayed.

The grand city hall occupies a full Broad Street block and, beside it, Ford's Hotel. Memorial Hospital is at Broad and Twelfth Streets, facing the austere and imposing First Baptist and domed Monumental Episcopal Churches. Across Capitol Square, at the southwest corner of Tenth and Bank Streets, is the morning *Times-Dispatch*, and the offices of its afternoon rival, the *News Leader*, are on the northwest corner. The newer competitor, the *Evening*

Journal, publishes out of 8–12 South Ninth Street. Between Tenth and Twelfth Streets on East Main are several clothiers, including Burk & Co., conducting business at 1003, and O.H. Berry at 1017–1019.

One of Richmond's most liked grocers is R.L. Christian on the north side of Main between Eighth and Ninth Streets. Almost none of the goods are packaged and everything is measured and placed in boxes, bags or bottles. Years later, lawyer Cutchins summons the place's scents: a marvelous mixture of ground coffee, pickles in open barrels, spices and sweets in huge bottle-shaped containers. Hams hang from the ceiling and, in season, oysters can be inspected in special vats equipped with long-handled dippers for making the tricky transfer into cans. Barrels along the floor hold crackers, flour and other condiments. Old Fulcher and Old Bumgardner's whiskies are available for a dollar a quart. No matter the errand to Christian, a shopper is liable to meet someone he knows, and the proprietor is always up for a chat.

The Chamber of Commerce building stands at the southwest corner of Ninth and Main Streets. Marion Dimmock's Chicago School design–inspired six-story, iron-girded high-rise is handsome and modern, eschewing Victorian frippery, with a central courtyard covered by a skylight, an auditorium and restaurant. The building says that Richomnd is modern, yet traditional, and on the go.

On the opposite corner of Ninth and Main is the Ebel Building, the home of the Polk Miller Drug Company, though the founder cannot often be found there because of his touring schedule. Miller is among the best known of Richmond's private citizens; indeed, he could be described as both a regional celebrity and curiosity.

"Originally and Utterly American"

James A. "Polk" Miller grew up on a Prince Edward County plantation where he absorbed the music, folklore and language of his family's many slaves. He was a gifted banjo player who sat in for regular jam sessions with black musicians.

He enlisted in the First Virginia Artillery during the Civil War. Miller afterward settled in Richmond, where he established his pharmacy. He was an accomplished sports hunter and devoted to his hounds. His animal remedies, Sergeant's Condition Pills and Sergeant's Sure Shot for Worms, were named for Sergeant, his favorite hunting dog. The later twentieth-century Sergeant's Pets Products are a direct descendant.

Minding the store, however, is not Miller's calling. He left the prosperous business to his son, Withers, and at age forty-eight took to

In his element. Sportsman Polk Miller rests from hunting, with his gun and dog nearby. Miller's concern for the health of his favorite hound created what became the Sergeant's line of canine remedies. *Courtesy of the Cook Collection, Valentine Richmond History Center.*

the stage with his "Evening of Story and Song" devoted to "The Old Virginia Plantation Negro."

Billed as a banjoist, humorist and impersonator, Miller barnstorms throughout the Southeast and also accepts bookings in Boston and Chicago. He appears wherever he can, often at benefits for Confederate benevolent groups and monument building fundraisers. He performs at YMCA gatherings, conventions and reunions.

Miller is an unrepentant apologist for slavery. He declares, "It has been my aim to vindicate the slave-holding class against the charge of cruelty and inhumanity to the Negro of the old time." He does this using his voice and music, without costumes or makeup. He recreates the companions of his youth through stories in dialect.

Music historian Doug Seroff explains, "Miller's stage presentation was too sincere for minstrelsy and too rich in music to be categorized as a lecture." Describing his presentation as a "show" nauseated Miller, as he would tell a *Richmond Evening Journal* reporter a few years later. He stresses the educational aspect of his work in his effort "to reproduce the Negro of by gone days." He desires to remind the older generation of their childhood and provide insight

to the young people of "the happy past of the old regime of Dixie." His is a nostalgic exercise of a more ephemeral nature than the booted and bearded bronzes of Monument Avenue.

Miller has little use for blacks who have attained higher learning and are promoting the well-being of their communities. "They have made no progress in identifying themselves with the duties of citizenship," he said in 1893. "The educated among them are much less in accord with the spirit of the institutions under which they live than foreigners from despotic countries who have been naturalized."

His thoughts are not out of the mainstream of his day. Racist language and cartoons are features of newspaper columns and cartoons. Yet, the public seeks out black music and entertainment. And while Miller tours the South with his act celebrating antebellum plantation days, a lynching occurs almost every two days.

Miller came to national attention during 1894 in New York City, when humorist Mark Twain interrupted his "author's reading" to bring the Richmonder onto the stage of Madison Square Garden. Twain related to the crowd, "Mr. Miller is thoroughly competent to entertain you with his sketches of the old-time Negro. I not only commend him to your intelligent notice but I personally endorse him. The stories I have heard him tell are the best I have ever heard."

Miller performed the song "Lucinda" and the audience response was tumultuous. They demanded more. Miller then gave one of his hits, a retelling of "The Prodigal Son" in his version of black dialect:

> *The people laughed and applauded as the unique story progressed, but when he related how the hungry tramp ate "de cawn husses" and sighed for "de good things he lef" behine when he went away from home—"all dem spare ribs, chitlins and crackling bread," &c., the young folks shouted and the old folks collapsed in their seats.*

Twain's public recognition of Miller provided incalculable impetus to his career. Other celebrity endorsements followed. Writer Joel Chandler Harris, creator of the *Uncle Remus* stories, wrote that the performer was the "humorist the country has been looking for. I know of no one who can more aptly depict the real Negro character or more faithfully render the true Negro dialect. There's a live 'nigger' hidden, children, somewhere in Polk Miller's banjo, and you look for him to jump out and go dancing when Miller strikes a string."

Late in 1895, Miller's touring took him through Cincinnati, Ohio, where a sort of reunion occurred. At the home of writer Howard Saxby, Miller

received black editor and journalist Wendell Phillips Dabney. Dabney grew up in Richmond and was a classmate of Maggie Walker's who led a boycott of their school's commencement ceremonies when authorities refused to permit blacks a graduation ceremony in the white Richmond Theatre. During the 1890s, though, Dabney had also directed the Richmond Banjo and Guitar Club and composed music for guitar and mandolin. An Oberlin College graduate, Dabney moved to Cincinnati in 1894, where he founded the courageous black newspaper the *Union*. He continued to teach music.

Dabney brought his banjo to Howard Saxby's study. Miller explained to Saxby, "His father was a slave on my father's plantation, down in Prince Edward County, Virginia. He bought his freedom with proceeds from entertainments he gave with the banjo. His son has improved the talent his father left him, and to-day there is no more respected Negro in Virginia than Prof. Dabney."

With that introduction, Miller began tuning his banjo, saying, "We'll give you a sample of the kind of music we used to have down in old Virginia."

Dabney acknowledged, "It's been a long time since we played together."

The two proceeded to render "a number of choice selections."

Sometime between August 1899 and April 1903, Miller began touring with a black vocal group from Richmond that he styled as the Old South Quartette. He recruited men from street corner singing groups and barrooms. Miller's lifelong friend and fellow banjoist, Colonel Tom Booker, often accompanied the Quartette.

This incarnation of Miller's vision proved even more successful. The troupe plays social clubs in New York, Boston, Baltimore and Washington, D.C. The Quartette garners superlative reviews: "a marvel" in Augusta, Georgia; a Boston writer found the interpretation of traditional songs by black voices full of "revelations"; and the Bristol, Tennessee *Courier* reported, "Their music is like nothing else on the platform, for they sing the old songs as the old time Negro sang before the War and not like the Negroes trying to demonstrate how much like white folks Negroes can sing."

Mark Twain again offers his praise: "I think…that Polk Miller and his wonderful four…is about the only thing the country can furnish that is originally and utterly American." He refers to the Quartette's rendition of "The Watermelon Song" as a "musical earthquake."

Little is known about Miller's accompanying musicians. They are not the same for every concert, and Miller circulated some twenty men through the Quartette. The few existing images show the men wearing formal concert suits and holding guitars or banjos. In one picture, the guitarist is singing while the others watch, hands raised, in a synchronized gesture resembling male black groups a half-century later.

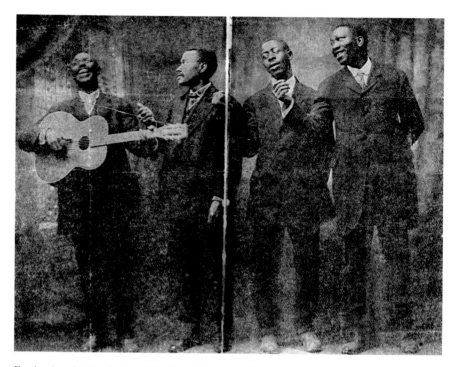

Fascinating rhythm. In late 1909, the Edison recording company visits Richmond to commit to cylinders the Polk Miller Old South Quartette. The attitude of these men, and their raised, rhythm-keeping hands, would be seen more than a half-century later among rhythm and blues groups. *Courtesy of the Valentine Richmond History Center.*

During the spring of 1909, there is what has become a customary series of Richmond presentations. In February, with advertising billing an Academy of Music performance by pianist Padereweski, Miller and the Quartette receive promotion for an evening of story and song to benefit the Ladies' Aid Society of Grove Avenue Baptist Church at the YMCA Hall at Sixth and Main Streets, with an admission of fifty cents. In March, the Quartette is in Petersburg to raise money for the D.M. Brown school library fund, and in Blacksburg providing similar assistance for the Virginia Tech track team. By mid-April, they are back in Richmond at the Jefferson Hotel for the entertainment of the Virginia Bankers Association convention.

On the evening of June 16, amid the festivities attending the statewide gathering of the black fraternal group the Knights of Pythias, Miller and the Quartette are part of the Grand Pythian Concert at Fifth Street Baptist Church. *Planet* editor John Mitchell Jr. is the Pythian grand chancellor. His newspaper mentions that the introduction of the Polk Miller Quartette causes prolonged applause and a "commotion among the listeners." The old-time melodies generate enthusiastic outbursts to the extent that the Quartette cannot step from the stage without encores.

In November 1909, Edison Phonographs comes to Richmond to record seven cylinders of Polk Miller and the Old South Quartette. The songs include the earliest recording of the nineteenth-century black spiritual "What a Time," the jocular "Laughing Song" and "Watermelon Party," which caused Mark Twain's enthusiasm, a dialect song created by the Quartette's bass voice, James L. Stamper. There is a rendition of "The Bonnie Blue Flag," believed today to be the most complete presentation of the music by an actual Confederate soldier. Seroff observes, "The presence of the black quartet, joining in on the chorus with the old Confederate veteran, evokes southern ghosts and lends an uncanny quality to this ancient recording."

Miller is sixty-five years old and, whether his intention, these recordings constitute the apex of his career with the Quartette.

Choices for Survival

Jackson Ward is under siege. The center of Richmond's black culture and business, for thirty years the Ward made careers and sent black representatives to city government. During the 1890s, the Irish grocer and saloonkeeper James Bahen allied with John Mitchell Jr., and in the smoky back room of Bahen's establishment at First and Baker Streets, deals got made.

The vote was a sacred responsibility for Jackson Ward's community and an occasion for all-night social events. At about midnight on voting day, participants gathered around the polling places and kindled small fires to keep away the pre-dawn chill. Groups of women served sandwiches and coffee to the men. They might drag chairs and benches to prevent standing for hours and then pull their seats along as the line moved. Entire families came to witness the function of democracy. Beyond pride, the purpose of these activities was to prevent fraud and the intimidation of black voters by whites.

The 1894 statewide Walton Act complicated voting procedures, with ballots that left absent party affiliation and required drawing lines from the name to the vote. Poll taxes and literacy requirements instituted by the 1902 state constitution further marginalized voters. Later, the 1904 redistricting of Richmond split the residents of Jackson Ward among five neighboring wards.

Men and women, born in the slave times, who experienced liberation and the granting of their civil liberties, now find themselves unable to participate in political life. Even their right to own property soon comes into question. Small wonder it is that by 1910, just 37 percent of Richmond's population is nonwhite. Part of this is caused by recent annexations diluting the number of blacks. Within a few years, however, this percentage rises, as rural blacks flock to the city seeking jobs.

Richmond gives scant attention to the neighborhood of Jackson Ward except as a place to haul refuse. A trash incinerator was placed on St. Paul Street between Baker and Orange in 1892. Nobody in Richmond wanted the furnace; thus, Jackson Ward was chosen. Then-Alderman Mitchell's eloquent oratorical protest delayed the decision but could not stop the inevitable.

The barn-like building was fitted with an eighty-foot-tall smokestack. An assortment of household garbage got shoved into the fires, along with excrement, rotten meat and animal carcasses. The summer heat cloaked Jackson Ward with a putrid odor. In August, Mitchell asked that the assessors determine how the foul smells were causing property value to decline. The furnace's builder professed his chagrin at the obvious failure, and the city engineer made the smokestack twenty-five feet higher. Nothing helped, and when trash arrived faster than could be consigned to the flames, stinking mesas of refuse formed, providing physical and noxious illustrations as to how Jackson Ward mattered to the city administration. Mitchell continued putting anti-furnace measures before council into 1895.

The True Reformers

Jackson Ward's residents, shut out from greater participation in Richmond life, form support groups that often originate from churches and fraternal mutual benefit organizations. A major tenet of these groups is the providing of life insurance and burial costs for poor blacks denied this coverage. As time goes on and race laws tighten, the organizations become more sophisticated. Ann Field Alexander, in *Race Man: The Rise and Fall of the "Fighting Editor" John Mitchell Jr.*, gives an excellent description of their complex social histories. Much of the following sections is derived from her work.

The three most active groups in Jackson Ward are John Mitchell Jr.'s Knights of Pythias, the Independent Order of St. Luke under the directorship of Maggie Walker and the Grand Fountain of the United Order of True Reformers.

The True Reformers is the largest and oldest of the three and was led by the charismatic, dictatorial and influential W.W. Browne, who, as Alexander says, "transformed fraternalism into big business and in the process left his imprint on a generation of black Richmonders."

The True Reformers founded the country's first black-run bank in 1889. This institution assisted Mitchell and the *Richmond Planet* in difficult times. Browne's 1897 death did not impede the organization's growth. Within a few years, the True Reformers operated a department store, a hotel and a

The pragmatist. Successful Jackson Ward lawyer Giles B. Jackson knows how to work the system for his clients, and for this he is viewed by some Richmond blacks as a racial "accommodationist." *Courtesy of the Foster Collection, Virginia Historical Society.*

retirement home. In 1907, W.E.B. DuBois viewed the True Reformers as the "most remarkable organization in the United States." The True Reformers provided a template for all others that came after.

The group's attorney is Giles B. Jackson. Throughout his life, in Alexander's words, Jackson "demonstrated an uncanny ability to win more from whites than they intended to give." Born a slave in Goochland County, Jackson is eloquent and candid in private letters and among intimates. But for the public benefit of the white power structure, he assumes the guise of a self-deprecating "white folks nigger," as he describes himself. He came into law through a white firm and has developed a unique relationship with Judge Crutchfield. Blacks in trouble tend to seek Jackson's counsel, as he knows how to handle the judge.

His facile talent is demonstrated in Jackson's defense of a client accused of stealing a hound from a white man. Using the personae for these cases that agreed with Crutchfield, Jackson said, "Judge, you know dat a yeller dog will follow a nigger anywhere. My client ain't stole him. Dat dog jus' followed him home." Crutchfield, either persuaded or amused, dismissed the case. It was one of many. When Crutchfield first took office, Mitchell gave the judge credit for dispensing harsh justice to what Mitchell perceived as the loafing, delinquent segment of blacks who brought dishonor to the race.

The 300th anniversary of Virginia's founding was commemorated at a massive exposition in Norfolk during 1907. Jackson organized the Negro building to display elements of black culture and history from throughout the country. The undertaking received a paltry budget and contractors went to the whites first. Some 9,100 representations of black life were packed into a two-story structure that received 750,000 visitors—many of them white men—during seven and a half months. This was the single building blacks were permitted to visit at the massive fair that some 3 million people attended.

Many of Jackson's peers considered him an "accommodationist." Jackson knew his parameters—and the score—and he operated to best his advantages. He also earned more money than his fellow black lawyers.

Born with a Clothes Basket upon Her Head

Two proud citizens of Jackson Ward built lives and careers through their efforts to advance their people's cause—but not without social challenges and personal trials.

Maggie Walker would say that she was not born with a silver spoon in her mouth, but a clothes basket upon her head. Her genius for organization and inspiring leadership by 1909 has made her one of Richmond's most prominent citizens—though most whites know little about her. She is biracial. Her mother, Elizabeth Draper, a former slave, worked as a kitchen servant in the household of the renowned and infamous Elizabeth Van Lew. The widow Van Lew lived in a huge Church Hill estate with her niece and an assortment of cats. The personal enmity of the neighborhood was generated due to her activities during the Civil War as a pro-Unionist spy.

A frequent visitor to the Van Lew residence was Irish-born *New York Herald* correspondent and abolitionist Eccles Cuthbert. He and Draper became acquainted. Cuthbert remained around Richmond as a journalist, but a formalized relationship with Draper was impossible. She married Van Lew butler William Mitchell, described later by Maggie Walker as the lightest-skinned colored man she could find. The couple moved into a modest, two-story alley house between Broad and Marshall Streets. Mitchell was headwaiter at the St. Charles Hotel in Shockoe until February 1876, when he went missing. His body was found in the James River. The likelihood was that Mitchell became a victim of robbery and murder. His death cast into poverty Draper, young Maggie and her baby brother Johnnie.

Maggie's young life was shaped by attending the Valley or Old Lancasterian School, which accepted students on a sliding tuition scale, and later the Navy Hill and Richmond Colored Normal Schools. She joined the congregation

of First African Baptist Church, worked with her mother as a laundress and delivering the clean clothes and at age fourteen became a member of the Good Idea Council #16 of the Independent Order of St. Luke, a mutual benefit organization. She rose through the society. At sixteen, she was a delegate to the biannual national convention, and the next year she served as secretary of the Good Ideas Council.

The Richmond Colored Normal Ten

The students of the Richmond Colored Normal School were prepared for a life that, for most of them, would not include college. While there, they learned French and Latin, general history and basic science. They received a better education than most Richmonders of that time.

The class of 1883 had Maggie Mitchell in its ranks and also future newspaper editor and biographer Wendell P. Dabney. Thus, there was a kind of historic inevitability about the boycott they led of the traditional graduation ceremonies.

The city's segregation policy allowed white schools to make their commencement presentations at the Richmond Theatre, while the black schools went most often to the sanctuary of First Baptist Church. Ten Normal School classmates banded together, Maggie Mitchell and Dabney among them, and announced to the school's white principal, Mary Elizabeth Knowles, that they intended to graduate in the Richmond Theatre.

Their proclamation hastened an arraignment of the ten before the white school administration. The meeting became, according to Dabney, a "verbal pyrotechnical display." They were told that they should be grateful for their advancement thus far and not raise a disturbance. They were also threatened with no graduation at all. The ten, though anxious, would not be dissuaded. The students insisted that their parents paid taxes just as the whites did, and they thought that a graduation in the theatre was as much a right of the black students.

The management of the Richmond Theatre posed another problem. Blacks were permitted admittance only in the balconies. There were not enough seats in the upper tiers to accommodate the families of the graduates. Thus, challenged by the administration and rebuked by the venue, the young people chose to have their commencement in the Norman School's assembly room. The space was inadequate, but that was not the point. Police were on hand to keep order among the audience that was crammed into a far too small space. The school superintendent and mayor also attended. Though the ten students could not know of the effects of their achievement, their actions constituted the first school strike by blacks in the nation's history.

That fall, Maggie Mitchell was hired by the Richmond schools. For black women in this period, teaching served as a major avenue for professional advancement, and the position was a symbol not just of success but also of respect. While teaching, she studied accounting.

Black schools existed in a perpetual state of inadequacy. At the Valley School, she confronted as educator what she had experienced as a student: cracked blackboards, broken desks and worn textbooks, of which there were not enough. She taught for three years and met other prominent members of Richmond's black community. They included Yale-educated attorney Edwin Archer Randolph, who co-founded the *Richmond Planet* with bookseller Reuben Thomas Hill as business manager. Maggie Mitchell was inspired, too, by activist Rosa Dixon Bowser, the first black teacher in Richmond, the founding president of the Virginia Teachers' Association and creator of the Women's League, which she started in 1895 to raise $650 for legal expenses in the defense of three Lunenberg County black women accused of murdering their employer. All were pardoned.

Then Maggie Mitchell came against yet another legal restriction: she could not teach if she was married. On the steps of First African Baptist Church, she met brick contractor Armstead Walker Jr., and they wed on September 14, 1886.

"Let Us Put Our Money Together"

Typical of Maggie Walker, when the system refused her an opportunity, she altered the paradigm. She stayed active in the Teachers' Association and the literary club. Most importantly, at the Order of St. Luke convention of 1895 in Norfolk, she advocated for a juvenile wing in the organization. Walker designed the young people's division to impart values of thrift and community responsibility and to teach etiquette. These elements were conducted in the guise of backyard parties, parades, talent shows and storytelling. Walker knew about teaching children without their realizing they were learning. Within a year of its inception, more than a thousand children had joined.

She became a mother in 1890 with the difficult forceps birth of son Russell Eccles Talmadge Walker. She was confined to bed and house rest for five months. Another son, Armstead, born in 1893, lived just seven months. The Walkers brought into their home Armstead's niece, Margaret Anderson, and raised her as their adopted daughter. Son Melvin DeWitt was born in 1897.

Though Walker's dynamic endeavor in Richmond caused the city's St. Luke branch to prosper, elsewhere the order declined. The Grand Worthy Secretary William Forrester, at the thirty-second annual convention in Hinton,

A candid glimpse. In addition to her numerous public functions, Maggie Walker is also a wife and mother. Here, around 1895, she poses with sons Russell (left) and Melvin (right). Troubled Russell died at age thirty-three and Melvin at thirty-eight. *Courtesy of the National Park Service, Maggie L. Walker National Historic Site.*

West Virginia, placed the blunt facts before the assembled membership. He suggested that the order, established in part to assist in defraying burial costs, had outlived its purpose. Then he resigned. Walker recalled how the death of her stepfather sent her family into penury. If she had any say in the matter, Maggie Walker wanted to spare anybody that experience.

The convention dissolved into dramatic discussions about a course of action and electing new officers. Out of this, Walker emerged as the new grand worthy secretary. One of her first acts was to cut the position's salary from $300 a month to $100. Her "first work was to draw around me women" to fill executive positions.

At the thirty-fourth annual convention, held at the Third Street AME Church on August 20, 1901, Walker presented her mission for the order:

> *Let us have a bank that will take the nickels and turn them into dollars. Then, as our patron saint went about doing good, how easily can this great organization now start and do good in our ranks. Who is so helpless as the Negro woman? Who is so circumscribed and hemmed in, in the race of life, in the struggle for bread, meat and clothing as the Negro woman? They are even being denied the work of teaching Negro children. Can't this great Order, in which there are so many good women, willing women, hard-working women, noble women, whose money is here, whose interests are here, whose hearts and souls are here, do something towards giving*

employment to those who have made it what it is? Brethren and sisters, we need to start and operate a factory for the making of clothing for women and children, men's underwear and a millinery store.

We have the means, the brains; we are simply waiting for the motion to be made, seconded and carried, and our Order will take a new lease of life. Do not understand that our sick and endowments are to suffer. Let us always, like St. Luke, the beloved physician, care for the sick and dying; but, at the same time, let us have a bank and factory, and let our cry be let us save the young Negro woman; let us feed and clothe her and give her a chance in the race of life.

Walker established a newspaper, the *St. Luke Herald,* in 1902 to promote closer communication between the order and the public. No women worked for John Mitchell Jr.'s *Planet,* and that lack of female representation may also have provided some inspiration. Walker, in great demand as an inspirational speaker, exhorted her community to achieve financial self-reliance.

She said, "Let us put our money together; let us use our money; Let us put our money out at usury among ourselves, and reap the benefit ourselves." She founded the St. Luke Penny Savings Bank in 1903. She served as the bank's president, making her the first woman to charter a bank in the United States. Eight of the first nineteen directors of the St. Luke Penny Savings Bank were women.

Women working for St. Luke's organize adult and juvenile councils and direct recruitment. They are paid for each council organized and every new member, and for travel expenses. The position gives to black women of Richmond "a significant amount of independence, visibility, and occasionally a foothold in politics," writes Elsa Barkley Brown. Lillian Payne, a chief organizer for St. Luke's, evolves into a political speaker throughout the Northeast. The women, whether clerks in the home office or field operatives, commit to political and community service that complement their St. Luke responsibilities.

The regime of the St. Luke Home Office embraces assigning clerks to community undertakings, such as fundraising for the Community House for Colored People, the Afro-American Old Folks Home, the Friends Orphan Asylum, the Council of Colored Women and the NAACP.

The St. Luke Emporium department store, opened in 1905, was the collective effort of twenty-two women. They sought not only to provide good and affordable retail for the community, but also to offer employment and a business education to black women.

Of Richmond's more than 13,000 employed black women in 1910, just 222 give their occupations as typists, stenographers, bookkeepers and salesclerks. Black secretaries and clerks depend upon stable black businesses. Maggie Walker's St. Luke is chief among them.

"Our inspiration." Maggie Lena Walker,
a woman of national accomplishment, in
1910. *Courtesy of the National Park Service,*
Maggie L. Walker National Historic Site.

The Walkers moved into 110½ East Leigh Street in 1904. This Jackson Ward neighborhood is known as "Society Row," the black version of West Franklin Street, where doctors, lawyers and businesspeople reside. The nine-room house grew with the family and, when completed, will have a total of twenty-eight rooms, electricity and central heating. The Walkers entertain often at this time and receive black intellectuals and activists from throughout the country.

The Making of a Colored Gentleman

John Mitchell Jr.'s life and career mirrors the existence of a black professional class in Richmond of this time. He was born a slave on July 11, 1863, at Laburnum, the country estate of lawyer James Lyons in Henrico County, in the northern environs of Richmond. His father was a coachman for Lyons, and his mother Rebecca, a seamstress. After the war, the Mitchells were retained as servants at the Lyons city mansion on East Grace Street, three blocks west of Capitol Square.

Mitchell answered the door one morning to receive a visitor who was black. Young Mitchell informed Lyons that a "colored gentleman" was calling, whereupon Lyons admonished him for the description because a "colored gentleman" implies a quality that could not exist. Mitchell's mother, though,

John Mitchell Jr., the "Fighting Editor" of the weekly *Richmond Planet*. The son of slaves, he became a vigorous voice of Richmond's black community and tireless advocate for legal reforms and educational and financial improvement, and a savvy businessman whose success annoyed white power brokers. He ran as a Republican for Virginia governor in 1921. Mitchell's public disputes with church leaders and the forced closing of his Mechanics' Bank damaged his reputation. His December 3, 1929 death received scant notice in Richmond's papers.

had full expectation of her son rising to the status of gentleman, and he took his mother's word about the matter with greater weight than his employer's. The instance gave Mitchell an epiphany about himself and his aspirations that he never forgot.

Like Maggie Walker, Mitchell received his education in Richmond's black schools and taught for a time in Fredericksburg and Richmond. He resided at 222 East Broad Street, above the book and stationery shop of Reuben T. Hill, who propounded that the best way for blacks to achieve middle-class status was to build their own institutions. Hill's bookstore served as a portal into black culture, not just in Richmond, but also with newspapers from other cities that allowed those of Mitchell's generation to inform themselves of what was going on elsewhere. This later evolved into a Chautauqua Literary and Scientific Circle that discussed topics of the day and other loftier issues.

Mitchell's writing career began in the pages of the *New York Globe*, which recruited writers from all over the country, and though it did not pay, to see one's name in print suited many contributors—one of whom was "Willie" DuBois of Great Barrington, Massachusetts.

The House of Mitchell. Architectural rendering of Mechanics' Bank as it appeared in the June 12, 1909 *Richmond Planet*. The bank's 1922 closing by bank examiners and Mitchell's subsequent arrest (and 1925 absolution by the courts of any wrongdoing) damaged his reputation and demolished the financial aspects of the Knights of Pythias. *From* Richmond Planet *microfilm, Richmond Public Library.*

Mitchell's first column gave a wrenching account of a black woman hanged in Henrico County for conspiring with a lover to kill her husband. His deft touch and penchant for invective got him to the front page with passages like, "There is a determination to take what comes, die when we must and go down contending for those God-given rights that no man has the right to take away."

In the fall of 1883, Yale law school graduate and city alderman Edwin Archer Randolph gathered with a group of prominent black citizens and aspiring journalists to form the weekly four-page, hand-printed *Richmond Planet*. The publication emerged against the backdrop of the political foment created by Mahone's Readjuster Party and its violent collapse. "Readjusterism" had given some blacks, particularly those in education, some measure of optimism about their future. The attitude of this brief period was exemplified by the masthead logo of a flexed bicep and a clenched fist radiating lightning.

Just as the *Richmond Planet* appeared in Richmond streets, however, Republican rule faltered. The paper's endurance, despite upheaval and a high illiteracy rate in the community it sought to serve, proved that

there is no good time to start a publication. What matters is quality—and financial backing.

Randolph quit in December 1884, leaving unpaid bills and the paper's future in limbo. A crisis meeting convened with Mitchell, R.T. Hill, writer and lecturer Daniel Webster Davis and several teachers now deprived of employment. Mitchell emerged from this meeting as the *Planet's* new editor and publisher. He assumed the task with gusto, traveling the state to attract subscribers. The *Planet* could not have had a better spokesman.

Alexander describes, "Only twenty-one years old, he was handsome, articulate, and self-assured. As he later explained, 'I win over the colored people by coming into personal contact with them and bringing them over to my way of thinking.'" His mission against resignation and injustice attracted a wide readership.

"The Colored Man Is Everything"

In 1888, the paper moved out of Mitchell's rented room into two dingy basement offices in the sagging Swan Tavern, built in the 1770s. The planks of its long, splintery front porch had known the tread of Thomas Jefferson and Edgar Allan Poe. Decrepit though it may have been, the Swan was busy with enterprises ranging from a Chinese laundry to a hatter's shop and lawyers, including the returned Randolph and Giles B. Jackson.

The *Planet* and Mitchell became symbols of black self-reliance. He tracked lynching throughout the South and published the grim statistics. He wrote that if the government could not protect black men, then they must defend themselves. The best guard against lynch mobs, he said, was a rifle and the willingness to use it.

The twenty-two-year-old Mitchell strapped Smith & Wesson pistols to his hips, jumped on a train and went to Charlotte County to investigate the mob-related death of Richard Walker, killed after being accused of attempting to rape a white woman. At a time when a black man could be seized and dragged to a tree for any real or imagined pretext, Mitchell's manliness of purpose was never questioned. Despite the belligerent tenor of his editorials and readiness to action, Mitchell also advocated on behalf of civility and middle-class manners.

Mitchell did not marry, but he maintained a decades-long relationship with pretty, pert-nosed Marietta Chiles, whom he met when teaching. Their affair was no secret, and they were often seen in each other's company at social occasions. Mitchell gave her expensive jewelry. The arrangement generated much public gossip about why the couple would not wed. Mitchell was perhaps

too self-centered or preoccupied with the advancement of the race to bother. Or maybe his obstinacy prevented him from marrying Chiles, while her protective brothers precluded his marrying anyone else. Rumors later surfaced about other dalliances and even children. He gave his true self to the *Planet*. The paper, and eventual business interests, became not just his living, but also his reason.

The *Planet*'s subscription is small but wide-ranging, and in 1891, when by chance in Washington, D.C., he met the great civil rights pioneer Frederick Douglass, the elder man said, "You have indeed nationalized yourself."

Throughout the 1890s, Mitchell expended inordinate hours working to free individual blacks sentenced to jail on dubious pretexts, and through heroic effort, preventing deaths. His was a wearying struggle against unreasonable policies, and the unyielding effort takes a psychological toll. His well-tempered rage could not alone end Jim Crow. The laws continued the constriction of his world.

Mitchell wrote in 1893, "The colored man is everything. You can't keep him out and the Southern folks like him. If they want a man to wait on them, they get a Negro. If they want a shave, they get a Negro. If they want a bootblack, they get a Negro. If they want a man to curse, and if they want a man to hang and burn, they get a Negro. Strange people are these Southern white folks."

He opposed the Spanish-American War and wrote blistering editorials about black units commanded by white officers that incited protests within the army. That a black man would volunteer to fight and die in the service of a system dedicated to preventing his full rights made no sense, and Mitchell said so.

He represented Jackson Ward on the city's Common Council and became a political force. The abrogation of the black vote through the 1902 constitution followed by the suspension of Jackson Ward as a voting district ended Mitchell's practical political career. Through his advocacy in the *Richmond Planet*, he continued his lopsided contest with inequality.

He founded the Mechanics' Savings Bank in 1902 and became the first black man to address the American Bankers Association. Through public speeches and the pages of his newspaper, Mitchell called a boycott by blacks of the Richmond streetcar system in protest of Jim Crow seating restrictions. The six-month campaign proved fatal to the already troubled traction company, suffering from losses due to a labor strike the year before. The company fell into the receivership of outside interests.

The regulations dictating that blacks be seated in the back of the cars stayed on the books. Mitchell never rode another trolley, though he didn't need to, as he was able to get around in his gleaming Stanley Steamer automobile. He purchased residential properties along Clay Street and rented them to white tenants. Jackson Ward had gone through a few cycles

since the Civil War era, when whites lived on street-fronting houses while the blacks lived behind them. Afterward, blacks moved out to places of their own. Clay became a white enclave and Mitchell found himself renting to white tenants.

Alexander explains, "For a time he seemed to confuse his own progress with that of the race, assuming that as his net worth increased, the race also advanced. He cast aspersions on black loafers, forgetting that he had risked his life to save defendants who were themselves poor, illiterate, and outcast."

Mitchell mediated his fire-breathing activism. Race riots in Atlanta, Georgia, during 1906 caused the deaths of twenty-five people, and the editor of the *Voice of the Negro* publication there ran for his life. Mitchell observed that liberal-minded white men were of little use against lynch mobs.

By 1909, his greatest dispute with the white establishment concerns his undercapitalized bank. Mitchell struggles to attract assets, thinking that the bank's worth as an institution would be limited until reaching a half million in deposits. This amount would allow Mechanics' Savings to make loans.

Mitchell knows his Richmond audience. A bank needs to look like one, so he purchases a tumbledown structure at Third and Clay Streets, demolishes the house and erects a four-story, white and yellow brick Renaissance Revival building. Customers enter the building through a lobby fitted with green and white Italian marble and an elevator for carrying people to the roof garden. Despite all this aspiration to respectability, whites protest that the bank will bring down property values and disturb the street's character. He is allowed to proceed with his construction after considerable personal lobbying by Mitchell of city leaders and public testimony, in which he urges the city not to "block the progress of the better class of color." Mitchell holds a "whites only" reception on June 27, 1910.

Around this time, the Virginia State Corporation Commission exercises its new power to make annual assessments of banks, first on the True Reformers, the largest and oldest black thrift in Richmond. The agency finds that too much of the bank's funds are in mortgages and loans and there is not sufficient liquidity to pay out death benefits. The state orders shut True Reformers' Bank on October 25.

The effect on Jackson Ward and the wider black community is seismic. "No event which might have befallen the colored race in America could have produced a more profound shock or could be more far-reaching in its effects," the *Richmond Planet* announces. "The True Reformers is at once the largest, the most prominent, and had hitherto been regarded as the most successful of all the colored secret societies in the world, around which whose existence as much of this activity of the race centres."

Beneath the travails of the True Reformer closing, a smaller mention in the paper assures readers that the financial condition of Mitchell's Mechanics' Savings Bank is the best since its inception. No disruption has occurred in its business, all obligations will be met and a cash reserve kept on hand for eventualities. More properties have been acquired in the 100 block of East Clay Street, and a house at 611 North Sixth Street has been sold for $5,000.

Another regulation made it illegal for banks to be connected to fraternal organizations. Maggie Walker's thrift, which had survived its state inspection, was forced to separate Penny Savings Bank from St. Luke. Mitchell and Walker are the city's remaining black bankers.

"Negroes Treated Like Cattle"

Yoder's ambivalence toward blacks is typical among even the most progressive Southerners of his day. In the June 19, 1909 issue, *The Idea* prints this joke: "'I'll take some o' dat flesh colored candy,' said Sambo the porter as he pointed to the chocolate drops." On the second page of that issue, in an article entitled "ELECT NEW MEMBERS" concerning filling vacancies in the city's Democratic Elections Committee, Yoder writes of the election of Frank Ferrandini, an ex-barkeep,

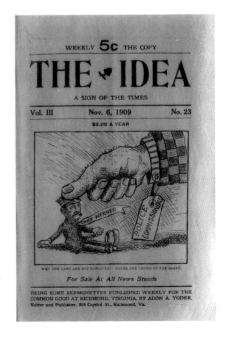

Under my thumb. Police Chief Lewis Werner is helpless due to pressure from the city's law-breaking administration. *Courtesy of the Library of Virginia.*

who for years ran a low negro resort, on the walls of which was exhibited for the benefit of the lowest element in Richmond a fine mammoth oil painting of a nude white woman, and who operated next door to his bar-room a slot machine amusement stand for negroes...in these machines were shown indecent moving pictures of the vilest description...When the Chief of Police and Mayor went there to examine conditions...negro bucks were so wrapped with salacious sights they had to almost literally fight their way through the throng.

One of the most galling aspects of the city's racial arrangement, though, is law enforcement. Yoder underscores police mistreatment of blacks in a July 10, 1909 condemnation of the methods Justice Crutchfield uses in his court:

Not only is the negro the butt of many jokes and the payer of many a speedy sentence given at the expense of impartiality, but unless he has good strong pull in the Richmond police court he is likely to come away, guilty or not guilty, mad enough to fight a hornet's nest, for it seems to be a rule of this court to regard a man a criminal unless he can prove otherwise and he is given scant opportunity even then to tell even his side of the case.

Yoder asserts in "Andy Griffith Policy King—Partner of Clyde Saunders in Stock Farm" that the police department protects saloonkeeper Andy Griffith on lower Franklin Street. In addition to a booming gambling business with whites, Griffith also employs "a large force of negro men at so much a day to do the dealing with the ignorant negros [*sic*] who infest this, the vilest section of the city...Everyone knows the strong temptation to the superstitious negro to gamble and Griffith knows from experience that in them is a source of immense revenue to him."

On September 18, 1909, Yoder wonders why Negro Chris Dabney, who on August 14 was shot in the head, treated and then arrested, and who attempted to place several warrants out on his assailant, could not receive help from authorities. He beseeches *The Idea* for help. It appears "that the police and the surgeon and the justice of the peace have all aided in shielding the man whom [Dabney] claims shot him."

During the late summer of 1910, one of Yoder's strongest condemnations of the Richmond police's treatment of blacks comes in "Wholesale Arrests—Negroes Treated Like Cattle." He describes overzealous raids of blacks, male and female, "herded together like cattle, [who] have been hurried away to jail after being hustled out of their beds at midnight, absolutely without

warrant or right to search their premises, the only excuse being that some petty thieving had been going on." To Yoder, it sounds more like "accounts of Russian persecution of Jews than it does like orderly American procedure. It looks like the Richmond police force delights in showing its authority, but never delights in enforcing the law."

The single mention of Yoder in the *Richmond Planet* comes in the February 19, 1910 issue. An obligatory two paragraphs give an uninspired account of his arrest, fine and fifteen-day jail sentence. No commentary is offered.

Brio and Beauty

East of downtown and south of Capitol Square is the busy wholesale and commission district along East Cary Street, called Shockoe Slip. In the spring of 1909, the cobbled central plaza there receives an adornment in the shape of a sculpted concrete horse fountain designed by sculptor and plasterer Ferruccio Legnaioli, an Italian-American immigrant. The fountain is for the use of draught animals still plentiful in Shockoe and employed for hauling merchandise at the nearby First Market.

Not long ago, such a commission would have gone to the city's preeminent sculptor, Edward Virginius Valentine. Valentine, however, is turning toward writing history and seems to have recommended the

Artist in residence. Ferruccio Legnaioli in his studio, circa 1930. During the early twentieth century, Legnaioli designed, installed or directed the placement of plaster and sculpture ornamentation and decoration for many of the city's theatres, government offices, parks, financial institutions and private houses and gardens. *Legnaioli family photograph.*

That ole gang of mine. Ferruccio Legnaioli, (second from right) with his crew of artisans giving a larkish pose in the yard of his Scott's Addition workshop, mid-1920s. He brought Italian workmen to assist him in his numerous undertakings. *Legnaioli family photograph.*

younger man to the widowed Mrs. Charles Morgan of Baltimore. Her husband, a Richmonder buried at Hollywood Cemetery, was a Confederate cavalry officer, and etched into one of the panels of his gravestone is, "For One Who Loved Animals."

Legnaioli brings to Richmond's architectural designs a sense of brio and beauty. His style exhibits the city's effort to achieve distinction. His name resonates with decorative swirls, twists and forceful artistic character.

He grew up in the northern Italian town of Pesci. During his 1891–94 attendance at Florence's Royal Academy of Arts, he won design awards each year. He studied in both Paris and London, until by 1902, at twenty-nine, he came to New York City. He spent four years there working in the decorative style of the dominant architectural firm McKim, Mead & White.

In 1907, Richmond businessman and second-generation Italian-American Frank Ferrandini went to New York, where he encountered Legnaioli's work. Ferrandini knew that Richmond lacked resident decorative plasterers. His persuasion brought Legnaioli to Richmond, and for a time Ferrandini put the artist up in his own house. Thus began a profitable relationship, with Legnaioli in charge of art and Ferrandini minding the business. In 1909, Ferrandini hires Legnaioli to create his family crypt at Mount Calvary Cemetery. Architect Stanford White hires Legnaioli to work on buildings he is designing for the University of Virginia. The artist executes the ornate barrel vault ceiling of Garrett Hall.

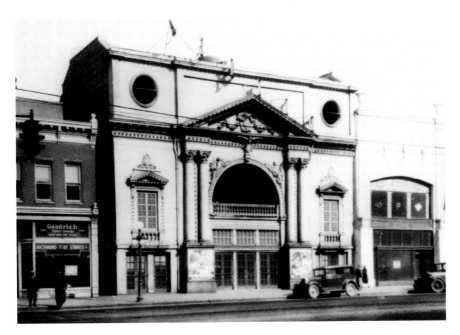

The big drama. The Empire Theatre (1911), a vaudeville and playhouse with decorative interior and exterior plasterwork by Ferruccio Legnaioli, is renamed the Strand (1915), showing movies. In 1919 the theatre, generally for whites, is purchased by black editor and businessman John Mitchell Jr., disturbing the white community. A 1927 fire damages the Legnaioli façade. The building becomes the Booker T. and is dormant when, in 1984, Theatre IV revitalizes the building.

By 1910, the Ferrandini-Legnaioli Co. at 1305 Haxall's Lane employs some thirty people. The shop turns out a diverse assortment of work, from garden ornaments to elaborate interior decoration, statues and busts of bronze, marble and cement. When occasion warrants, other experienced plasterers and detail men are brought from Italy. These artisans pour custom and stock plaster and cement castings, lay terrazzo tiles, execute plaster ceilings and moldings on building sites and in general carry out the designs rendered by the master of the shop, which he most often sculpts in clay.

After their long day, Legnaioli sits with his workmen around a small kitchen table, and their conversations become louder and more amusing as the wine flows. He needs their companionship. While his professional life gives him reason for optimism, Legnaioli's recent marriage to an Italian immigrant ends with her sudden death.

Legnaioli begins work on the Empire Theatre at 118 West Broad Street, a 1,220-seat cinema and playhouse constructed for Moses Hofheimer by the firm of Scarborough & Howell. The architects give the artist wide leeway with his vision. Classical maidens, garlands and arabesques embellish the

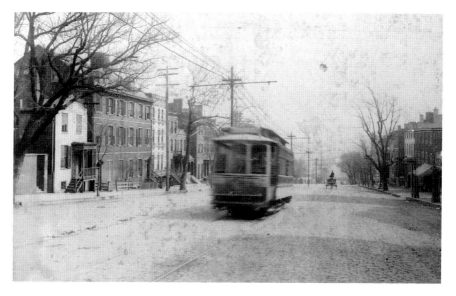

A streetcar climbs the hill along dense, residential Broad near Twelfth Street. This is looking east toward Shockoe. Close by are the tenements of immigrants and the red-light district. *Courtesy of the Cook Collection, Valentine Richmond History Center.*

interior. The façade includes a classic triumphal arch and paired Corinthian columns, and dancing maidens adorn the semicircular window bay of the coffered-ceiling musician's gallery.

Turkey Town

Along East Main Street into Shockoe is a warren of wretched slums. Past Seventeenth Street are busy saloons. Neglected, barefoot urchins run in the streets, where starvation and nakedness are their formative experiences. Here in the city's lower depths are clusters of overcrowded, dilapidated hovels. Brazen women of all shades and hues and hardened young people come and go for the five-cent whiskies and wander into lodging houses where a bed can be had for fifteen cents, no questions asked. Broken windows and doors let in sunlight and the rain, and during winter the soft flakes of snow fall through the pocked roofs like springtime apple blossoms dropping on orchard grass. The *Richmond Times* journalist, noting these conditions, suggests that if the James River should be made to turn its course to wipe "these wretched abodes off the face of the earth it would be a God-send to the young girls and boys who are compelled to witness the debauchery and come into contact with the sin that surrounds them."

These narrow, dark tenements are also the places where immigrants eke out their livelihoods and cling to the first rung of a new life. Where they are all coming from mystifies Richmonders, who call the amorphous district "Turkey Town."

The *Times-Dispatch* describes the inhabitants of this neighborhood as embracing "every nationality between the Aegean and China Seas. The residents come from every footpath in Assyria, from the plains of Afghanistan and Beluchistan and the foothills of the Himalayas. There may be some other places, but they are not down on the map which Commodore Matthew Maury laid out for the school children of Virginia."

One enumerator discovers a colony of Southern Europeans who, due to their recent arrival, cannot speak English and do not know the census taker's purpose. He quits in disgust. Another man in the field encounters "innumerable individuals with names that would cause a Spanish grandee to turn green with envy. Not enough space was left on the blanks," he complains, "to hold the entire cognomen."

A frustrated Richmond-based national census taker, Moses Weinberg, relates how when landing "in a nest of Syrians" in Turkey Town he tries Yiddish, English and hand signals to get answers, without success. His census taking is by circumstance a slow and painful procedure. "I haven't finished with the first family. When I finish them I think they [the Census Bureau] ought to pension me." If he doesn't get a talented translator to assist him, Weinberg states, "I am going to commit suicide."

The census counts Richmond with a population of 127,628 people and 4,085 listed as "foreign born white persons." Turkey is not among the selected places of origin.

A Harvard Man Tells and the Whisky Question

Richmonders who can follow the language attend topical lectures. Speakers on current events and subjects philosophical or scientific attract hundreds or even thousands of people where space allows. Political candidates are expected to give dynamic orations. There are frequent mass meetings pertaining to the day's topical questions, often dealing with politics of one kind or another.

Dr. Charles Eliot, president of Harvard University, pays a busy visit to Richmond on March 29, 1909. That morning he addresses the student bodies of Richmond College, the Westhampton Womens College and the Richmond Academy on "The Cultivated Man." This is followed by a luncheon at the exclusive Commonwealth Club hosted by prominent businessmen.

Several speakers precede Eliot. One reviews the railroad situation in the South, another takes on federal regulation of commercial carriers and a third expresses the need for business trusts but asserts that the government needs to intervene to prevent the overrunning of small enterprise.

The *Times-Dispatch* notes that Richmond College law professor W.S. McNeill devotes the greater part of his speech to the "evils of the fourteenth and fifteenth amendments." Politicians of the South use these statutes to hold the masses of the people to the one prevailing party below the Mason-Dixon line. He says that the South does not understand Harvard, and Harvard certainly does not understand the South, and that when a common ground is reached one could aid the other in the struggle for social and political betterment.

Eliot responds to each of those who spoke ahead of him. He expresses how during his past seven weeks touring the South he has been agreeably surprised by the condition of Southern railroads. Further, he believes that the government should regulate interstate commerce. Eliot endorses the continuation of trusts, providing the implementation of laws to protect the weak against invasion and ruin. The most egregious trust, in Eliot's view, is the Federation of Labor, organized for the selfish purpose of securing greater wages, yet if a member is expelled from the organization, that person loses all insurance benefits.

He adds that his experience in the South has been one of the most pleasant of his entire life, and that everywhere the South is prosperous and is following New England's example of frugality. The one thing that he and others like him cannot understand is the Southern willingness to accept political bosses instead of thinking for themselves. He believes the trait arose within Southern people when whites needed to protect themselves from the "dark evil." The custom, thus ingrained, became difficult to overcome.

Eliot again takes to the lectern in the evening at Richmond College. He explains how his interest in restructuring city governments came out of his direct experience of school boards affecting the quality of students that fed into institutions of higher learning. He says several things that endear him to like-minded Richmonders. Eliot credits the city of Galveston, which converted to a commission-based government after a devastating hurricane. He extols Galveston's reform and says: "The nation owes the South this…the most important municipal reform made since this nation was organized."

He declares a two-branch council and mayor—such as exists in Richmond—ineffective and corrupt. Eliot believes that education requirements at the polling place create a quality voter. He urges for the abolition of the ward system and the selection by the electorate at large of

five men to head the commissions. Some cities have allowed the installation of strong mayors, and Eliot disparages this arrangement as no better and often worse than commissions.

The simple and direct message of Eliot's speech keeps the attention of the collegians who fill every inch of standing room and give vociferous applause at the close. They escort President Eliot's carriage through the grounds with yells and songs, according to the *Richmond Times-Dispatch* of March 30.

On April 13, 1909, despite a spring downpour, more than two thousand citizens gather at the Academy of Music to express their displeasure at movements toward prohibition of alcohol. The assembly resolves that halting the liquor trade would be "revolutionary, extreme and disastrous."

Chamber of Commerce business manager William T. Dabney gives the evening's keynote address. He frames the ordinance limiting the number of liquor dealer licenses and regulating its traffic by placing the responsibility in the control of responsible citizens. No further laws are needed, he says.

He reaches into the city's history, holding up the examples of the Revolution and the Civil War, of stalwart men who, if poisoned by whiskey, would not have marched with such bravery and heroism. If those who rebuilt Richmond following the devastation of the war were drunkards, how could one account for the current prosperity? If whiskey is an evil here, let the police enforce the laws already on the books. Prohibitory laws in many cities have resulted in placing the traffic into the hands of persons with absolute disregard for law and decency, producing a most disastrous effect among the people.

Dabney compares Richmond to Boston, a city five times its population, where last year 42,000 persons were arrested for drunkenness. Richmond had just 2,500. (In proportion to Boston, Richmond should have had 8,400 arrests.) In fact, the Dabney ordinance, law enforcement and the general well-churched and moral nature of the community have kept Richmond's public intoxication numbers well below what one would expect.

The liquor trade is also an engine of a city's economic successes. Tax revenue from liquor sales generate $400,000 for the city's coffers. This is revenue that can be spent on schools, playgrounds and to pay for paved roads. Dabney further explains that Richmond wants a convention trade, and if liquor is banned, he claimes, "you will get no conventions, unless it be the Anti-Saloon League."

The meeting adjourns, having voted its desire not to have the liquor trade banned, and a rousing version of "Dixie" played by Professor Moses Stein's orchestra ushers them outside.

On April 26, temperance leaders announce their intention to hold a big meeting of their own.

"No Pushee, No Pullee"

In 1900, Richmond's electric streetcars, the world's first practical urban service, provided more than eighteen million separate trips for its riders. Despite the advent of public transit, however, and the first hints of a personal automobile, horses continued to pull commercial loads and carry passengers. The horses spread dung throughout the city. A few years earlier, 8,747 barrels of manure were collected from Richmond's dusty streets.

On February 26, 1900, Richmonders received a glimpse of the shape of things to come. The contraption was a 1,500-pound, battery-powered truck owned by Swift & Co. meatpackers. According to the *Richmond Times-Dispatch*, the firm was "experimenting with a view to adopting them as delivery wagons."

A newspaper headline described Richmond's automotive advent thusly: "No Pushee, No Pullee, But Goes Nearly Everywhere All The Same." The thing cost $3,200 (making it more obtainable for a business rather than an individual) and could "run at a rate of 12 to 15 miles per hour."

During the afternoon of September 24, 1900, Captain Andrew J. Pizzini Jr.—a Richmond electrical contractor, former councilman and Civil War veteran—put to the streets in his personal steam-powered "runabout," built by the Mobile Company of America and purchased in New York City. Pizzini's ride traveled at ten to fifteen miles per hour and, assured the *Evening Journal*, was "more noiseless than similar conveyances propelled by electricity." The car's operating range was 5,100 miles "and embraced all the latest improvements."

As though made breathless by the excitement, a reporter explained that Pizzini would "take a few of his friends out for a ride over Richmond's hills this afternoon to show them something of the delights possessed in cities in which automobiles, mobiles, and other horseless conveyances are seen by the hundreds and even thousands."

Automobiles in Richmond required regulations with specific application. John A. Cutchins, a lawyer and city councilman during the advent of the automobile, recalled the increasing difficulty of controlling this mode of transportation and threading it into the pattern of everyday life. The first decisions of the courts proceed from the assumption that the laws applicable to animals on the roadways did not apply to automobiles. The few motorcars that appeared on the streets alongside horse-drawn conveyances required special regulation. One new law requires that if a horse became frightened of an automobile, the machinist (driver) must stop and lead the horse past.

The expense of the best makes of these motorcars made them at first a wealthy person's novelty. "Any young man who owned an automobile in its earlier years was regarded as an impossible credit risk by the banks," Cutchins said.

With the advent of the automobile, the condition of roads became part of the public agenda. The *Times-Dispatch* sponsored some auto-related public relations stunts involving a motorcar visiting remote localities along miserable routes to incite municipal and state governments to address this issue. "Virginia is known for many things," the paper opines, "among which is not her roads." Auto manufacturers, dealers and owners were eager to contribute to this effort.

Two novel automobile-related events occur in Richmond during May and June of 1910. The newspaper teams with American Automobile Association and the Richmond Automotive Club in running endurance contests for machines and the men—and women—who drive them.

"Dogs and Chickens…Must Be Spared"

Planning an extended motor excursion resembles campaign logistics. There are no service stations, comfort stops or interchange oases. The motorists must carry their provisions, with food and clothing for themselves and also tools and replacement parts for their cars, which are assured to require at the very least minor repairs and routine maintenance. The poor Virginia roads are rife with chuck holes, running streams, grasping mud, rocks and flying debris. Motoring in these "benzine buggies" is an expensive challenge. Coverage of such contests is provided on the sports pages. Many of the participants, and those who come to watch the cars shudder past cloaked in dust clouds, regard motoring over long distances as an adventure.

The first contest, beginning May 5, 1910, involves twenty-three automobiles for a three-day competition on a circuit from Richmond to Washington, D.C., to Charlottesville and home. The autos are competing in three division classes based on power and weight. Thousands of the curious gather at the bank between Tenth and Twelfth Streets to watch the parking of the cars.

At a pre-event meeting in the *Times-Dispatch* offices, AAA officiator of the contest, New Yorker Alfred F. Camacho, urges drivers to be mindful of horses and to guard against running over "live property." Dogs, chickens and other fowl must be spared. The course wends deep into farming country. If a driver encounters a frightened horse and the motor must be stopped, the down period will not be counted against the car. Observers score the drivers

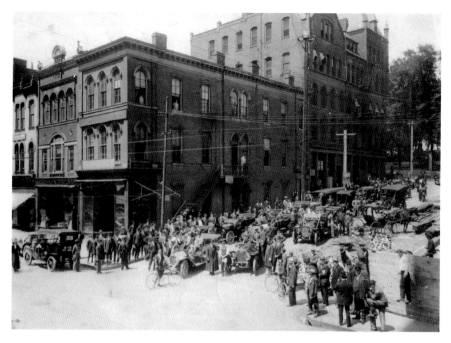

Motor city madness. A convocation of vehicles, drivers and spectators cluster at the northwest corner of Tenth and Main Streets on May 5, 1910, at the outset of a *Richmond Times-Dispatch* automobile endurance contest. The newspaper's offices are in the towered building up Tenth. *Courtesy of the Valentine Richmond History Center.*

on the handling of their vehicles, the frequency of repairs needed and time. There are a series of control stops. The *Times-Dispatch* has arranged for toll payments and hotel rooms. This is not a race. The motorists should maintain an average speed of twelve and a half miles an hour. More important is the safety of the cars and passengers. No car is to reach Washington in under ten hours. The motorists are scheduled to meet President William Howard Taft the next day.

Around four o'clock in the morning, the chauffeurs, observers and officials begin arriving. Several neighborhood stores open early, and there are many last-minute purchases of automobile toggery, cigars and light refreshments, reports the *Times-Dispatch* of May 5–6, 1910.

Automobiling's accoutrements and clothing are somewhat paramilitary in appearance. The men wear duster-length double-breasted reefer jackets with small turn-down collars and sometimes aviator-style leather helmets and goggles; but flat motoring caps with longer bills are a compromise for this more formal time, when few people go outdoors without some kind of head cover. Anything with a brim blows off and light clothes flutter and balloon. The women also wear long coats during these spring events, most

often made of linen or alpaca. Wide hats to shield them from the elements are fastened to their heads with thick veils.

At five o'clock, the whirring of starter motors burns the air. The contesting cars move into order along Main Street in a line that stretches a block and a half eastward. Several hundred spectators gather along the sidewalks.

The start begins at six o'clock on the mark. The first car, a Chalmers "30," shoots up Main Street without regard for the speed limit, and at one-minute intervals the others follow. Horns blow and the crowd cheers, even louder when a car passes carrying one of the eight women who are participating.

Anna Dunlop of Petersburg, driving a Maxwell, is in for the whole run, though listed as a noncompetitor. She is the same Anna Mercer Dunlop, twenty-six in 1909, who, as a member of a prosperous Southside Virginia family, studied art at Columbia University in New York and the Art Students League, where her instructors included William Merritt Chase. In Paris, she took classes taught by James McNeil Whistler. Throughout her life, she has sought to raise the culture of her community, and in her middle age she will found the Petersburg Area Art League. For this endurance run, however, Dunlop is a curiosity known as a woman motorcar driver.

A gaggle of noncompeting cars trail along behind. Up to Main and Fifth, then over to Franklin, out Brook Avenue and the wanderers are lost to the city in a cloud of dust away toward Yellow Tavern.

Taft with Wheels

There are no road signs, accurate maps or pavement; bridges, when they exist, are flimsy and are often repaired in anticipation of the automobiles' arrival. The dry roads generate plenty of dust and deep mud following rains. Ruts two feet deep wind uphill and down where oxcarts have dug them during the past years.

Due to the bad roads approaching Fredericksburg, the competitors cannot get through the town. Citizens charter a special train to meet the cars as they converge on Orange. Where they can, people gather along the roadway to see the autos go by. Some farmers bring out their horse teams to accustom them to the sights and sounds of a motorcar. Just one horse rears and starts to bolt, but a course official catches the animal and averts an emergency.

A committee of Washington regional motorists meets the Richmond contingent and escorts them into the nation's capital. Anna Dnnlop arrives on time at 10:00 p.m., having earned a perfect score for her driving. On May 6, the *Times-Dispatch* reproduces a telegram from Leo Folger announcing the arrival of his Chalmers underneath the account of the departure from

Richmond, and images of the crowds in Orange—a kind of rudimentary print version of a screen crawl.

On May 7, the auto excursion must compete with real world headlines. Britain's Edward VII has died, and in Richmond, an investigation is underway against City Councilmen Gilbert K. Pollock and George E. Wise. Each is accused of accepting $500 bribes from dairymen to pass an ordinance allowing the feeding of distillery waste to milk cows. The two men express their indignation. Pollock, with a twinkle in his eye, says he has lived here thirty-nine years and received thirty-nine charges of wrongdoing. Wise, a Richmond resident of forty years, says no charge of impropriety has ever been made against him.

None of this affects the motorists meeting with President Taft outside the White House. The cars line up in front of the Executive Mansion and the five-foot, eleven-inch, three-hundred-pound Taft, well-known for his automobile advocacy, comes to shake hands and pose for pictures. Taft congratulates the motorists on their accomplishment and the *Times-Dispatch* for drawing attention to the need for road improvements.

Taft says farewell to the drivers with a cordial wave and smile, and bids them Godspeed on their way to Harrisonburg. The *Washington Post* pilot car guides the group into the countryside. The roads beyond Leesburg cause the automobilists to stop and deal with numerous punctured tires. Outside Winchester, one car smashes into a buggy driven by two women who spill into the street. They claim no injury and are soon left in a cloud of dust, which cloaks the landscape as far as the eye can see.

At Falls Church, Leesburg, Bluemont and Berryville, townspeople come to the sidewalks and corners and peer from every window, and their cheering is heard above the throbbing motors. When the cars reach Harrisonburg, a layer of dust covers everyone through their clothes and gets everywhere where it is not wanted. The participants are ready for their evening stop at the Kavanaugh Hotel.

The motorists come down Rockfish Gap without reported mishap and begin arriving in Richmond during the later afternoon. A five-way tie of perfect scores necessitates a drawing for the cup a day after their Richmond arrival. The cars that come home go by marques of Chalmers, Hudson, Reo, Buick and Rambler. Anna Dunlop drops from the newspaper accounts because, being a noncompetitor, she does not qualify for the engraved silver cup. There are protests about scoring. An Oldsmobile driver files against a Rambler operator, and the Ford Auto Company dealer against a Hudson "20" sold by the Gordon Motor Car company.

New rules are adopted to govern the upcoming North Carolina run, including that each day will not exceed 120 miles or ten hours' time and that

no car may pass any control point ahead of the scheduled time. There will also be a one-hour timeout at each midday control point.

The endurance scoring contention clashes with the great celebration surrounding the completion of the long-delayed castellated armory for the Richmond Light Infantry Blues Battalion at Sixth and Marshall Streets. Feasting, marching and martial music marks the organization's anniversary, and military units from Rhode Island and Connecticut, and the governors of the respective states, join the festivities. Meanwhile, the accused Pollock and Wise admit to taking the money but claim the dairymen paid them to make an argument before the hustings court and the chief health officer about the distillery waste used as feed.

A Bevy of Girls

Despite the rule changes, the June 7–10 endurance run of 409 miles from Richmond to Raleigh, North Carolina, and back is marred by more serious mechanical mishaps and physical injuries. The course runs through Emporia and Panacea Springs, Virginia, and the North Carolina towns of Littleton, Henderson, Raleigh, Durham and then, back in Virginia, Clarksville, South Hill and Lawrenceville. At every stop along the way, the fourteen cars are greeted with enthusiasm, flowers, speeches, food and drink.

In Durham's Lakewood Park, the drivers are fêted at a barbecue underneath a shady grove upon the sloping lawn with a thousand people in attendance. "Knowing that the thirst of a journey is a staying thirst," writer A.R. Mackreth writes, "the committee of arrangements had also supplied plenty of soft and malt drinks to appease the appetite and wash down the dust of travel."

At a fifteen-minute control point in South Hill, the tourists are welcomed by a bevy of girls and young women, all dressed in white, who stand on either side of the road and lustily cheer while waving their handkerchiefs. There, in a tobacco warehouse, ice cream, cake and lemonade for "twice the number in the party" and the eagerness of the hostesses seem to indicate that there is nothing they "could and were not willing to do." When the visitors depart, the young women again crowd to the side of the streets and cheer and pelt the drivers and passengers with flowers. Dr. Stuart McGuire, the pace driver, rises in his forty-horsepower Oldsmobile and sprays out fistfuls of confetti as the line of cars lurches off, and the girls cry, "Goodbye! Goodbye!"

The mess of Virginia's highways receives plenty of press. "This is Virginia," remarks one passenger in a dismal tone when his car crosses into the state during the return leg. "I know it by the roads."

"Like a Baby Carriage Rolling Down Steps"

This tour begins just as the one in May; the lineup includes the makes of Rambler, Speedwell, Chalmers, Hupmobile, Cadillac, Hudson and one hapless White "Special." Ahead of them all comes Dr. McGuire in his Oldsmobile, goggled and gauntleted, a linen duster streaming behind. Few onlookers would recognize him as the dignified Richmond physician and head of St. Luke's Hospital, on Grace between Harrison and Ryland Streets.

Outraged hens ahead and dust clouds billowing behind his horseless carriage mark McGuire's passage; those on the roadside gasp, field hands fall to their knees in prayer, mules waken and take to the woods. Among the competing cars, springs break and axles snap. T.E. Williams's Buick suffers fourteen punctures in one stretch of road. He seals them with patches and rubber cement, pumps them up by hand and gets on his way. Motors are taken apart and put back together again more than once.

While at the wheel of a White "Special," the rigors of the first one-hundred-mile leg overcome board of health clerk and novice driver Coleman Cutchins. The passengers are observer W.B. Nelson, Allen Potts and R.B. Allport. Outside Littleton, North Carolina, Cutchins loses consciousness, and the car drives on for perhaps a mile and a half, kept straight by its wheels fitting in the straight dirt road's deep ruts.

When the car ahead signals the need to slow due to a gentle rightward curve, Cutchins cannot respond. None of the passengers realize that Cutchins is out. The White, left to its own devices, barrels straight along at between fifteen and eighteen miles an hour. The car leaves the road and runs thirty-five feet along the slope like a baby carriage rolling down steps.

Allport jumps from the car, but rolls headlong down the embankment. The others stay onboard as the car reaches the bottom, snapping an axle and breaking its headlamps, and jerks to a fast halt in red clay. Cutchins falls out of the car, Potts gets jettisoned across the railroad tracks and Nelson slides across the bonnet and comes to rest with his head on a railroad tie.

Traveling behind the White is John D. Alsop's Speedwell, and Mackreth, the newspaper reporter, and those who witnessed the wreck think the car's occupants are dead. But Cutchins rolls over and groans. Allport and Nelson are pale, although their faces are covered with blood. Potts pops up from the railroad track, but livid pain drops him. Rushing up is Dr. J. Fulmer Bright—a future mayor of Richmond—who tends to the injured.

Potts's wrist is sprained and his flesh purpled; Allport's collarbone is broken; Nelson fractured a wrist; and Cutchins, dug from the mud, is bruised. All

the men are shock. Cutchins recovers enough by evening to appear at the dining room of the Panacea Hotel, where cheers and foot stomping greet his entrance. All except for Potts are put on the first train back to Main Street Station and St. Luke's.

Busted Shoulders and Broken Axles

The contest continues without major incident, and the cars reach Raleigh at four o'clock on June 8, met by a contingent of auto-borne officials who guide them into the city. Mackreth notes that the six women taking part in the contest "have not suffered and appear to be in the pink of condition." Members of the endurance party are entertained at the Yarborough Hotel, and the men attend a smoker at the Elks Club, while the Women's Club calls upon the ladies.

A blinding downpour between Raleigh and Leesville forces those cars with tops to button up and beat along the road as best they can. By Durham, the rain tapers off, though the closer to Virginia, the road quality is "so abominably bad that it is surprising some of the smaller car were not stalled." Outside Clarksville, the night stop, even the larger cars strain to move up mud-thick hillsides. The cars send planks flying as they cross bridges.

The last leg is the longest and worst of the whole trip. The roads from Clarksville to Boydton are abysmal. Drivers steer clear of potholes two feet deep and, as Mackreth describes, "stumps and stones which have been in the roads since the time of Father Abraham." Just beyond South Hill, T.E. Williams's Buick loses its left front tire and goes into a frightful skid that lands the machine in a ditch. The day's observer, B.W. Wilson, pitches headfirst out of the car, landing twenty feet away with an audible thud and breaking his shoulder.

The endurance cars stagger into Richmond on June 10 from five o'clock in the evening to ten at night. A few are not able to make it. Rainwater in the gas tank of Thomas S. Stagg's Regal stalls the car for a long while. He leaves Clarksville with a bent axle and is reported stuck in Dewitt, twenty miles south of Petersburg. Nothing is heard from him until he arrives in Richmond on June 11. When crossing a dilapidated bridge, one of the competition's big Maxwells upends a plank that smashes a hole in its crankcase, and the car is laid up in Petersburg. The White arrives, like some of its riders, by train but gets driven to a Richmond garage under its own power. Another heavy rain near Petersburg soaks latecomers. The women who ride alongside husbands or brothers appear less fatigued than their male companions and in fine fettle, despite the downpour.

The recipient of the big cup is L.M. Foster, driver of a Buick 17, upon whom the judges confer a perfect score.

"Russian Like Procedure..."

Adon Yoder underscores in the September 1910 *Idea* how the automobile reflects class consciousness by showing the disparity of punishments between an automobilist found guilty of reckless speeding and a wagon driver. The motorist's number is taken and the offender reported, but often without legal action. If this occurs, the owner who appears in court most often claims that he was not in the car at the time and that other people were driving, and the guilty party is not brought to justice.

A very different story occurs when, one day, a livery wagon driver gets the reins stuck in the horse's tail. The animal runs two blocks before being halted. Then a policeman arrests and handcuffs the driver and, leaving the horse on the street, hauls the driver into the city lockup, where he is refused a telephone call. Bail cannot get arranged until eight o'clock the next morning. Without time to find witnesses, the man goes to court with his word against the policeman's, who cites the arrested man for reckless driving.

"On this charge and after such Russian like procedure," Yoder recounts, "the driver was fined $10.00. Then he had to go to Bliley's Livery and pay Bliley, the councilman, for keeping his horse." On top of everything, the driver discovers that a gum coat and whip he left in the wagon are gone. All this indignity occurs because, perhaps by accident, he made a technical violation of a statute that by contrast an autoist is sometimes reported, and other times fined.

Yoder asserts that nobody should receive such demeaning treatment, rich or poor, bond or free, black, white or yellow. He goes on, "From our close observance of the procedure of police and courts in Richmond, it depends almost altogether on your standing with the powers that be whether you get justice or not...The Virginia negro known to the judge sometimes gets justice while the North Carolina negro is convicted at birth."

"A Magnificent Animal"

Meanwhile, those Richmonders of an artistic inclination are endeavoring to interpret their experience to a wider world. Novelists Ellen Glasgow, James Branch Cabell and Mary Johnston approach their Richmondness with perspectives that are provocative, fantastic and even heretical.

The woman within. Novelist Ellen Glasgow, in a 1921 painted portrait. A proponent of neither moonlight nor magnolias, the quick-witted, omnivorous observer wrote of a corrupted old world transforming into a crass new order and, as an artist and activist, she tried to negotiate the way between the two. *Courtesy of the Virginia Commonwealth University Cabell Library Special Collections and Archive.*

Cabell and Glasgow grew up a few blocks apart and in similar circumstances. Glasgow was the fourth daughter and eighth child of Francis Thomas and Anne Jane Glasgow. Her father is one of the managing directors of Tredegar Iron Works, whose position allows him to make a home in the serious Greek Revival mansion at 1 West Main Street. Ellen is the artist in the family. While she is not quite a bohemian—she is a Richmonder, above all—her fiction unravels the circumstances of how families like hers came to their situation. Some of her central questions are: How does a tradition-bound culture collide with a chamber of commerce–driven aesthetic? How can the dying society preserve some semblance of dignity, absent its preoccupation of keeping women repressed and treating animals as nonconscious creatures?

Glasgow's *Romance of a Plain Man* appears in Richmond bookstores by May 1909. A young woman who considers herself fashionable, perhaps riding the streetcar to an office downtown and wanting to exhibit herself as *au courant* in a Richmond-styled way, could have been a reader, and a discerning one, at that. *Romance* sells just twenty-three thousand copies nationwide. Macmillan Publishing doesn't quite know how to sell the novel, in particular because bookstores are holding unsold copies of Glasgow's previous mystical meditation, *The Ancient Law.*

Glasgow strives toward several accomplishments at the same time with this book; as an artist, she's seeking another way of writing while addressing topics of the day. Her desire is to universalize—as she says—the personal. *Romance,*

too, is a Richmonder's Richmond book, though the few Richmonders who may have read the story would not have liked it much.

The narrative is expressed in the first person of a man growing up impoverished on one of Church Hill's lesser streets following the Civil War. This, too, made Glasgow examine issues close to her, like women's suffrage, through perspectives that do not mesh with her own, somewhat like an actor coming to terms with a character's motivations that are contrary to the performer's own beliefs. One brief scene inverts the sentimental theme of moonlight and magnolias that has dominated Southern literature—until this moment. This comes late in the story, when the protagonist, Ben Starr, learns that his and his wife Sally's infant son is dying. Starr, a man who wants to control everything, paces by Sally's bedside, enraged and impotent.

"At that moment I longed to knock down something, to strangle something, to pull to earth and destroy as a beast destroys in a rage. Through the open window I could see a full moon shining over a magnolia, and the very softness and quiet of the moonlight appeared, in some strange way, to increase my suffering." Unable to do anything of importance, Starr crushes a moth flittering about the room at the instant his son dies.

Starr's primary romance is with capitalism, represented here by former Confederate General George Bolingbroke. Bolingbroke is the blustering president of the South Midland and Atlantic Railroad. Starr as a youngster meets the general while running from his impoverished and abusive Church Hill home.

Starr's secondary romance is with Sally Mickelborough, who is from a Richmond family of history-encrusted lineage and is described as "soft as velvet, but inflexible as steel." Their chance childhood encounter alters Starr's life because of her dismissive attitude toward him. He becomes obsessed with triumphing over his background. He repeats the name of Bolingbroke's rail line like a mantra for power.

Sally's relations have little regard for Starr's "common" upbringing. Her social set considers him a magnificent animal with no social manner. She, too, wants to break free of future-strangling sentiment and archaic manners. Sally demonstrates her break with the past by desiring marriage to Starr. She declares to her maiden aunts—one of whom is portrayed as a somewhat batty suffragist—"What do I care for a dead arm that fought for a dead king? Both are dust to-day, and I am alive." She continues, "Is family tradition, after all, as good a school as the hard world? A life like Ben's does not always make a man good, I know, but it has made him so."

Starr is a man of the present, and through his efforts, he is dispersing the Civil War ghosts that fog progress. His material success comes through hard labor and a disregard for most people. The young man's ambition is goaded

by his memory of poverty, but his arrogance causes a devastating reversal that destroys his finances and his psyche. The spirited Sally, who throughout the novel expresses her lack of concern for the trappings of wealth, is forced to take in laundry to make ends meet.

Perhaps the most romantic aspect of the novel is its conclusion, which steers away from a complete tragedy. Sally's body and health are wrecked. A New York medical specialist advises Starr to take her to Southern California. She does not need an operation, but constant tender care. Starr eschews the coveted presidency of the South Midland and Atlantic Railroad at the moment of inheriting the position, choosing instead to meet the needs of his stalwart but suffering Sally.

"Compelling Physical Magnetism"

Glasgow travels, but she is a lifelong resident of a city that frustrates her. Biographers and critics suggest that the character of Ben Starr is based upon Glasgow's mysterious lover, whose identity is known only as Gerald B. They met in New York during early 1900 and the effect upon her was immediate and "transfigurative." He had read her first two novels, *The Descendant* and *Phases of an Inferior Planet*, but could not quite explain what he found in them. Despite her increasing deafness—she was just twenty-seven at the time—Glasgow heard Gerald B.'s every word. The two were not intellectual equals, but a "compelling physical magnetism" made their amorous collision a certainty.

Petite, brown-haired, dark-eyed and round-faced, Glasgow was not a belle, but her natural Richmond charm and alacrity with language and ideas made her an extraordinary conversationalist. Gerald B. seems to have worked on Wall Street and made a fortune, and he was married and the father of two college-age sons. The relationship both invigorated and tormented Glasgow. Her 1998 biographer, Susan Goodman, explains, "An affair—requited if probably unfulfilled—had its advantages, making her the heroine of her own drama, while reinforcing the complex and romantic vision she had created of herself: a woman at once desirable, rebellious and plagued by tragedy." According to Glasgow's biography, *The Woman Within*, Gerald B. died in 1905.

All the efforts by literary detectives to identify Gerald B. have failed, to the extent that some have suggested he never existed. Was he Glasgow's massive research project to get inside a man's head? Male reviewers of *Romance* could not take Ben Starr with seriousness and insisted no woman could render a man's thought processes. Yet in 1913, Glasgow submits to three male poets a poem titled "Albert of Belgium," under the name of John J. Newbegin, Esq. They accept the poem.

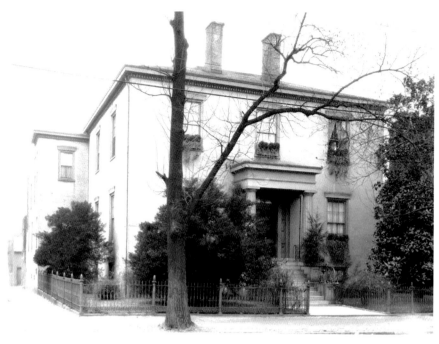

House of spirits. The home at 1 West Main, Ellen Glasgow's lifelong residence, which stands little altered from her day. *Courtesy of the Virginia Commonwealth University Cabell Library Special Collections and Archive.*

Glasgow's writing in *Plain Man* is too subtle for satire, too realistic for romance and gives short shrift to the Lost Cause. Glasgow is not glorifying what she sees as an undeserving past, but she is unable to express much enthusiasm about a future that seems destined for incivility and crass commercialism. Her art mediates and negotiates the chasm between what was and what is not yet.

Romance describes lush gardens and the springtime streets of Richmond. The narrative is garlanded by descriptions of plants and flowers and references to parrots and canaries in golden cages. The tangy smells of an East Main Street tobacco stemmery, the down-at-the-heels First Market, the mansions of Franklin Street and the sacred, shaded streets of Hollywood Cemetery are all familiar sensations to many 1909 Richmonders.

An amusing scene between Bolingbroke and the eccentric Dr. Theophilius remains familiar in today's Richmond, as they engage "in a violent controversy over the departed residents of Church Hill." At issue is whether Bushrod or Robert Carrington lived in a certain big house, and while endeavoring to show how well they knew the brothers and their personal lives, they reveal gossipy intimacies of the brothers' characters.

Theophilius recalls how Robert was married unhappily to Matty Price. He tended on Robert during his final illness and on his deathbed the dying

man said he would do it all over again. "'I never had a dull moment after I married her, doctor,' he said, 'I lived with her forty years and I never knew what was coming next till she died.'"

General Bolingbroke snorts, "Robert was a fool...a long white-livered, studious fellow that dragged around at his wife's apron strings." Bushrod was a real man, "the greatest dandy and duelist in the state," who bought his clothes in Paris.

Theophilius makes the rueful remark about Bushrod, "A sad scamp, but a good husband." He cannot remember Bushrod's wife's name, which Bolingbroke supplies. "No, Bessy Randolph was his first flame, and when she threw him over for Ned Peyton, he married Bessy Tucker. They used to say that when he couldn't get one Bessy, he took the other." In order to settle their argument, the two old men must, in the heat of the day, visit St. John's Cemetery to see the Carringtons' tombstones.

In another scene, General Bolingbroke is giving the Starrs a tour of the countryside near Richmond where the old tycoon grew up. They pass the schoolhouse where he learned his first lessons from Miss Deborah Timberlake, who elected to teach, though her husband provided well for her. "Taught us English history, then Virginia history," he reminisces. "As for the rest of America, she used to say, it didn't have a history, merely a past. Mentioned the Boston tea party once by mistake, and had to explain that *that* was an incident, not history."

London Sojourn

During the spring of 1909, Glasgow is in London with childhood friend Elizabeth Patterson, in part to meet leaders in the English suffrage movement, but also to escape family problems and to search out means to alleviate her deafness. In Richmond, within the solid walls of 1 West Main, Glasgow's frequent travel companion, her sister Cary, is dying of cancer. Her brother Frank is exhibiting signs of depression. On April 7, he alters his will to ensure a $1,000 income for his sisters and then goes into his office at Tredegar Iron Works and shoots himself. The newspapers attribute his despair to lingering effects from typhoid fever.

Glasgow decides that she cannot accomplish anything by returning to Richmond. The experience of this family tragedy from such a distance seems to burrow worry lines into her smooth face overnight. She nonetheless maintains her itinerary. During her weeks in England, she makes the acquaintance of poet and novelist May Sinclair, active in the Women's Freedom League and the Women Writers' Suffrage League. Glasgow also

discusses the movement with women who put their bodies on the line for their civil rights, the leader of the Women's Social and Political Union, Emmeline Pankhurst and Lady Lytton. At Sinclair's invitation, Glasgow joins a suffrage march. Sinclair counsels Glasgow that she walk away prior to the end because of the potential for arrests. The event exhilarates the Richmonder. She is united with thousands of women motivated by a mighty and just purpose.

"Subject to the Democratic Primary"

James Branch Cabell draws his inspiration from Alexandre Dumas, Sir Walter Scott and all the world's mythologies, but also the front-parlor ruminations of relatives recounting the Arthurian tales of their Confederate youth. He parlays all of these into a sprawling epic fantasy of Dom Manuel the Redeemer of Poictesme and his descendants. This endeavor was, in small part, an extension of his fascination with genealogy, which came as a matter of course for someone descended from the Branch and Cabell bloodlines that had produced a governor, legislators, soldiers and businessmen. He has two older brothers, Robert Gamble III and John Lottier. His parents, physician father Robert Gamble II and Anne Harris, separated and then divorced in 1907.

He was raised in the distinguished three-story urban manor of 101 East Franklin Street, some three blocks from Ellen Glasgow's house. The

Hamlet's uncle. James Branch Cabell, fabulist, circa 1910; during this period, his fiction is diverging from stories of sophisticated romantic roundelay among the fashionable, rich and unemployed—which in some ways was as much a fantasy as his works become, set in the mythical realm of Poictesme (Paw'tem). Cabell is both ahead of and behind his time, which, as a Richmonder, is appropriate.
Courtesy of the Virginia Commonwealth University Cabell Library Special Collections and Archive.

Richmond Public Library is built on the site, and Cabell later jokes of his nativity in the rare book room.

His writing is often a guise for pointed satire and of people's willingness to be deceived. While he is working on these particulars, Cabell writes comedies about morals and mirth. Cabell's short stories appear in such magazines as *Harper's Monthly*; in April's issue, "The Satraps" is published, and others will follow. The thirty-year-old Cabell is emerging from a perceived slump of just three published stories in the previous year. He lives with his mother at 1509 Grove Avenue.

Cabell's novel *The Cords of Vanity* comes out in March 1909, set in Lichfield, read Richmond, and traces the development of a young man quite like the author in the guise of Robert Etheridge Townsend. He leaves Kings College in Fairhaven (the College of William and Mary in Williamsburg) to seek love and experience in the wider world, and tries to understand how he and his hometown may relate. Cabell's tone is witty, acerbic and even ironic, and his satire, while directed at Lichfield/Richmond, is less sharp than later fiction allows him.

"I had designed to be very droll concerning the 'provincialism' of Lichfield," Cabell explains in *Cords*; "for, as every inhabitant of it will tell you, it is 'quite hopelessly provincial,'—and this is odd, seeing that, as investigation will assure, the city is exclusively inhabited by self-confessed cosmopolitans."

Townsend is a fashionable young cynic who, being an artist, must find a woman who can allow him to "adopt infancy as a profession," as one of the would-be wives rebukes him. His course in fiction is narrowing due to the average reader's disdain for adventurous reading. He criticizes his mentor, John Charteris, an older accomplished novelist, because Charteris doesn't understand that contemporary fiction is "a mere diversion of the mind" and writers are "really druggists who trade exclusively in intoxicants and hypnotics."

He continues, "Half of the customers patronize the reading-matter shops because they want to induce delusions about a world they know, and do not find particularly roseate; and the other half skim through a book because they haven't anything else to do and aren't sleepy, as yet."

Cabell portrays provincialism in Townsend's encounter with Mrs. Adrian Rabbet, wife of Fairhaven's rector, following a performance of *Romeo and Juliet*. She chirps, "Such a sad play, and do you know, I am afraid it is rather demoralizing in its effects on young people. No, of course, I didn't think of bringing the children…Shakespeare's language is not always sufficiently obscure, you know, to make that safe."

Cabell holds too much filial affection for the city of his nativity to poke more than gentle fun. He writes that Richmond and Williamsburg "got at and

into" him when he was too young to defend himself. Neither he nor Glasgow makes Richmonders into Southern eccentrics such as later novels of Carson McCullers and William Faulkner. Cabell explains that to the contrary, *other* cities, when judged by Richmond's standards, seem a bit odd:

> *I am too familiar with these places to attempt to treat them humorously. The persons who frequent their byways are too much like the persons who frequent the byways of any other place...For to write convincingly of the persons peculiar to any locality it is necessary either to have thoroughly misunderstood them, or else perseveringly to have been absent from daily intercourse with them until age has hardened their brain-cells, and you have forgotten what they are really like. Then, alone, you may write the necessary character studies which will be sufficiently abundant in human interest.*
>
> *...So I may not ever be so droll as I had meant to be; and if you wish to chuckle over the grotesque places I have lived in, you must apply to persons who have spent two weeks there, and no more.*

Cabell provides a proto-Fitzgerald glimpse into the *nouveau riche* while Townsend visits the beach with the family of one of the several women he pursues and dismisses. Along for the summer are friends, including a St. Louis brewery owner. Townsend observes, "They all looked so unspeakably new; their clothes were spic and span, and as expensive as possible, but that was not it; even in their bathing suits these middle aged people—they more mostly middle-aged,—seemed to have been very recently finished, like animated waxworks of middle-aged people just come from the factory. And they spent money in a continuous careless way that frightened me." But, he goes on to say, he is never allowed to pay for anything.

The St. Louisans are properly impressed when Townsend is presented as one of "the Lichfield Townsends." Cabell/Townsend recalls, "One of them—actually—supposed that I had a coat of arms; which in Lichfield would be equivalent to 'supposing' that a gentleman possessed a pair of trousers."

When a woman whom Townsend is wooing with something that passes for ardent intentions rejects his marriage proposal, he attempts to negotiate by explaining all he would concede to do, including become a prominent citizen. If she insists, he will even go into civic politics "and leave round-cornered cards at all the drug stores, so that everybody who buys a cigar will know I am subject to the Democratic primary. I wonder, by the way, if people ever survive that malady? It sounds to me a deal more dangerous than epilepsy, say, yet lots of persons seem to have it."

"Perpetual Escape from Actuality"

Reviewers of *Cords* describe the novel as plotless, tedious, laden with epigrams and puns and over-clever turns of phrase. At least H.L. Mencken recognizes the book as "head and shoulders above the common run of department store fiction" and acknowledges Cabell as a true craftsman.

Undisguised biography surfaces within the book as Townsend muses upon how Lichfield "knew a deal more concerning my escapades than I did. That I was 'deplorably wild' was generally agreed upon, and a reasonable number of seductions and murders and sexual aberrations as, no doubt, accredited to me." Cabell references here a complicated series of events of his younger days that in Richmond remained part of public knowledge and affected how he chose to live in Richmond and how the portion of the city's public that indulged in novel reading regarded Cabell.

During the final weeks of his senior year at William and Mary in 1898, rumors circulated within the university about "certain practices alleged to have been in existence between students and certain college officers." The gossip may have started after a party Cabell hosted for the Kappa Alpha fraternity. Though a state institution, William and Mary relied on funds from Baptist and Methodist legislators. An investigation was undertaken by faculty members to determine if the talk contained any truth. The action riled the student population and caused one faculty member to quit and another to flee. At least four students resigned, including Cabell, though in the end, the faculty admitted that its investigation found nothing.

Cabell's recent biographer, Dr. Edgar MacDonald, notes, "The trial of Oscar Wilde a scant three years before branded as a pervert almost anyone considered an esthete." At no point in the days of discussions about the incident was mention made of the cause, and the word "homosexual" never materialized.

Cabell's mother, Anne, interceded. She hired a Richmond lawyer, and Cabell wrote a letter to the faculty asking for reinstatement that was accepted. He had socialized with a small group of people in Williamsburg, and now most of them were gone and few residents acknowledged him. Even his love interest of the time, a physician's daughter named Gabriella Moncure (to whom *Cords* is dedicated), stopped speaking with him.

Ellen Glasgow called upon Cabell in Williamsburg while there researching her third novel. She recalled, "He had, even then, that air of legendary remoteness, as if he lived in a perpetual escape from actuality." She was young enough to see in Cabell a romantic figure, innocent but persecuted.

Glasgow concluded that there was not a shred of evidence to connect Cabell to the scandal. "There was, indeed, not anything more compromising than a shared preference for *belles-lettres*."

The second event involved the 1901 murder of John Scott, a prominent and dissolute Richmonder. Scott, after a night of drinking at the Commonwealth Club and while attempting the walk home, had the indecorousness to drop dead with a shattered skull at the front door of Richmond, Fredericksburg and Potomac Railroad chief Major E.T.D. Myers, on the corner of Franklin and Belvidere Streets, and next door to where the Cabells then lived. Scott's final screams and his fearful pounding on the Myerses' door jolted the slumbering neighbors.

"Rumors that Connect You with the Death of My Brother..."

Rumor, fanned by incomplete and speculative newspaper reporting, implicated Cabell as the murderer because of Scott's supposed intimacies with Cabell's mother. Scott was also her cousin.

A man in a gray overcoat had been seen near the Cabell house prior to the murder, and stories surfaced about Scott having affairs with two women, one married and one not, who lived in the country.

The private detective hired by the Scotts came to a conclusion that was never made public. The matter dropped from the papers with the same abruptness with which it had first appeared. That should have been the end; except that Richmond never forgets.

In February 1910, Cabell's younger brother, Robert Gamble III, is preparing to marry Maude Morgan, a young North Carolina woman from money and with connections to New York and Richmond. The Morgans have asked Cabell to produce an affidavit that he was not the murderer of John Scott in revenge for an affair with his mother. As MacDonald puts it, "Annie Cabell had to make the painful confession to her incredulous son that he was indeed suspect to the social circles that mattered."

The single person in Richmond who can clear up this mess is Anne's cousin, Fred Scott. Mother and son each write a letter to Scott explaining the situation and assuring they wish nothing made public. Then Anne goes off to Atlantic City, for her health, she says, but also perhaps to escape admonition for her alcoholism.

What follows is a bizarre correspondence of messages and letters that cross in the mail and further complicate an already difficult situation. Cabell

receives a call from Blair Stringfellow, Scott's brokerage partner, informing that Scott was writing a letter. A letter dated March 9 is received by Anne from Scott that, in part, says, "In the investigation which I made of the facts and circumstances attending the death of my brother John nothing developed that connected any member of your family with the affair."

Cabell understands from Stringfellow's call that he, too, will be getting a letter. When none arrives, he sends a typed note to Scott's 810 Park Avenue home that is one long sentence. He addresses it for return to himself, hoping that Scott will sign the following statement:

> *Having heard of certain rumors which connect your name with the death of my brother John W. Scott, I desire, in justice to you, to state that, in the thorough investigation which made all the facts and circumstances attending the occurrence, no reason was developed for supporting you could have any motive for, or could have played any part whatsoever, in the bringing about of this event.*

Scott does not sign the letter but instead consigns it to his files, where the document remains until after his death. Cabell writes again on April 10, telling how he had understood from Stringfellow's telephone message that Scott intended to write letters both to Anne and he. Cabell does not feel that it is an exorbitant request to be absolved of any association with the 1901 murder.

Anne Cabell is then asked by Fred Scott if she has received the letter exonerating James. She replies that she had forwarded the letter, but Stringfellow interfered. She chastises Scott that if he had a quiet conversation with her and James at the beginning of all this, such distressing miscommunications could have been avoided. "The matter has been very more far reaching than you can possibly imagine and one that only perfect frankness can eliminate," she writes.

Scott then dispatches a copy of his March 9 letter to Robert Gamble Cabell III for presentation to his anxious in-laws. As MacDonald puts it, "Fred Scott made a fine distinction: a personal note to the mother of the aggrieved son was a private matter between relatives; a formal statement to James Cabell could be regarded as a document intended for public scrutiny." Mother and son know the difference, although both desire a public exoneration to quiet the susurrus of gossip.

Anne wants the last word in the matter, and on June 3, she sends a letter to Scott's office saying that she shall not hesitate "to discuss the matter with any of my friends or relatives who have my interest at heart. I consider it is only fair to write you this."

Cabell, for the remainder of his creative life, deals with plots involving his characters' perceptions of their world, the nature of reality itself and how people create realities to suit themselves. Cabell dedicates his recent collection of fantasy stories, under the ironic title of *Chivalry*, to his mother, an "excellent and noble lady." The volume is released for Christmas, bound in red and green, and with some of its twelve-color illustrations by the artist Howard Pyle. Cabell, in one of his elaborate prologues, explains how fourteenth-century monk Nicholas de Caen originated the ten stories. His density of fake proof persuades several critics of the narrative's truth.

"Prisoner of Hope"

Between the realism of Glasgow and the sardonic wit of Cabell, and their complicated perspectives on Richmond's milieus, is Mary Johnston, whom critic Lawrence G. Nelson later describes as "a deeply grained Virginian and a clear-eyed realist superbly fitted by heritage and training to recreate in tragic romance the history of Virginia and the South. Another sees her as a "transcendental dreamer and hard student of historical happening, a strong-minded feminist who celebrated the heroic virtues of men, gentle and simple, aristocrat and commoner." Like Glasgow, she never marries, and if Johnston engages in love affairs, they do not rise into the record. She is an ardent champion of civil rights who, in her journal of 1910, writes, "I will sooner or later find myself identified with the [socialist] movement." As historian Wallace Hettle describes, "Johnston thought the vote for women could advance the cause of peace…the militarist…is opposed to the political theory of women." She insists that leaving black and working-class women out of the suffrage question is self-defeating.

Mary Johnston was born November 21, 1870, in Botetourt County, Virginia, the eldest of six children and cousin to the peevish Confederate General Joseph Eggleston Johnston. Her education for the most part took place in her father John William Johnston's well-stocked library. He was a former Confederate officer and held public and business posts requiring travels to Europe, New York City and Richmond. Mary took charge of the household after her mother Elizabeth's 1889 death. Financial necessity drove the writing of her earlier books. Johnston's heroine protagonists tend to be strong-willed women caught in difficult circumstances.

Johnston's first novel, *Prisoners of Hope* (1898), a mistress falls in love with indentured servant yarn, was produced to make money. But the 500,000 copies of 1900's *To Have and to Hold* make Johnston known and secured her finances.

To Have and to Hold's fast-moving story, set in early colonial Virginia, concerns the plight of Jocelyn Leigh, who is sold to a Jamestown settler as she flees a forced marriage in England. The plot involves attempted kidnappings, shipwrecks, pirates, ocean battles and Indians who plan to wipe out Jamestown. The novel receives two silent screen adaptations in 1916 and 1922. The 1916 version features the screen debut of Mae Murray from Portsmouth, Virginia, who became known as the "Girl with the Bee-Stung Lips."

During 1910, Johnston plots a Civil War trilogy to portray the conflict in a manner not redolent with Lost Cause wistfulness. Her vision is to recreate the war not as a glorious event, but as one of tragedy with a hint of the absurd. This approach is what gets this member of the United Daughters of the Confederacy into some serious trouble and makes her the recipient of a public denunciation from a living symbol of the Lost Cause.

"Not Even by the Devil Himself"

I love the wild the race
With the hounds on the chase
But love not the glory of game,
I glory to fight
For honor and right,
But I love neither honors nor fame.
—*Adon A. Yoder,* The Idea, *July 3, 1909*

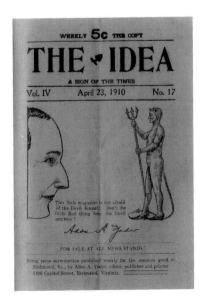

Beat the devil. Yoder underscores his willingness to go one-on-one with evil incarnate to clean up Richmond. *Courtesy of the Library of Virginia.*

Police Chief Louis Werner wants to see an issue of *The Idea* before its premiere number hits the streets and calls upon Adon Yoder in the Capitol Street print shop the night before publication. Yoder is leery of releasing a copy until the day of sale. The editor thinks better of it, hands the chief a paper and Werner promises not to show anyone until Saturday. Soon after, according to Yoder, *The Idea*'s front door is graced by a policeman and Yoder's shadow is doubled by a detective. The editor's reputation precedes him.

In June 12, 1909's *Idea*, Yoder gives the major difference between his publication and the rest of Richmond's papers: "THE IDEA is different in that it is just like you and I talk on the street and you and I know that we've been saying things on the street for years that never got aired in the daily press just because the daily papers are so short-sighted as to think that if they ever published facts which blamed any individual they would lose by it." *The Idea* is, Yoder is fond of saying, gotten up by the minority for the benefit of the majority—news for the rest of us.

Yoder writes *The Idea* himself, sells the ads and prints the publication, first at the Park's offices and then a few doors down in the basement of the Ford Hotel, both facing on Capitol Square. He recruits sales boys, arranges prizes to give away for those who sell the most and, when events turn, complains of their harassment by other publications' sellers or their henchmen. He collects damning information from sources he does not name. He cannot be intimidated by anybody, "Not even by the Devil himself or herself, as the case may be."

He assails Richmond's social establishment, newspapers and government. He sees corruption almost everywhere and all the time, and he is not too careful in identifying those he believes responsible for public malfeasance. Yoder contends that the acts of officials are public property, "and when, by giving them publication, we think we can accomplish a public good, we shall hesitate at nothing."

Mayor David Richardson is criticized in almost every issue. Richardson, by Richmond charter, is a referee between the two-chamber Richmond legislature. His authority is limited but includes ensuring that the city's officers fulfill their obligations. Yoder blames Richardson for lax enforcement of laws, in particular those governing the houses of ill fame clustered in Shockoe. Any person found guilty of maintaining such a resort is by law to receive a year in jail and a $200 fine. The courts have determined that not even proof of specific acts are required, nor names of the persons going to the place; just the character of the house is enough to convict.

Yoder, the intrepid reporter, goes to the tenderloin quarter. He sees women sitting in the street drinking wine and giving bold acknowledgement of their shame for money to passersby. A policeman is holding conversations with two of the women on their porch, while another seems to be taking in the sights from his stand against the building. That this can go on, for years, exasperates Yoder. There is a ring of influence behind Richardson, Yoder says, making it impossible for him to hold office and enforce the law.

Yoder makes his own modest proposal. If the Richmond police will not break up the red-light district, then make it legal and the city's coffers profit. He suggests charging $500 to license each of Richmond's two hundred houses of ill fame. Employing some five hundred harlots, they would generate a revenue of $100,000, which would cut down the tax rate. If the city has not the courage to end the social evil's scourge, then it must adopt a different tactic.

"As we have stated before certain laws are not enforced at all in Richmond," Yoder observes on July 24, "because those in charge think they have a right to 'use their own discretion' in refusing to bring to justice those who violate the following laws: (1) The Gambling Laws; (2) The Sunday Closing Laws; and (3) House of Ill Fame Laws."

Police Commissioner Gilbert K. Pollock gets all manner of charges leveled against him, mostly in what would be called today influence pedaling. "He is popular because he is too shrewd and cunning to ever give offense," Yoder

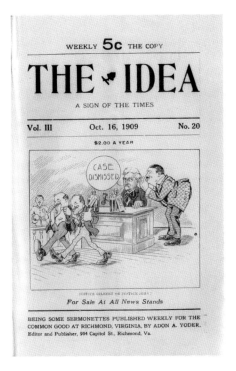

"Case Dismissed!" *The Idea* takes on police court justice on illegal liquor dealers. Judge Crutchfield listens to the persuasion of the slick attorney and Police Commissioner Gilbert Pollock, while the proud scofflaws go free. *Courtesy of the Library of Virginia.*

explains, "and he wields his sceptre by his amazing suavity and his ability to mislead, which his legal training has given him."

Yoder is particularly pointed in condemnation of Judge Crutchfield. Week after week, Crutchfield's whimsical approach to law frustrates and enrages Yoder.

The Crutchfield method of justice in his court is a training ground for numerous Richmond journalists. One observer is James Branch Cabell, who by 1901 was the police court reporter for the *Richmond News*. Cabell sat in the small "press pen" for six mornings every week at Crutchfield's feet. He credits the experience, he recalls in a later autobiographical sketch in the third person, with teaching him how to write.

The writer viewed the courtroom proceedings as "life quintes serialized, and condensed into a matinée." The judge is

> *as famed for his trenchant observations as for his profoundly informal administration of justice as he sees it irrespective of any existent statutory laws. The follies and crimes, the whims and sufferings of humanity—white, black, and intermediately shaded—were unveiled there, hour after hour, in multifarious parade, and were dealt with summarily, but in the main with understanding and sympathy...and contemplation thereof afforded the young reporter to write daily some three or four thousand words, in which he handled nearly every conceivable happening to, and combination of, human being. Thus it was that he learned how to approximate the telling of a story in its most generally appealing form, by a daily effort toward, and a daily falling-short, of doing it.*

The picaresque scene inspires Yoder to splenetic outrage. He observes Crutchfield and Pollock whispering to each other or passing notes, and thus a case is decided. Yoder cries that Pollock's power should be destroyed and Crutchfield's idiosyncratic behaviors be superseded by justice and dignity.

Councilmen, police commissioners and judges are frequent targets, but another of Yoder's annoyances is incompetence in matters of civic utilities. Richmond's chief engineer, Charles E. Bolling, makes for an alliterative headline with "Bolling's Blunders." Yoder takes him to task for allowing workers to dig up an alley to lay a water line and then coming along a week later to lay gas pipes. Settling foundations of schools, poor road construction and faulty sewers are all examined by *The Idea* and Bolling blamed.

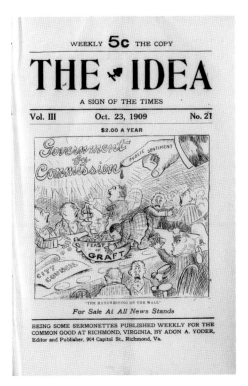

WEEKLY 5c THE COPY

THE ♥ IDEA

A SIGN OF THE TIMES

Vol. III Oct. 23, 1909 No. 21

$2.00 A YEAR

"THE HANDWRITING ON THE WALL"
For Sale At All News Stands

BEING SOME SERMONETTES PUBLISHED WEEKLY FOR THE
COMMON GOOD AT RICHMOND, VIRGINIA, BY ADON A. YODER,
Editor and Publisher, 904 Capitol St., Richmond, Va.

Uninvited dinner guest. The feast of corruption is interrupted by the finger of fate pointing to Adon Yoder's solution to Richmond's problems: government by commission. *Courtesy of the Library of Virginia.*

"Never Been Cursed by Men More Dangerous"

At one point, Yoder calls upon Chief Werner to ascertain why the police are instructed to ignore their duty and their oaths at certain instances. When he asks point blank, Werner replies, as though trying to quote word-for-word what he has been told, "I shall have to refuse to answer you."

"Why?"

"Because you are publishing *The Idea.*"

Yoder informs the chief, in a quiet voice, that other means will be taken to determine why the law is sometimes enforced according to protection being afforded to certain individuals. He hints at a powerful collaboration of lawyers and citizens waiting in the wings to institute a lawsuit against the city.

Yoder arranges a similar conversation with Commonwealth's Attorney Minetree Folks, whom Yoder quotes expressing no opinion as to the mayor's position on law enforcement, nor can he compel the mayor's office in any way. Yoder explains in *The Idea* that Virginia laws stipulate that the state's attorney has the authority to see that the state's codes are obeyed by elected officials. Yoder accuses Mayor Richardson, Folkes and Chief Werner of violating their oaths of office and allowing crime to flourish.

The Idea's three thousand weekly copies disappear almost as soon as they are distributed. Advertisers line up, including Mayo Furniture Co., which sells used items at 1402 East Main Street; cement paving contractor and Yoder's friend for two decades, A.H. Ewing of 32 North Lombardy Street; the well-known Cook photographers at 913 East Main; and C.B. Haynes & Co., 603 East Main, Richmond sellers of the Edison Phonograph.

A hustling newsboy sells 112 copies one summer Saturday for a profit of $2.24, "a good sum for any body these days." Yoder needs boys to work the routes of Barton Heights, Church Hill and the West End, and there is a contest with a watch to gain. People from all walks of life call or write to express their appreciation for Yoder's work.

In July 1909, ward elections are held to fill vacancies on the Democratic Elections Committee. Powerful Clay Ward boss and printing company president Clyde W. Saunders and Madison Ward leader William P. "Dutch" Leaman are up for the slots. But some unusual opposition begins forming, and these stirrings are eagerly flamed by Yoder's editorials. "Richmond has never been cursed with men more dangerous to the cause of purity and civic righteousness," Yoder declares. Andy Griffith, an associate of Saunders, runs a bar, a gambling operation and owns racehorses in partnership with Saunders. A "man of large affairs here" estimates Griffith to be worth $50,000 a year, due to his policy or gambling interests.

On July 27, 1909, Clyde Saunders slaps a $20,000 defamation suit against Rufus C. and R.H. Williams Printing Company. When Williams, quite anxious, informs Yoder of the suit, he is elated. In the July 31 *Idea*, Yoder tells Saunders that if he wants to put him out of business he should sue him personally, not the printer. The problem with Saunders is that with the truth coming out prior to election, he wants to make a show of denial. "Is it worth $20,000 to Mr. Saunders to be a member of the City Committee for one term?"

Besides, during 1903 investigations Saunders admitted that he was paid $1,000 for his services of securing votes in the city's two branches of council. At the same time, Leaman confessed to earning $900 from a similar arrangement. "The Idea *can't* slander these men," Yoder says.

Saunders, the *Times-Dispatch* reports, is "the Nestor of the City Democratic Committee." He has represented Clay Ward for more than fifteen years and his reelection seems given, though unexpected opposition is noted.

"Two Bosses Down"

Statewide primary elections are held August 4. Nomination for the governorship means that the Democratic candidate is assured victory. The

"Let us prey." This Frank Baptist illustration portrays city officials as buzzards feeding off the city of Richmond, presumably represented by William Byrd II, bound by red tape. Byrd grasps the cudgel of "government by commission," the cure for corruption. *Courtesy of the Library of Virginia.*

contenders are George Washington College president, lawyer and former congressman Harry St. George Tucker and Nottoway County Judge William Hodges Mann. Mann stands for Prohibition—if the people demand it. The two fight a prolonged and vigorous campaign. Tucker is favored. Other political contests include those for the Virginia House of Delegates and the city Democratic Elections Committee.

Elections are public events. Outside the downtown newspaper offices, whirring wires bring the news from the precincts, a mighty megaphone is employed to inform the thousands gathered of up-to-the-minute information and running voting tabulation with big blue letters is projected from a glass slide in a stereopticon onto a sheet hanging alongside the *Times-Dispatch* building.

"And they were all there, too," the paper says of the crowds, "the people of the city, and the prophets of honor of the country. From the nearby suburbs, from far-away places, they came to learn the final word in an exciting finish in Virginia politics. Here and there a pretty girl held court out there on the Capitol Square, her admirers completely oblivious to the other issues." A uniformed band strikes up airs of old and the present day, and on occasion strains of "Dixie" waft into the still summer air.

As results are posted, the crowd response alternates in volume and intensity, depending on the energies of the Tucker and Mann cohorts. They

stand with faces glued on the shadowy sheet where a big lens writes the lasts chapter of an arduous campaign.

One disturbance causes portions of the crowd to run pell-mell from the sound of what most think to be a pistol shot. But the sharp report is determined to have come from an automobile backfire.

When the results for Clay Ward's election committee contest appear on the screen later than all the others, and Saunders is shown to be losing, the assembled throng cheers. After the band stops playing and the stereopticon's lens darkens for good, the cold numbers appear in the morning paper. Though Tucker carries the city, he loses the state, and Mann is the next governor. The *News Leader* otherwise editorializes "Two Bosses Down," with reference to Saunders and Leaman's defeat because they had been "Marked for Slaughter" by earlier articles in the newspaper.

Yoder chortles in the August 14 *Idea* that the *News Leader* had stayed silent throughout the campaign and now makes claims based on reflected glory. He uses the newspaper's phrase to make an exuberant declaration and warning: "Marked for slaughter—Saunders Leaman, Pollock, Mills [next name is blacked out]—and a host of others."

Letters of commendation on the unseating of Saunders and Leaman come to Yoder from Richmonders and elsewhere, though either by preference or Yoder's own sense of protecting them, their names are not printed. One says, "Congratulations on defeat of Saunders and Leaman. Fight them to the finish on the suit business." A pastor of a large and well-known church writes, "You did it with your little hatchet! I recognize that ugly scalp hanging at your belt. THE IDEA is rough on grafters. Let it shoot until the last corruptionist expires...I think Richmond owes you a vote of thanks...You see your duty and are bravely doing it."

Richmond's voters ought not to rejoice overmuch in the defeat of Saunders and Leaman, Yoder cautions. There is always a way for unprincipled men in power to overthrow the wish of the people. The boss may be beaten, but lieutenants take his place, and unless the rotten press of Richmond keeps up a consistent and continuing fight for clean government, the situation will worsen. Yoder makes the dark hint that notorious crooked politicians have already threatened to kill him, but that is easier said than done.

"There Is Going to Be Shedding of Blood, Too"

During the sweltering afternoons of August 13 and 14, harsh words between Yoder and his opponents lead to bloody blows, first near the *Richmond News Leader* building and second in the office of *The Idea*. On Friday, Yoder dashes

to the *News Leader* offices to retrieve three hundred pamphlets obtained under false pretences by a clerk to sell an hour and a half ahead of when they were supposed to go on sale.

He encounters "Dutch" Leaman at Ninth and Franklin Streets. Leaman accosts him. "Look here, I want to see you," he demands.

"I have not time to see you now," Yoder says. "I have to see a fellow this minute at the *Leader* office."

Leaman grabs Yoder by the coat and says, "I've got to see you now," and he pulls a copy of *The Idea* out of his pocket. "You write this book, don't you?"

"Yes."

"Well, I'm going to fix you," Leaman says in a threatening manner. Then, without even opening the pamphlet to express his displeasure at any particular statement, he strikes Yoder in the face once, twice. Yoder, smaller and more maneuverable, gives Leaman a blow square on the nose and then gets away and continues his mission at a full run. The lumbering Leaman cannot follow and stumbles into Capitol Square.

At the *News Leader* business office, Yoder asks to use the telephone and remarks in a casual manner to the clerk behind the desk, "I just whipped Dutch Leaman." Whether he means the election, the fight or both is not clear.

On his way back to *The Idea* with seventy-nine retrieved issues, Yoder stops in at the First Precinct and before Squire McCarthy swears a warrant on Leaman for assault. He seems none the worse for the attack, aside from a somewhat inflamed eye and a bloodied cheek. McCarthy asks Yoder if he ran.

"Yes, I ran," he answers. "I can take care of myself all right, but that man is too big and husky for me to fight."

"Well," McCarthy says, "a good run is better than a bad stand."

A *News Leader* reporter sees Yoder as somewhat disheveled but smiling. He asks why Leaman attacked him, and Yoder explains what happened. The reporter asks, "Did you get the best of him?"

"You ought to see Leaman," Yoder answers.

This excitement over, Yoder returns to the office, where soon enters the whiskey-breathed, two-hundred-pound William D. "Rex" Griffin. According to Yoder, Griffin, a former barkeep for Leaman, was made a police officer after another man, Moody, who'd made no secret of his anti-saloonist sentiments, got relieved following a closed-door session. Griffin wants to correct Yoder's reporting and insists that the editor speak with Chief Werner.

The next evening toward dusk, Griffin, in street clothes, again visits the newspaper office. He asks Yoder if he has yet spoken with Werner. Yoder, without even looking at Griffin—and perhaps unnerved by his most recent

encounter with an aggrieved party—replies that Friday and Saturday are the busiest days for *The Idea*, so no, he hasn't checked with the chief.

Griffin then snaps and blindsides Yoder with a blow to the head that knocks him down. Griffin jumps on Yoder, beats and kicks him. His brother Claude is having dinner in the Ford Hotel's dining room when he hears the commotion and runs to help. He tries to pull the powerful Griffin off the editor, but an apparent accomplice grabs the editor and drags him out. They tumble, fists flying, into Capitol Street, where Griffin kicks Yoder in the face. A crowd forms and some friends seeking to help are prevented from reaching Yoder. Police at last arrive, but not before Griffin and his accomplice melt away. Griffin's pistol, shaken loose in the fight, is turned over to a uniformed officer.

Yoder swears out a warrant because the police, who in their laggard fashion showed up to break up the fight after Griffin had gone, show no inclination toward arresting Griffin of their initiative. One policeman tells Yoder he will need to get a warrant to have Griffin arrested. The object is to have a bond placed against him to prevent further assaults.

The Leaman incident comes before the court on Saturday morning. Yoder has been warned that Leaman will try to goad the editor into saying something that will put him in contempt.

Yoder emphasizes to the court that he swore out a warrant not to prosecute Leaman, but to put him under a peace bond, because he has threatened Yoder before. If Leaman pleads guilty, then there is no need for testimony. When asked by the court, Leaman admits to the assault.

Then something occurs that Yoder thinks is odd. Both he and Leaman receive $100 fines, though no bond is against the editor and no evidence is presented. Though the case is settled, the court permits Leaman, in Yoder's words, "to deliver a tirade of abuse and invective" against him. This goes on even after the judge twice asks Leaman to stop.

Leaman says that he has indeed made threats and will continue to do so, and that he is going to get Yoder. "Yes, and there is going to be shedding of blood, too."

Yoder responds, "You see, he makes threats, and I make none, and I object to your requirement of bond and will take an appeal." An officer of the court tells Leaman to take an appeal, too, and so he does.

The peculiar legal procedure is again seen when another court officer, after noting that the appeal comes up in October, requires Yoder to give bond anyway. Yoder wonders what an appeal from bond amounts to if one has to give bond after taking an appeal. As he leaves city hall after what Yoder sees as a farce of a trial, spectators are indignant about how the court gave Leaman opportunity to use the courtroom as a way to denounce him.

Sleeping duty. Mayor David C. Richardson dozes as criminal corruption overtakes the city government. *Courtesy of the Library of Virginia.*

Yoder tells them that if there has ever been a more flagrant contempt of court than Leaman's act, he has failed to hear of it.

Monday is a busy one for Yoder. He has the Saunders suit to answer to in law and equity court and the Griffin case in police court. A large crowd assembles, expecting sensational developments in the Griffin assault matter. Among those present are Mayor Richardson, several members of the police board and Chief Werner.

Yoder, "a small man," the *Evening Journal* notes, presents a battered appearance with two black eyes. Griffin does not have a scratch on him. Attorney W.H. Sands appears for Griffin, who pleads guilty to attacking Yoder and in doing so states that he intends to whip him again if he continues circulating false comments about him. Sands makes what Yoder considers slanderous charges against *The Idea* that have no bearing on the case. Isaac Diggs represents Yoder, though he does not seem to do much. The editor objects to Sands's remarks and asks that he confine himself to the case.

Griffin is fined $25 and put under a one-year, $500 bond to keep the peace. The trial is over, but later in the day Yoder learns that the bond against Griffin is removed because he is already under bond as a police officer—a

bond that he forfeited with his assault. Never mind that Griffin, carrying a pistol, thrashed him in his private office and then out in the street.

In the evening, about 11:00 p.m., Yoder receives a summons from Chief Werner to appear as a witness at a special police board hearing of whether Griffin should be suspended from the force. The next morning's *Times-Dispatch* report is far more benign than Yoder's account. The newspaper says Yoder was "invited into the meeting of the board and he was permitted to ask questions."

The fact is, Yoder says, he was summoned by legal process to appear before this farce or else he never would have attended. He is not going around begging a secret police board to prosecute a man. If he has any prosecuting to do, it will be through open methods.

Griffin is not the evening's real subject, but the agenda is to quiz Yoder and try him for libel of the three commissioners who ask most of the questions. They seek justification for what Griffin has done to him. The board continues cross-questioning Yoder to make him entangle himself for his humiliation before the board. He refuses to enter into a discussion about *The Idea*'s motives and methods that has no bearing on the case.

"In every one of his refusals and objections the Mayor sustained him and the case proceeded only to find other impertinent questions," Yoder reports. He goes so far as to remind the board that he is not on trial here—there is an actual court for that. Griffin is supposed to be undergoing a disciplinary procedure. Yoder understands that the board is more interested in protecting Griffin than punishing him.

The board finds Griffin guilty of assault and makes official reprimand, mitigated by taking into consideration the provocation of untrue published statements and that he has been on the force for such a short time and thus is unaware of the gravity of his offenses. Griffin is fined twenty-five dollars and is allowed back to the station house for his 1:00 a.m. shift.

The stewards of Clay Street Methodist Episcopal Church send a complaint about Yoder's treatment to the *Times-Dispatch*. Their recording secretary, F.L. Baughan, writes expressing the board of steward's indignation at the action of Griffin, who took the law into his own hands by assaulting Yoder "for an insult, whether real or imagined." Griffin has demonstrated his unfitness to serve as a police officer and the Police Board of Commissioners should order his summary dismissal. The stewards consider Griffin's behavior and the police court's decisions an affront to the respectable element of the community.

On another page of the paper, a paragraph-long article attests to Yoder's fear of assault by city officials. The day before, in the company of attorney Diggs, he went to hustings court in application to carry a concealed weapon.

The hustings members, however, were on vacation and could not honor Yoder's request.

Yoder writes of recent difficulties in the August 21 *Idea*: "If such anarchy is permitted to run Richmond, violence may be resorted to right any supposed wrongs." It is time for the people of Richmond to rise against not just the corrupt politicians, but also the ancient and outworn form of city government that makes such abuses so easy. Government by a small commission of five paid specialists is the solution for other cities. Why not Richmond?

"Against the Evils of the Hour"

"We agree with those who have little faith in the average magazine started in Richmond," Yoder writes in the closing essay of September 8.

Richmond is called the burial ground of magazines because of the fact that they do not thrive here and they nearly always die.

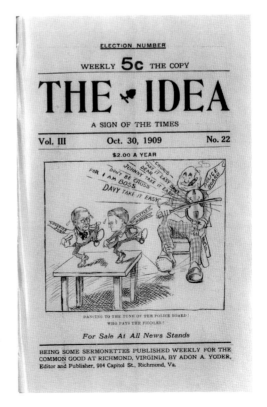

Dance craze. Police Court Judge John Crutchfield and Mayor David C. Richardson give in to the frantic tune of the corrupt police commission.
Courtesy of the Library of Virginia.

Now the reason is this: The magazines started in Richmond have always been literary magazines and have not appealed to anyone but the literary classes and then not for what they were but simply for the sentiment, because the people hoped they would grow into some great Southern magazine.

Notice this big fact, however, that THE IDEA is published because of a demand for a fearless and outspoken paper against the evils of the hour.

The demand comes from everywhere—the mechanic, the doctor, the lawyer, the preacher, the teacher, the farmer, poor and rich, all like not only desire better conditions but recognize in THE IDEA, the fighting organ of those who work and hope for better things.

…Our sales on Church Hill and Fulton, where so many of the wage-earners live, are especially rapid in their increase. These are the people that feel the most oppression of the priviledged [sic] few and the burden of taxation brought about by wasteful extravagance of city funds and loose and lax methods of management and crookedness of officials and graft in the building of municipal works.

Flight and Huchy-Kuchy at the Fair

Fireworks and electrical scenes of a veritable fairyland brighten the opening night of the Virginia State Fair on October 4, 1909. Fiery fountains and rockets illuminate every corner.

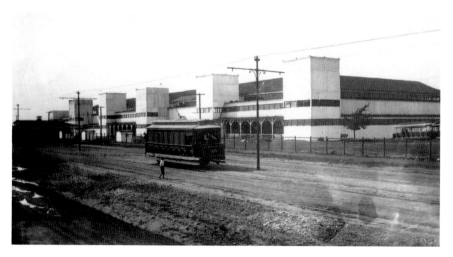

Exposition buildings for Virginia State Fair with streetcar running past. The Virginia State Fair, revived after a period of dormancy, occupies property near Boulevard and Broad on the western outskirts of town, about where the Diamond is today. *Courtesy Cook Collection, Valentine Richmond History Center.*

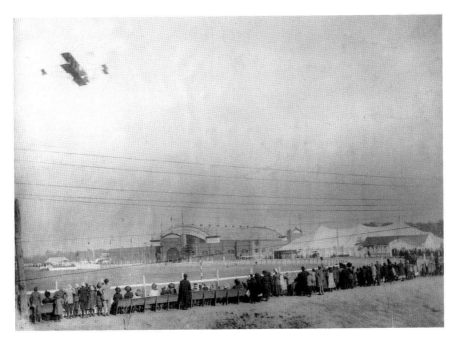

Now we're in the air. Charles Foster Willard, at the controls of a Curtis airplane, soars above the heads of 1909 Virginia State Fair spectators in the first appearance of such a craft in Richmond. The future has arrived—on wings. *Courtesy of the Cook Collection, Valentine Richmond History Center.*

Tens of thousands of people from all over the state converge on the Broad Street fairgrounds, cheering the races rollicking along the Joyway, crowding through the exhibit buildings, blowing whistle and eating pink popcorn and hot dog sandwiches.

One of the primary attractions this year is the first aircraft in Richmond. Foster Willard pilots the Curtis biplane and is accompanied by P.Q. Taragarona, a Baltimore lecturer on flight in general and the Curtis in particular, who explains to the gathering crowds that small accidents happen and that all impediments must be removed before flying machines try leaving the ground.

The Curtis is delayed for some time in completing its first fair flight, due to needed maintenance. Innumerable wires, drawn taut between points of stress, must be soldered into place. Every crack in the two hundred square feet of rubberized silk requires as dainty a covering as working on a lady's glove. Then the four-cylinder, sixty-seven-pound engine is started up and tested. Just before dusk, the tent poles are taken down and the craft is pushed to the racetrack, inside of which the Curtis will make flights all week.

The outer barrier of the track is lined ten deep with curiosity seekers who, despite the lateness of the hour and dinners cooling on tables at home, refuse

to leave until the craft makes its run. One bumpkin, hefting, in the *New Leader*'s words, "a hide full of strange and curious liquor, insisted on jumping the fence and getting a near view of the flight."

Among the new technologies moving into Richmond, most are expected evolutions. The automobile is a motor in a carriage. The telephone is an extension of the telegraph. The airplane, though, is something else; this is the future impinging on the present, it is the fulfillment of men's dreams: to soar as birds do. Once it is possible to leave the earth, what else can follow? Those Richmonders eager to see the machine go aloft are eager to add a new experience to their lives, one that even their parents would not have believed possible.

Prior to alighting, Willard states to reporters that he does not intend to fly for any duration this first time up but that his intention is to show it can be done and give him the opportunity of rectifying any break or fault. With this, he goes to the craft parked at the south end of the track.

The powerful motor starts and, at a word, the attendants give the machine an assisting push. Then, just as graceful as a bird, the plane ascends in a long sweep until attaining a height of about twenty feet. Willard lands the craft three hundred yards later and then flies back. During the return trip, a bamboo rod jams a large hole in one of the lesser planes, and at the second landing, Willard can see that this is the end of flying for the evening. As dusk's shadows deepen across the track, the Curtis is guided back to its tent for more repairs to be in readiness for tomorrow's demonstrations, beginning after noon.

Yoder makes no mention in *The Idea* of this merging of science and art. He is concerned with the moral depravity of the fair, with beer and whiskey sold in violation under one license at various points throughout the fairgrounds. There is licensed gambling with wheels of fortune. The worst transgressor is the "vile and indecent and lewd huchy-kuchy show." Yoder admits that he has never seen such a display, but since he is fighting such things, he thinks it best to at least see what he is against. If seeing this show did not burn out his eyes, it may have scarred him for life.

"No young man could see this performance and not carry away with him a picture so intensely stamped on his memory as to be the uppermost thing on his mind today—a picture that in all probability would lead him to licentiousness and crime." On the Sunday following the fair, nattily dressed boys are observed by Yoder as they are going along one of the residential streets cracking foul jokes in boisterous voices about the "huchy-kuchy."

The October 23, 1909 issue is the first illustrated *Idea* cover. Yoder, ever the salesman, knows that a compelling graphic is more interesting than dark headlines, no matter how sensational. These drawings have at least two

artists. The best of them is Frank Baptist, and the more crude may be from Yoder's own pen. This first cartoon, though unsigned, compares to later work by Baptist. Pictured is a banquet table around which is arranged city council, and one member is on the table, face shoved into a pot of Graft, smelling of money. A divine hand is writing in the air, "Government by Commission," and the words cause shocked councilmen to flee.

"Robbers!"

President of the United States William Howard Taft visits Richmond on Wednesday, November 10, 1909, as the final stop of a fifty-five-day, thirteen-thousand-mile; thirty-three-state "Swing Around the Circle Tour." City Council President Robert Whittet Jr.'s Entertainment Committee scurries about, draping the city with patriotic bunting and making all in readiness for the chief executive's arrival at Byrd Street Station, between Seventh and Eighth Streets. Taft's personal railcar, the Mayflower, rolls in at 5:10 a.m., but the reception committee knows not to come calling until eight.

Formal visits like this have their traditional choreography, and Taft has now experienced quite a few of them, though Richmond provides its own variations. A breakfast meeting with Governor Claude A. Swanson leads to an address in the House of Delegates chamber before the Virginia Press Association and the *Times-Dispatch* Correspondents Association; a half-hour meeting with a delegation of twenty-five prominent blacks in the State Corporation Commission courtroom; a parade and military review at the Lee Monument; luncheon at the Jefferson Hotel; and a public address at the City Auditorium.

After breakfast with the governor, Taft goes onto the porch, hat in hand, to allow a glimpse by the thousands of people straining to see him. The throngs extend past the mansion to St. Paul's Church and in every direction. He gives a broad smile in response to the great ovation. An automobile ferries him to the capitol's south portico, where the executive party enters.

Taft views the famous Houdon from-life statue of George Washington. The president and Governor Swanson pose for a photograph and light explodes in the rotunda from the camera. Whether intending to make subtle reference to Taft's considerable weight, the *Times-Dispatch* reports that capitol elevator operator David Blankenship possesses misgivings that his beloved machine might suffer a breakdown from "overcrowding." Blankenship's anxiety is for naught; Taft does not use the elevator.

When Governor-elect Judge William Hodges Mann appears in the doorway of the House of Delegates chamber, the impatient assembly

stands, thinking this is Taft, and then, realizing the mistake, sits down. Taft's bemedaled military aide, Colonel Archibald Butt, precedes the president with the governor and a phalanx of secret service men.

After applause and introductions, the genial Taft tells a story of his trip. He went 1,100 feet down into a Butte, Montana copper mine, the descent made in two cages, one over the other. The first cage took on eight correspondents who were traveling with Taft, and the next carried him. "And I said to them," Taft recalls, "for the first time, I had them where I wanted them. But then I found, and this is the moral of the tale, that I could not get to the top without bringing them with me."

He mentions how he began his career and earned his first money as a journalist for the newspaper in Cincinnati, on the courts beat. He covered the 1880 Democratic National Convention, where he received the great opportunity as a pesky reporter to question the leading men of democracy.

Taft speaks well of the South and the healing of sectional differences. He says that at the end of this long tour, there's a lady in Washington he's looking forward to seeing, but he's also enthusiastic about touring all he can of Richmond in his allotted time.

On his way out, two women—suffragists most likely—approach to speak with the president, against the will of attaché Butt. Taft is cordial. When he enters the State Corporation Committee courtroom, the black delegation rises and remains standing until Taft, in a pleasant voice, says, "Be seated, gentlemen." John Mitchell sees that Taft is embarrassed as he glances at Governor Swanson, asking, "Do they represent educational interests?" Swanson nods.

His words to the representatives seem disconnected from the audience. He talks about the marvelous progress made by the colored race since the Civil War and the importance of farming and institutions like Tuskegee and the Booker T. Washington at the Hampton Institute. Mitchell understands Taft to say that blacks striving for professional careers are folly, that farming and technical education are the hopes of the colored race. "The President avoided the use of the word 'Negro' during his entire remarks," Mitchell notes. As Taft concludes, he grasps his silk hat and turns to go. A member of the group stands and asks if he may speak. "Certainly," Taft replies.

This is Daniel Webster Davis, minister of Second Baptist Church of Manchester, poet, historian and lecturer who has toured the North presenting tales of the antebellum South. His remarks follow the now-expected pattern of deference, with a slight twist of assertion toward the end. He gives thanks to the whites for elevating the blacks following their own personal devastation of the war. Davis says, "It is strange indeed that this Capital of the Confederacy has become the Mecca of the Negro race, and that we are actually accomplishing more than in any other city in the South."

Davis informs Taft that the colored people of Richmond own four banks, many small enterprises and represent $3 million in commercial wealth. "We have done this," he says, 'because of the kindnesses and help of our white neighbors and because we have faith, in ourselves, in God, and in our President."

Archie Butt, standing next to the president in his dress uniform with its gold aiguillette, appears ready to keep Taft to his schedule. To Mitchell, this is a picturesque scene, and Davis ends his comments just in time, because another moment and impatience would have replaced resignation. When Davis mentions the graciousness of the whites, this relieves the tension of the moment. The president and his staff leave the room.

Mitchell feels that the colored people were called here to listen and be seen and not heard. Davis secures their brief audience "by the exercise of that rare good judgment for which he is noted." The black men proceed to the capitol's portico for a group photograph.

Taft requests that the reception committee take him to the Confederate White House, St. Paul's Church, St. John's Church and Hollywood Cemetery, and at hurried intervals this is managed. Just prior to the parade stepping off, Taft is whisked to Jefferson Davis's wartime residence. The *Times-Dispatch* overstates that this is not the first time a U.S. president has stood in Jefferson Davis's wartime residence: Abraham Lincoln was its first credible tourist. Taft makes an odd comment that the portrait of Davis "did not compare in excellence with the one in the War Department at Washington." Museum officials respond that they will probably apply to have a copy made.

Strike up the band. The Richmond Light Infantry Blues marching along Ninth Street for President Taft's visit. Note Smithdeal Business College at far right. *Courtesy of the Virginia Historical Society.*

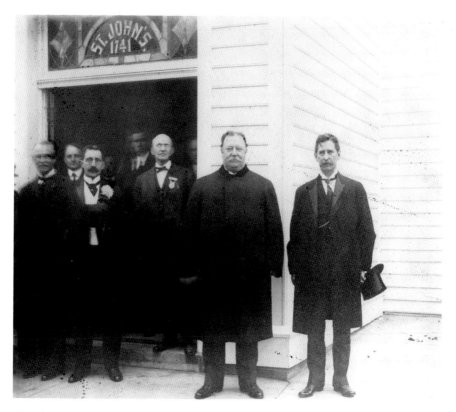

The big man. U.S. President William Howard Taft alongside Virginia Governor Claude A. Swanson at the conclusion of Taft's November 10, 1909 visit to Richmond. From here, he was transported to Main Street Station for the train to Washington, D.C. *Courtesy of the Valentine Richmond History Center.*

A blaring, brassy martial parade wends its way through town to Monument Avenue. Following police and motorcars come the Fort Monroe post band, a battalion of Virginia Military Institute cadets and the Richmond Light Infantry Blues Battalion. Next in line is the vaunted First Virginia Regiment and its band, with the Richmond Howitzers coming behind. The parade has a mobile tail of police on horses and bicycles and a moving tail of twenty-five cars carrying assorted dignitaries.

People lean out from every window and door, the sidewalks are banked from curb to house front and every church porch and public building is crowded. The Westmoreland Club and Commonwealth Club are massed by spectators, and twelve thousand schoolchildren two lines deep display little flags. Taft bows and waves to those watching from housetops, trees and telegraph poles.

When cars bearing members of city council round the corner at Grace and Seventh Streets, someone starts a loud and noticeable cry of "Robber!" Others nearby take up the chant, which passes along through the crowd while council's machines roll by. The city's legislators all of a sudden look uncomfortable in their high hats, and they shift, trying to find somewhere else to look, but wherever their eyes fall, they are met by the screams of "Robber!"

Someone at last shouts, "Stop it! They are not robbers, but they don't know how to catch one."

"We Are Americans under Old Glory"

At Monument Avenue, Taft leaves his automobile and—accompanied by Butt, Governor Swanson and Mayor Richardson—takes his stand in the green plat between the Stuart and Lee statues. Confederate veterans in gray raise their hats and salute the United States flag. The passing military review lasts a half hour. Then Taft's automobile, surrounded by a cloud of bicycle police, circles around the monuments. The cavalcade proceeds east to Shafer Street, where the pilot car and those of the secret service veer south toward Hollywood Cemetery.

The motorcade halts while the obdurate gatekeeper, one Saunders, will not permit entry to the president of the United States, the governor of Virginia or the mayor of Richmond because, he explains, vehicles are not allowed as

Parades and speeches. President William Howard Taft (hatless) motors through the streets past crowds thronging the roads. Businesses close for the day. *Courtesy of the Virginia Historical Society.*

a hard and fast rule. Cordial handshakes go around until Mayor Richardson prevails upon Saunders to ring up B.C. Wherry, president of the Hollywood Cemetery. Wherry backs up his employee and also refuses permission. Richardson takes the phone and expresses how very desirous President Taft is to see the tombs of Presidents John Tyler and James Monroe, among other sights. Permission is granted, the gates swing open and Saunders, at Taft's side, points out monuments of interest. Taft gets out of the car to gaze in silence upon the memorials of the presidents, including that of Jefferson Davis. He wanders about the tombs and the rows of unknown Confederate soldiers for about a half hour.

With Hollywood checked off his agenda, Taft must now return to the Jefferson and luncheon preparations. He does not know, but Councilman Whittet has arranged with the telephone company to keep open a long-distance telephone line to Washington so that Taft may speak with that lady he so wants to see again. Whittet's effort fails because a severe sore throat prevents her from speaking.

Meanwhile, at the banquet hall door, an overzealous secret service man, who thinks he has identified a real bomb-throwing anarchist, detains state Senator Folkes. Folkes lifts his frock coat to display no infernal engines of destruction on his person and produces cards and badges to prove he is, in fact, an invited guest. The guard seems more apologetic and crestfallen than Folkes is distressed by the misidentification. He remarks that perhaps some of his General Assembly colleagues consider him an anarchist for opposing their pet schemes in the legislature.

Taft gives no remarks at the banquet. He and his party dine on French caviar, Lynnhaven oysters, olives, almonds and radishes; Baker Brook trout; breast of guinea hen; fresh mushrooms; French peas; lettuce and ham. Dessert is fancy ice cream, Roquefort and Camembert cheeses, coffee and scotch and rye whiskies with Apollinaires, even champagne. "The president did not partake of the liquors but ate heartily," the *News Leader* remarks.

The rest of the luncheoners must be satisfied with chub and chicken, Julienne potatoes, spoon bread, waffles, coffee, La Flor de Cuba cigars and Pall Mall and Milo cigarettes.

Taft's speechmaking is for the City Auditorium on West Cary Street. By the time he and the entourage arrive, the flag-bedecked building is filled to capacity, with half of the gallery given to those of color. Thousands of others line the ropes, eager just to see the president, even if they cannot get into the hall to hear him.

Taft's address is not one of rafter-ringing oratory. He notes how his tour began in Boston and concludes in Richmond, both capitals of great and historic commonwealths. He runs through a list of what he wants to

accomplish during his term, including the revision of antitrust laws and interstate commerce regulations and the overall monetary reform, which is now receiving study. While every man has a different theory as to money and banking, resolution is difficult. Taft remarks, "I am convinced, however, that we should reform today what is today nothing more than a patchwork."

The U.S. system of justice is "too slow, too cumbrous, too intricate and too expensive." Taft wants to reorganize the federal judiciary as a model for the country to follow. This sentiment gets applause, but greater enthusiasm greets his suggestion of founding a national bureau of health to investigate the causes and cures of disease. He plays to his audience by advocating "a great memorial in honor of General Robert E. Lee" in the form of an engineering school at Washington and Lee University, a project first proposed by Taft's predecessor, Theodore Roosevelt. He finishes off by evoking the death of sectionalism, and rejoicing that "we are Americans under Old Glory."

Following his speech, Taft and his party slip away to visit St. John's Church, where Patrick Henry gave the "liberty or death" speech, and the grave of George Wythe, signer of the Declaration of Independence and the country's first law professor, whose students included Thomas Jefferson, John Marshall and Henry Clay.

Taft stands by the pew from which Henry spoke. "I am greatly interested in this church," he says, gazing around him, "and I have always wanted to see it." St. John's reminds him "somewhat of the church in Williamsburg," referring to Bruton Parish. He spends fifteen minutes, has a picture taken standing at the front door with Governor Swanson and then it is time to get whisked down to Main Street Station. The road is clogged by traffic, though, and the station filled with onlookers form top to bottom The president gets aboard the train in two minutes, but spends another fifteen minutes shaking the hands of the Reception Committee and numerous others, including W.F. Gordon, his chauffeur for the day.

The train pulls from the station and Taft emerges onto the back platform and bids farewell to all. "Goodbye!" the crowds shout. Distance diminishes the big man, and he is waving his hands even as the train slips from view.

"Like Topsy, We Have Never Had a Mother"

On November 20, 1909, at the hour of tea—4:00 p.m.—at 919 West Franklin Street, in the home of Anne Clay Crenshaw, convenes a representative and enthusiastic meeting of women. Their purpose: to advance the cause of women by persuading the Virginia legislature to ratify their right to vote and to precipitate an amendment to the U.S. Constitution. Four states have

Suffragist and reformer Lila Meade Valentine. *Courtesy of the Virginia Commonwealth University Cabell Library Special Collections and Archive.*

amended their constitutions to grant women the vote, and eight others allow them to cast ballots in matters of taxes and bonds. Twenty-three states permit them to vote on issues affecting public schools.

Among those present at the creation of the organization are social activist Lila Meade Valentine, whose efforts to improve the public education system and healthcare for the underprivileged have earned her public renown; novelists Ellen Glasgow and Mary Johnston; and artists Adéle Clark and her longtime partner Nora Houston.

Due to the early winter hour, the atmosphere in the room is like that of a Caravaggio painting. A fire glows in the hearth, while deep shadows sink into the recesses and the folds of the women's dresses. A few are young, one or two are elders, but most are in the middle of life, moving with the hours across the high plateau of sun and shade.

This meeting may have originated from a smaller one a year earlier at Glasgow's home at 1 West Main. In May 1908, Glasgow again shared tea with fellow writer Johnston and Crenshaw's visiting sister and Kentucky suffragist, Laura Clay.

On this November afternoon, the Equal Suffrage League of Virginia (ESL), counting just eighteen members, votes itself into existence. A constitution and bylaws committee gets organized, and the women agree that a suffrage lecturer ought to speak in Richmond. Afterward, the women leave by twos and threes to prevent suspicion. Yet the Society page of *the Richmond News*

Leader a few days later carries an article with the headline, "Virginia Suffrage League Meets at Mrs. Crenshaw's." Such an announcement must rankle some of the well-connected neighbors, including prominent attorney and suffrage opponent Eppa Hunton Jr.

Crenshaw also hosts the second meeting, at which is chosen a six-member board of directors, with Valentine as president (she will serve eleven years), Ellen Glasgow as third vice-president and Adéle Clark as recording secretary.

The ESL invites nationally renowned suffragist Dr. Anna Howard Shaw to speak at the Jefferson Hotel. Shaw is a tireless champion of women's rights and a friend of Susan B. Anthony, U.S. suffrage's prime mover. Crenshaw— perhaps through her sister Laura—makes arrangements for Shaw, and she stays at the Crenshaw house when she delivers her address at the Jefferson Hotel auditorium on January 25.

Shaw's unsmiling, Queen Victoria–like countenance is tucked away on page nine of the morning paper of January 21. The description, "Leads Woman's Cause," or the headline, "Dr. Shaw Coming to Lecture Here," may have signaled to some Richmonders a warning of impending danger to their sensibilities.

Shaw gives in her career some ten thousand lectures, and she is trained and has practiced as a Methodist Episcopal minister. Like in any good sermon, Shaw presents her case using humor and metaphor, makes some reference to current events, offers a rich and uplifting message and then gets out on a high note. She is neither boring nor belligerent. The *Times-Dispatch* writer is impressed by Shaw's "voice resonant with power and sweetness and with a logic and force of argument" that causes even the scoffers to reflect on their reasoning. The Jefferson's auditorium is filled by almost equal numbers of men and women, and many young people.

Near the opening of her address, Shaw says, "It has been always taught that the son is free who is born of a free woman, but, really, men are not free, because their mothers are not free. None has deemed man to be free who has not a voice in his own government, and no man can be honest who does not believe in woman's suffrage." She goes on to ask, "What difference does it make if you are ruled by one man called a king, or by a thousand men called voters?"

Shaw knows how to adjust for her audience. During and following the Civil War, women moved into leadership positions by necessity, and many still inhabit these roles. "So has the government of the South been more accredited to women than to any other one cause."

Shaw gives an amusing history lesson to make a strong point. "And so, to the beginning of the nation more than three hundred years ago, you men thought you could get along without us. You came by yourselves, and were either killed

by Indians or by each other. But finally you brought the women, and then you had to stay. For you remember that when God took one of man's ribs to make a woman, He also took a joint of the backbone along with it."

As it is now, women who have no voice in the electoral process are instead reduced to lobbying, "the most loathsome thing a person could do," Shaw says. She sets up the arguments to shoot them down, picking up her pace and heading toward a conclusion with oppressed shirtwaist workers.

Women never have voted? Time was, not every man was allowed to vote in this country, either. Women are not educated enough to vote? In twenty-four of the leading coeducational institutions where women make up fewer than one-third of the total students, they take 84 percent of the prizes. Women are not logical? "Woman certainly has a bump of gumption. For instance, there is many a man in the pulpit who ought to be in the pew, and with all his logic, he hasn't the gumption to change his position." What if a wife is a Democrat and a husband a Republican? Cannot a Methodist marry a Baptist? She inverts them: how is it that in just thirteen states a mother has the right to her child, but in all others they can be taken into factories or, according to one example in South Carolina, a father can deed children off without permission of the mother? "We preach about motherhood then make laws damnable to motherhood."

She continues with vehemence:

> And look at the shirt-waist makers' strike in New York. The courts and police are employed to make of unavail the laws we have. The girls are dragged into jail with common criminals and out to Blackwell's Island, and we prate of protecting girlhood. They can't stay at home. There are five million girls earning their bread, and they are compelled to go out. You haven't left us the conditions of our mothers and grandmothers. You have put their jobs into your own workshops. People ask what are those Russian Jews to us.
>
> There is more tuberculosis spread in and from those sweatshops than anywhere else. The germs come out on the products they make. And I tell you, God made us all one family.

This is the biggest reaction of the evening. The audience cheers, and now Shaw approaches her conclusion. "The thing we need is mothering. We have had enough of fathering. We have had the Plymouth Fathers, the Pilgrim Fathers, the Revolutionary Fathers, the City Fathers, but, like Topsy, we have never had a mother. We need a little more father in the home and a little more mother in the government."

The audience does not disperse, but lingers to meet Shaw and attend the reception that follows.

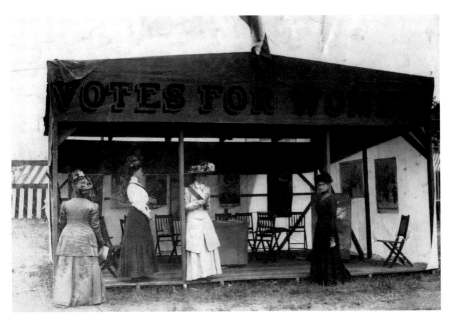

Get out the vote. Well-dressed women at the 1910 Virginia State Fair, campaigning for suffrage. Some of these exhibits include demonstrations of domestic skills—like cooking—to demonstrate that their desire for the vote doesn't diminish their "feminine" virtues. *Courtesy of the Cook Collection, Valentine Richmond History Center.*

A Fury of Doing

The ESL's women "expected a long siege, they went to work with high enthusiasm." They eagerly develop varied techniques designed to attract the attention of the public and General Assembly. They make speeches from elaborately decorated automobiles, the steps of courthouses and even overturned soapboxes. They canvass from house to house, rent booths at county fairs and hold bake sales. These activities both raise money and demonstrate that the women lack for nothing in domestic skills. In addition to these "domestic" methods, they also distribute leaflets, supply suffrage news to the press and establish the *Virginia Suffrage News.*

Adéle Clark reasons that she has an advantage because people think artists are erratic anyway. One method she and Nora Houston employ is setting up easels at Broad and Sixth Streets. When a sufficient crowd forms to watch them paint and draw, they commence to speak about suffrage. They have to move down the street once, after a theatre owner complains about the women interfering with his business.

When the Richmond suffragists begin their earnest long march to the voting booth, they receive either none or outright rude responses from state

Women of purpose. Richmond suffragists, August 1916. *Left to right*: artists Nora Houston, Adele Clark (bottom), Mrs. Frank L. Johnson (top) and Mae Schaill. Clark notes, after making a round of suffrage speeches at candidates' meetings: "You are asking for our vote; we are asking for the right to vote." *Courtesy of the Virginia Commonwealth University Cabell Library Special Collections and Archive.*

legislators. Virginia's lawmakers believe the suffrage question settled. It has not occurred to them that women would want the vote or that blacks should keep it.

Suzanne Lebsock, author of *"A Share of Honour": Virginia Women 1600–1945*, remarks, "The general view is that in 1865 slavery was simply replaced by Jim Crow." Racial segregation, mandated by law, occurs forty years after the peace at Appomattox. Many people who had been given the vote are loath to turn around and surrender that right. Influential black leaders like Maggie Walker are for the most part quiet on the suffrage question. Financial independence comes first.

In a paper on Lila Meade Valentine, historian Sean C.D. Lewis states that racist attitudes existed within the ESL. Valentine, though notably progressive on most important issues of her day, was nonetheless a product of her era.

During an 1898 trip to London, Valentine wrote to her sister Louise about a train ride that gave a shock to her and her husband. They see a black man in immaculate clothes accompanying two white women when, to their "horror we found out that they were getting in the first class carriage with us. It was little

more than we could shovel as he was evidently treated as brother or husband. I could not tell by which one of the women and we beat a hasty retreat taking refuge finally in the smoking compartment of the train." Valentine observed that this is a rare sight in England, but it does not engender disgust or astonishment.

For most of the white suffragists, the race question is not a serious issue. Lebsock contends, "Suffragists found themselves responding, (accurately it turns out) that with the poll tax and restrictions in the 1902 state constitution, black women would register in no greater numbers than black men had." The suffragists, to their credit, sought not to sling mud with their opponents, but, as Lebsock says, "it is not to their credit that they failed to take a more egalitarian stance."

If labor laws are to be changed and education reformed, women need ballot power. Those women who have the understanding and the time to fight for their rights are primarily from the educated upper class, or else quasi-bohemian artists and writers. The courageous choice is, in part, to take on decisive leadership roles at a time when men are considered the exclusive political actors.

Lila Meade Valentine is a commanding officer in the reform movement. In 1900, she and Mary Cooke Munford founded the Richmond Educational Association (REA), dedicated to improving public schools. The appalling physical conditions found in public schools and the system's basic lack of funds inspired the women to action.

Valentine was born just two months before the fall of Richmond in 1865, to parents of old Virginia families. The second daughter of a family of five children, her rudimentary formal education was nonetheless thought acceptable for a society lady. Her nature could not be satisfied with the basics, however, when good Richmond girls weren't supposed to entertain thoughts of college and, furthermore, most universities in the state didn't accept them.

Voracious curiosity brought her to spend hours in her father's library. She grew tall and brunette, though with a weak eye that in later years forces her to hold a hand over it while reading and causes terrible headaches. Valentine is made to appear far sterner and more marmish than she is by perched pince-nez. Her notable wit and grace are the kind of attributes that ideal Richmonders are supposed to possess.

Valentine married her perfect match in 1886: banker, insurance executive and sometime poet Benjamin Batchelder Valentine. His attitude is that if Lila wants it done, it needs doing, and his support never wavers. Her connection to the Valentines and their intellectual pursuits (she and "B.B." lived for a time in the house that is now the Valentine Museum Richmond History Center) further expanded her understanding of the world. When her eyes bother her, B.B. reads to Lila from books, sometimes for hours.

They suffered a tragic loss of a stillborn child. Lila's health was further complicated by subsequent surgery. For recuperation, the Valentines traveled to England, where she became inspired by the strong liberalism of the Gladstone era. In Virginia, she works for universal education for all, regardless of race or sex.

Under Valentine's four-year presidency, the REA introduced kindergarten and vocational training into city schools and advocated for public playgrounds. The May Campaign of 1905, a massive fundraising drive, brought funds into black and white schools. By speaking about the rats and filth in the city's only high school, she obtained an appropriation of $600,000 to build the downtown John Marshall High School that became a beloved city institution. The statewide Cooperative Education Association also came out of the REA. Valentine assisted in bringing to Richmond the first racially integrated meeting of the Southern Education Board.

A few years later, at Valentine's home at 101 South Third Street, the Instructive Visiting Nurses Association (IVNA) was created. Historian Marie Tyler-McGraw, in her Richmond history *At the Falls*, writes, "The IVNA taught health and nutrition, visited homes with contagious diseases, placed nurses in factories, founded a home for working women, and reached into every corner of Richmond to nurse and nurture."

Valentine's "fury of doing" includes activity in Monumental Episcopal Church and Sheltering Arms Hospital. She commits her whole self to suffrage. She speaks, most often without notes, to groups whenever occasion presents, in drawing rooms, courthouses, lecture halls, churches, colleges, streets, state fairs and farmers' outings. Her name gets recognized, though not always her face. Numerous times at some dusty country crossroad gathering, the locals wait for her to speak, expecting a raucous-voiced Amazon without realizing she is already among them.

Valentine's method of "quiet, educational propaganda" proves effective in organizing for her time and place. When she hears of militant suffragists elsewhere, particularly in Washington, she does not view them as helpful. Valentine once exclaimed of the extremists, "If they only knew how impossible they are making the accomplishment of our aims!"

Her frequent and daunting visits to the state capitol to lobby legislators become the stuff of legend. Valentine's efforts mean she is not always welcome. "Former friends would meet her on the streets without speaking," one writer will recall. "False rumors hung in the air as though arisen from a miasmatic jungle. And an anti-suffrage league was organized to fight her in the open."

Lila Valentine bears it all with tact, courtesy and humor. Scurrilous anti-suffragist letters are printed in the newspapers, and whenever a suffragist

speaks she gets heckled. And men are not the only opponents. A 1911 letter to the *Times-Dispatch* from the United Daughters of the Confederacy declares, "No daughter of the Confederacy will be a suffragette. No veteran will permit Negro suffrage." Should the black cook threaten to quit if denied opportunity "to vote for Dr. Booker T. Washington as President of the United States...the women will be in the saddle with saber and pistol galore."

Midnight Methods

The most dramatic development for Adon Yoder happens on a mid-November evening while on his way to cover a city council meeting. He is served with a warrant "about three and a half miles long," charging criminal libel against commissioners Douglas Gordon, Chris Manning and Justice John Crutchfield. Among other things, Yoder had claimed that a woman of ill repute, Sophie Malloy of 2224 West Main Street, was accorded special treatment when before Crutchfield on charges and that the other commissioners had whispered in conference and taken leniency on Sophie, a white woman, and awarded a harsher fine for the same charges against the black Maggie Lee.

Personal correspondence that Yoder has on him is seized, along with a check. Gilbert Pollock reads the memoranda in the editor's presence even while Yoder tells the lawyer that he has no legal right. Pollock folds the papers together and keeps them, though he returns the check. Yoder is hauled not to the nearby First Precinct house, but instead to the Second, in the West End, some distance from his family and friends. He is allowed to call for assistance, but a number of his partisans are out of town. He is left to stew for an hour in the foul-smelling lockup. The furnishings are an ancient commode and a metal bed. The "closet stool" is without fixtures and exudes unsanitary odors. Waterbugs crawl along the grimy walls.

When Annie Yoder learns of what has happened, she falls into nervous prostration. *The Idea* man's supporters scurry to bail him out when the amount is at first set at $1,000. Professor Alwood of Smithdeal Business College and Dr. W.R.L. Smith each come to the rescue with $500 bail, and A.H. Robins arrives later, prepared to pay the whole amount. Justice John admits this is excessive and reduces it to $300, paid by Mr. N.W. Bowe, "never a partisan, could not stand to see injustice done."

The financial strain of publishing *The Idea* and staving off lawsuits causes Yoder to once more appeal to the public for assistance. He gives positive examples. "The men of the Allen & Ginter branch of the American Tobacco Company have gotten together and raised twenty-one dollars and other

individual contributions have been received." The funds are forwarded to the Reverend Tilden Scherer of Ginter Park.

Just in time for Christmas, on December 23 at 5:30 p.m., the water flume is switched on in the presence of Water Committee Chairman Mills and Chief Engineer Bolling. Close to two million gallons of clear water, though covered with a thin coating of ice, rush into the settling and coagulating basins.

Bolling and Water Department Superintendent Eugene E. Davis escort a party of sixty through the entire $500,000 filtration plant. Representatives of almost every business and commercial organization of the city, both chambers of council and the executives of many private corporations take the tour. The general consensus is that the city has undertaken the impossible in endeavoring to separate the James River water from its natural sediment.

Yoder does not think much of the operation, and if he took the tour, he does not say. He mutters in *The Idea*, "It is doubtful with the expenditure of a million dollars more the city will have a complete working settling basin."

"Every Low and Vile Means"

In December 1909 and January 1910, the matter of the Park Hotel's liquor license rises to public attention again. Yoder is established in Richmond as an anti-saloonist crusader. He finds himself in a strange debate in hustings court among representatives of the Women's Christian Temperance Union, secretaries from the Life Insurance Company of Virginia, George M. Smithdeal of the nearby Smithdeal Business College and assorted ministers and city officials. The topic is transferring a liquor license from Marshall Street to the Park. P.P. Murray, Atkinson's brother-in-law, requests the license.

The secretaries object because the loafers at the bar have in the past harassed them. The business school of staunch anti-saloonist Smithdeal is across Broad Street from the hotel. Samuel T. Atkinson, brother of James, and their mother Adeline, also testify. Adeline Atkinson testifies that James would have nothing to do with the Park if it regained a liquor license. The saloon's management would be Sam's responsibility, and Mrs. Atkinson owns the lease on the Park.

A New Year's Eve morning session of Judge Ernest H. Wells's court slips into unintended merriment when former state Senator Henry Atkinson testifies that he has known P.P. Murray for almost thirty years and that he is a fine Christian gentleman. The description causes the WCTU women to scream in derisive laughter. Jude Wells gavels them quiet and admonishes them from anymore outbursts.

The hearing requires of Yoder energetic pirouetting around ethical and moral issues that he represents. Atkinson is the primary reason *The Idea* exists. At the hearing, Yoder avers that a bar would be better located in the Park Hotel than on Marshall Street. A saloon in the latter location would be too close to residences and churches and would mean that Yoder's own wife and children—they live now at 524-A North Eighth Street—would walk by the place every day. Yoder objects to whiskey selling at any location, but at least the Park stands within eyeballing distance of police headquarters.

Adeline Atkinson testifies that the Park is costing her $500 a month and that it is not possible for a stag hotel of this size to pay for itself without an attached saloon. "If this license is granted," she says, "I will be the boss of the whole establishment."

Yoder's peculiar testimony at the hearing is soon overshadowed by an even more unusual turn of events. One of those testifying at the hearing is WCTU member Hannah Anderson, wife of attorney James W. Anderson. She presents an affidavit stating that Adeline Atkinson had told George W. Smithdeal that she would contribute $100 to the cause of Prohibition when it came to pass in Richmond if he gave a favorable report in terms of the Park regaining its license. Smithdeal had related this to Anderson's WCTU committee prior to the hearing.

Smithdeal, a member of the Anti-Saloon League, reads of Hannah Anderson's testimony in the newspaper. He refutes Anderson in the Sunday *Times-Dispatch*. Smithdeal believes that Anderson is confusing a statement made by Atkinson before the board of stewards at the Broad Street Methodist Church. There she spoke of supporting Prohibition and stated that she would contribute to its success when the time came. She confirmed this statement to one of P.P. Murray's attorneys.

On the Monday morning following the publishing of Smithdeal's rebuttal, James Anderson, armed with sworn statements and with the WCTU committee behind him, marches to Smithdeal's office. Anderson reads the papers to Smithdeal and demands he make a formal apology to Mrs. Anderson for calling her a liar in print. Smithdeal refuses. There are words exchanged. Smithdeal is sitting at his desk when Anderson flings himself at him and proceeds to strike Smithdeal about the head and shoulders. Three students hear the ruckus and run into the office to pull Anderson off Smithdeal. Anderson does not shut up, continues his rant and warns Smithdeal, "I will settle with you later."

Within hours, Anderson is charged with assault, which gets the lawyer in front of Judge Crutchfield, a fine of $20 and a $500 security against his good behavior for six months. The to-do continues with assorted statements to the newspapers.

Smithdeal could have had in mind Yoder's troubles with Leaman and Griffin of the previous summer besides his own when he tells the *Times-Dispatch*, "I sincerely hope that our courts will make these fellows who assume the role of judge and jury, sheriff and executioner, taking the law in their own hands, so feel the penalties for such high-handed and lawless actions that their number will speedily grow less. This conduct is especially reprehensible when indulged in by those who are sworn to uphold law and order."

The Park gets its license.

Yoder's muckraking against the city's institutions has further consequences. One of *The Idea's* advertisers receives a letter "telling him that he and his child would be found in some alley with their throats cut if his Ad in the Idea was not discontinued," Yoder reports in March 1910. His family, newsboys and advertisers all receive threats. He later notes, "Every low and vile means has been used to kill the Idea."

These incidents do not seem to discourage Yoder. Such behavior indicates to him that his work is achieving its desired ends. What effect this has on his family is not clear, though for the most part it is not good. When Annie appears in *The Idea* pages, she is most often portrayed as ill and distressed. There is little wonder as to why.

"Thinly Clad Women of the Midnight World"

Yoder often criticizes Democratic elections chairman Clyde W. Saunders, Police Chief Werner, Police Commissioners W. Douglas Gordon and Chris Manning Jr. and Judge Crutchfield. Yoder reviews City Engineer Bolling's lack of planning in street, sewer and public buildings construction and metes out harsh judgment. Few members of the city council escape *The Idea's* sting. He even prints the wins and losses of prominent men at the Albemarle Club, which he calls "a high class gambling joint and drinking place." When police raid the Albemarle in February 1911, Yoder sniffs that it took the police long enough, and he is certain that his drawing attention to what went on there was not coincidental to the police's interest.

Besides strong drink, Yoder remains outraged by the city's red-light districts, centered around Fifteenth Street and on Mayo Street and Locust Alley. Mayo Street is about three blocks long and stretches from Broad, near its intersection with Jail Alley, to Main. The last square, from Franklin to Main, is Locust Alley. Yoder describes how the looks of the women there attest to how "one can attract a fearful disease for a low price."

Yoder explains, "Mayo Street, from Broad to Main, and the adjacent streets and alleys, comprise this hot-bed of crime and debauchery. There may be seen

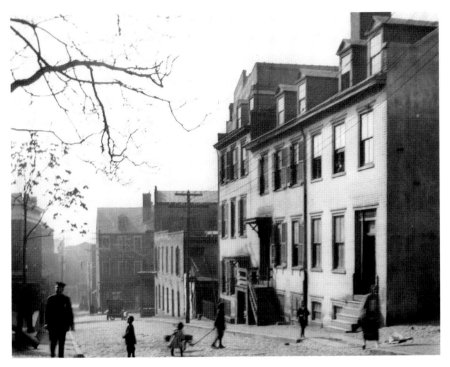

Kind of sketchy. Mayo Street looking south toward Ross Street in 1917. Muckraker Adon Yoder thinks the place so grotty that he fears catching a disease just strolling down the sidewalk. The presence of brothels and illegal saloons, and the proximity to city hall, causes Yoder to call it "Mayo(r)" street. This is part of what was the Council Chamber Hill neighborhood, along Fourteenth Street among present state office buildings. *Courtesy of the Palmer Gray Collection, Valentine Richmond History Center.*

any evening thinly clad women of the midnight world openly in the streets soliciting men, or telling vile jokes, or boisterously laughing over their drinking, and, by means too debasing to mention, advertising their wares."

In the spring of 1910, after *The Idea* has pointed out the evils of the red-light district and some perfunctory raids and arrests have been made, the intrepid reformer takes another tour. Although window shades are drawn and signs gone, business continues as before:

On the east side of Mayo, between Broad and Grace, a scarlet woman openly invited the writer to enter. Down nearer Main, a yellow girl stood in the porch way and called out sickly terms of endearment to the passersby. Between Grace and Franklin, a young girl was hanging out of a window indecently exposing her breasts below the danger line…Down on Mayo a fearful rough house was in progress and mere boys were vying with their elders in making the rounds of debauchery.

Yoder asserts that some madams receive police protection and that certain realtors underwrite their establishments. The frank descriptions of Mayo Street incite Werner to charge Yoder with circulating obscene literature. The Virginia Supreme Court of Appeals strikes this one down.

"Marked for Slaughter"

In February 1910, Yoder appears in city court for a pair of dramatic libel and slander trials, the first initiated by Clyde Saunders and the second by members of the Police Commission, including Douglas Gordon and Justice Crutchfield.

For almost three weeks, the trials occupy the front pages of every newspaper, and spectators pile into the courtroom, filling every inch, forgetting comfort in the desire to gratify curiosity, according to the *Richmond Evening Journal*.

Yoder and his defender, Charles V. Meredith, are in court for most of February undergoing rigorous questions from the merciless Harry Smith and a battery of prosecutors. They call Yoder a sneaking hypocrite disguised as a preacher and label him a viper, buzzard and torturer. The forbearance Yoder learned in Lynchburg when being insulted for his family's views keeps his back stiff. He sits immovable as one of the Capitol Square statues.

A major aspect of the trials was the role of J. Marshall Atkinson in bringing Yoder to Richmond and what kind of influence he exerts with the publication. A literal blot on Yoder's insistence that Atkinson doesn't exert his opinions is the darkening of Police Commissioner Chris Manning's name in a rather daring sentence from August 1909: "Marked for slaughter— Saunders, Leaman, Pollock, Mills [Manning marked out], and a host of others." Yoder was planning an article about city officials caught gambling at the state fairgrounds, but Atkinson informed the editor that Manning wasn't one of them. Yoder and several guests at the Park crossed out Manning's name. He simply didn't want to implicate Manning, though he soon enough found cause to accuse him.

Key witnesses are never called to testify, or else they have left town. J. Marshall Atkinson cannot be located. The moment bears resemblance to the disappearance of the mysterious Detective Denton, who orchestrated attempts to frame saloons for selling liquor to minors, back in early 1909. This was the reason Atkinson recruited Yoder to Richmond.

The jurors read the consistent negative press reports and are given instructions that make finding for Yoder impossible. But the thousands of dollars in requested damages are not awarded. The prosecution asks for

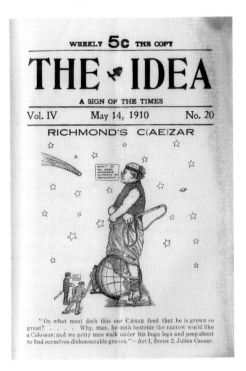

WEEKLY **5c** THE COPY

THE ✦ IDEA

A SIGN OF THE TIMES

Vol. IV May 14, 1910 No. 20

RICHMOND'S C(AE)ZAR

"On what meat doth this our CÆSAR feed that he is grown so great? Why, man, he doth bestride the narrow world like a Colossus; and we petty men walk under his huge legs and peep about to find ourselves dishonourable graves."—Act 1, Scene 2, Julius Caesar.

The colossus of Richmond. Police Court Judge John Crutchfield bestrides the world, his sandaled foot trouncing the law, and exhibiting the arrogance to question an approaching comet. A top-hatted "Evildoer" peers from behind the globe while Yoder, arms akimbo, is stopped by a policeman. *Courtesy of the Library of Virginia.*

leniency, so as not to make a "martyr" out of him or bring further hardship to his family.

Yoder doesn't trust the Richmond papers to publish the court proceedings with accuracy and, for several weeks afterward, instead prints transcripts of his own, broken by his corrections of other reporters. Charles V. Meredith defends Yoder; the dapper, cane-carrying Harry Smith represents the "persecution," as Yoder puts it. Smith is the city's premier criminal lawyer, with a large police court clientele. Though Crutchfield holds little truck with lawyers, Smith and he enjoy raillery. During one past case, Smith called for a delay "because the witness from Lynchburg has not yet arrived." The expression "witness from Lynchburg" is part of the city's legal vocabulary and holds an altered connotation for these trials.

A most amusing aspect to testimony comes from trying to determine whether Sophie Malloy runs a bawdy house (nobody says for sure, though it is agreed upon that she is a loose woman who has intercourse with colored men). Chief Werner keeps in his office a photography gallery of known prostitutes identified by name and address, and Sophie is not on his wall.

Yoder claims that a conversation passed between Judge Crutchfield and the lawyers regarding her sentencing. He is not able to prove this occurred. Judge Wilbur Griggs fines Yoder $100 and fifteen days in jail.

On St. Valentine's Day, Yoder's case is all but lost with the dramatic appearance of Congressman Carter Glass, who relates the Bell Publishing suit in Lynchburg. Glass says that Yoder had completely apologized for his statements and there was no reason to prosecute, while the writer claims that Glass didn't want anything more coming out. On that day, Scherer prints a public repudiation of his association with Yoder, due to the revelations of the Atkinson connection and after speaking with Glass on the long-distance phone. A few days later, Scherer retracts this statement with a sheepish explanation, claiming Glass hadn't quoted the letters in full. But Scherer receives no front-page print for this; instead, his reversing statements are put in *The Idea*, where few people will ever see them.

"The Yodeler"

Outside the jailhouse, a prankster credited as student John C. Bauman has some fun at the self-appointed reformer's expense. During Yoder's incarceration, clever parodies of *The Idea* are printed as exact reproductions of Yoder's style. There is no better measure of *The Idea*'s impact in Richmond than Bauman's satire. If nobody had read Yoder's pamphlet, Bauman would have had no one who would get his jokes. The publications, mimicking Yoder's to the size and typeface, are titled *The Burlesque* and *The Yodeler*.

The first, *The Burlesque*, is dated February 19, with the cover line:

I DARE
YOU TO KID

HIS HONOR THE MAYOR
OR BLASPHEME THE
COURTS OF JUSTICE
IF YOU DO YOUR NAME IS MUD

And in small type at the bottom:

This is a Yellow Journal. (You must say this with emphasis.)

The lead story is "Public Bronco Buster Is Busted—After Being Found Guilty, and Fined, He Wakes Up to Find Himself in a Fine Fix—Many Sturdy Men Weep Briney Tears." The issue contains a piece about Yoder's incarceration and the split between him and Scherer, and makes reference to his complaining about the bugs in jail, among other jabs. For those who have

been following Yoder's Richmond career, there is much to chuckle over in these send-ups.

Other stories include: "Pollock's Big Swoop—The Yodeler has just received information to the effect that Gilbert Pollock swiped City Hall and gave it to his brother, George, who is thinking of moving it to their old home in Prince Edward County. This should not be allowed, as we will need our Hall when we annex Manchester."

And: "Great Public Scandal: Police Commissioner Chris Manning was seen at Reservoir Park last Sunday afternoon walking with his own wife."

And: "The Saunders Suit—A newsboy's little sister told our office boy that if we mentioned the name of Claude Saunders, the 'Political Boss,' in our paper, that he would enter suit for ten million dollars. Well we mentioned it; so there!"

Yoder mentions these imitations when he gets out. Either not amused or trying to match their sarcasm, he wonders where they are now that he is back.

"Mistakes Have Been Made"

Yoder edits the March 5, 1910 issue of *The Idea* from the Richmond City Jail. The city's major newspapers pronounce his *Idea* dead.

Pokes and jibes. While jailed in February 1910, Adon Yoder edits his next issue of *The Idea* in jail, and on the outside, a prankster lampoons his earnest efforts with a series of satirical pamphlets, variously titled *The Yodeler* and *The Burlesque*, which imitate his accusatory style. *Courtesy of the Virginia Historical Society.*

A headline for that issue is, "Kill The Idea—Kill its Advertisers, Too": "One of our advertisers recently received a letter telling him that he and his child would be found in some alley with their throats cut if his Ad in The Idea was not discontinued." At its high point the previous summer, *The Idea*, by Yoder's record, sold seven thousand issues with some thirty regular dealers; now Yoder says he distributes fewer than five hundred because "great pressure has been brought to bear on all who dared handle THE IDEA until not a half dozen dealers in the city will handle it, tho their sympathies be with it...By this cutting down our mean of distribution many regular buyers of THE IDEA have been unable to secure the paper. Boys have been treated in the same manner and every low and vile means has been used to the kill THE IDEA."

A couple of days later, Mayor Richardson issues his "State of the City" report. He calls for the boosting of new neighborhoods, industrial expansion, general prosperity and the need for a Congressional appropriation of $100,000 to deepen the James. For all the money getting generated, though, the city is outpacing its needs to serve the citizens and may have to contract out its street cleaning—a persistent and annoying problem that receives frequent attention in the newspapers. Richardson presses for consolidation with Manchester and for building new wharves and sheds for the city's riverfront. Joseph Bryan Park was created out of the 262-acre contribution of his widow, Belle Bryan. The superintendent of Public Charities reports 1,406 cases of homelessness and friendless persons during the past year: 714 white, 752 colored. William F. Fox, former superintendent of Richmond public schools, went to his reward this year, and his able successor is Dr. J.A.C. Chandler. High up in his remarks, Richardson is careful to address incipient or current controversies and allegations. He says,

> *It has been my constant endeavor to exercise a watchful supervision over the conduct of all the officers and employees of the city. The few who have been found inefficient or negligent have been discharged or admonished, but these derelictions have been exceptions to the general rule of conduct. Mistakes have been made, and there has been some extravagance and waste, which will be guarded against in [the] future as far as possible, but no fraud or corruption on their part has been brought to my attention.*

In the spring of 1910, Judge Crutchfield attempts to lure Yoder into a fight to have him break the peace bond placed on him, a warrant later quashed on appeal. On city hall's steps, Crutchfield calls Yoder into the anteroom of Mayor Richardson's office, where he chastises the editor in the baroque manner for which Crutchfield is well known. The editor weathers this gale

and an hour later receives an apology. The justice admits he would've given fifty dollars if Yoder had lost his temper and struck him. He even confesses to being amused by the Frank Baptist caricature of him standing as a colossus astride the city in classical robes as "the Czar of Richmond."

"Declare Yourself!"

The Manchester Wizards youth baseball club has the score on the annexation question, or so it seems. At their first game of the season, on the afternoon of April 2, 1910, the team announces that it has renamed itself after the designation that Richmond plans to give the additional ward that is to encompass Manchester. To reflect the new state of things as they are expected to turn out the next evening, they will call themselves the Washington Wizards. The Wizards carry the small end of the score, however, in their contest with the Washington Warders, who win six to five.

For weeks leading up to this vote, mass meetings of pro- and anti-consolidationists are held in various meeting rooms, and orators are born overnight in the debate. A.J. Gallagher, a forty-year resident who speaks at a March 18 gathering in Manchester's Fourth Ward around Cowardin, Perry and Nineteenth Streets, thinks union with Richmond cannot happen soon enough.

"What is our city hall?" Gallagher poses. "First, it is a fire station, next a horse stable, also a treasury department. There is no way to get to the cemetery. Snow and mud everywhere; no comfort there for the living, and very little for the dead. Give me the gun of annexation, and I'll shoot it. Manchester was once called Cowchester, afterwards Mudchester. God knows it's a good name."

On March 29, anti-annexationists vent their feelings at Anderson's Hall at Ninth and Hull Streets. P.L. Anderson claims to have been an anti-annexationist since 1898. He insists, the *Times-Dispatch* reports, "that if any one could hear the wails of woe from the people of Henrica [*sic*] and Fairmount, that it would make antis of the very best of us."

Some Manchester residents are persuaded that this is an uncivil union. Solid citizen Herny Clay Beattie Sr. feels that George P. Eggleston has impugned his character at an anti-consolidation meeting. Eggleston claims that the businessman and former postmaster had said only low-grade people would oppose annexation. Beattie issues a formal affidavit that he never said such words.

"I do not think there are any low-grade people in Manchester," Beattie states. "I have the respect and trust of every person in this city, regardless of

politics or other issues, and I cannot conceive that there is any one who can believe that I would stoop to slander them in this outrageous way."

Late that afternoon, Manchester City Sergeant J.G. Saunders and City Collector J.P. Robinson announce that they intend to vote for annexation. A crowd marches to the Saunders home and, after a brief speech that verifies his decision; he joins the group, which moves on to the Robinson residence, where the same thing happens. Now numbering about one hundred men, the procession draws up before the home of Mayor Henry Maurice. The throng demands that Maurice declare his intentions. Demonstrating how he has retained his mayoral position for eighteen years, Maurice announces, "I shall not take sides with either party, and with both sides success."

Eggleston and his anti-annexationists try another meeting at Anderson Hall, and despite Beattie's published refutation of his claim, he nonetheless repeats to about sixty men at Anderson Hall the alleged insult and says he can provide affidavits. He denounces the Richmond papers for misrepresenting the effects of consolidation.

On the evening of April 3, the day prior to the vote, a great pro-annexation rally is held at Leader Hall at Tenth and Hull Streets and the courthouse. The Richmond Light Infantry Blues band plays patriotic tunes while enthusiastic citizens set off skyrockets and Roman candles.

The anti-annexation forces could not secure the courthouse or a theatre and resorted to using a stereopticon machine placed on the second floor of the Leader Building to throw pictures on canvas stretched across the front of Lee Latham's establishment. Sentences like "Save Manchester, Don't Mind the Bad" and harangues offered by anti-annexationists from the Lapham balcony do not move members of the audience. The roving blues bland drowns them out with "Dixie" and "The Bonnie Blue Flag." While the mood is festive, there is tension, more than those outside of the debates can imagine. Lifelong friends who differ in their opinions are working day and night for the success of their faction.

Despite potential for disruption at the polls, none transpires. The Anti-Consolidation League realizes its mission is a failure by noon on election day. In the end, out of Manchester's 9,715 residents, 513 vote for annexation and 224 against.

Judge Frank P. Christian of Lynchburg, designated by Governor Mann to hold a term of court for Judge Ernest H. Wells, ascends the bench of the Manchester Corporation Court at 10:20 a.m. on April 15 to call the annexation case. The election returns are certified without objections. Christian then decrees that, effective at noon, the union of Richmond and Manchester is a matter of law.

At 2:00 p.m., a motorcade of thirty to fifty motorcars crosses the bridge from Manchester. The line of vehicles is escorted by bicycle and mounted police of

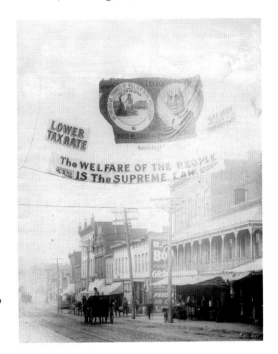

Manchester United. A banner suspended across Hull Street near Twelfth in Manchester proclaims the benefits of consolidation with Richmond. Voter turnout was low; but then half the population had no say due to race, gender or inability to pay the poll tax. *Courtesy of the Valentine Richmond History Center.*

both cities. The lead vehicle is a big Speedwell driven by John Alsop, and his passengers are Mayor Maurice, Judges Wells and Christian, City Assembly President J.D. Reams and President of the Board of Aldermen J.R. Perdue.

The parade weaves up to the grand and gray Richmond City Hall. Dignitaries make short, grandiloquent speeches and Mayor Maurice presents Mayor Richardson with a floral arrangement of red, white and blue made in the shape of a key and bearing the inscription "Greater Richmond." Maurice uses a marriage metaphor to frame the occasion, concluding, "Let no man dare to attempt to put them asunder forever!"

From mayor, Maurice moves to the bench. The morning after consolidation, he opens Richmond Police Court, Part Two, as Judge Maurice. Perhaps to his relief, however, there are no misdemeanors or otherwise to try. Although Friday had been declared a holiday and there was general celebration about the municipal union, the police are lenient on the revelers.

In June, after elections, representatives of the new Washington Ward will swell the fifty-six-member Richmond legislature to sixty-four.

"The Bird of Art"

After posing for photographers at the Virginia State Fair, Richmond Mayor David Crockett Richardson, at 5:45 p.m. on October 5, 1910, climbs into

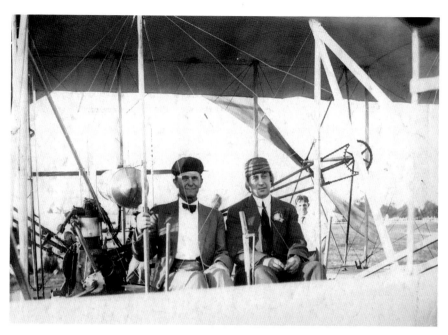

A magnificent young man and his flying machine. A somewhat uncomfortable Mayor David Richardson with pilot Ralph Johnstone prior to their short flight in a Wright Flyer Model "A" at the Virginia State Fair, October 5, 1910. A month later, Johnstone is killed during an exhibition flight in Denver, Colorado. *Courtesy of the Cook Collection, Valentine Richmond History Center.*

All's fair. Crowds jam into the Virginia State Fair grandstand, around 1910. *Courtesy of the Cook Collection, Valentine Richmond History Center.*

the cockpit of a Wright flying machine piloted by aviator Ralph Johnstone, who is no stranger to carnivals or sideshows. Johnstone began his career as a vaudeville trick bicycle rider and this past October, he and his machine overcame high winds to set a U.S. altitude record of 8,471 feet.

From the midway and exhibition buildings of the Virginia State Fair, some forty thousand people flock to line the rail around the track. Jammed in the grandstands, they crane their necks upfield to catch a glimpse of their dare-devil mayor. Beyond the fences that line the fairgrounds, a *Times-Dispatch* writer estimates that some ten thousand more people are arrayed on every conceivable perch.

Before he takes his seat, Mayor Richardson says (is the Civil War veteran thinking that perhaps these may be the last words anybody ever hears him speak?), "I am not taking this trip up into the air for the sake of notoriety. But as the personal representative of Richmond I'm going up to keep her in the front rank in the march of progress."

"The mechanicians" buckle him in. Shoulder straps are placed across his upper body and tied off behind the seat. Another belt goes around his waist. He places a blue serge cap on his head with the flap hanging back. He is pale but trying to joke with Johnstone. The crowd is ordered back and Johnstone climbs in, adjusts his helmet and starts the motors. Richardson can be seen smiling through the rising dust, with one hand clutching his belt. He has been warned to keep his hands away from everything. Then, at the word of the aviator, the mechanics let go and the airplane glides down its rail and into the air. Johnstone guides the craft up to fifty feet.

A great, excited shout comes from the multitudes at such deafening volume that the writer cannot recall of hearing any such sound before. Cry after cry rends the air, without any control; people just yell and yell. One person not demonstrating any excitement is Mrs. Florence Richardson, watching from her stand. She restrains herself with an intense inhalation. She had pleaded in vain to prevent her husband from making this foolhardy attempt.

Johnstone's intention is to do as he has for the earlier exhibition flights: to make three circuits of the track and attain an altitude of three hundred feet. First, though, comes a glory pass to allow the grandstands to see the mayor waving. The plane climbs to the height of about a five-story building.

Richardson is enjoying a view of blurring faces, though here and there he is able to pick out features. Perhaps he thinks this is what an army must look like from above. There would be little to see from here otherwise, because this is an autumn evening, and the darkness comes quick and deep. Perhaps he observes the roofs of the closer fairground buildings and then, spreading off to the south, fields and the lights from the cluster of mansions along Grace Street and Monument Avenue; to the north is Ginter Park.

Dream of flight. Johnstone's airplane
in flight at the 1910 Virginia State Fair.
Courtesy of the Virginia Historical Society.

If he has time to take his thoughts past his immediate anxiety into reverie (or perhaps this comes back to him in a sudden flash), he will remember how during that last winter of the war, he was with Parker's Battery stationed on the line between the James and Appomattox Rivers. The men had constructed two large buildings, one for religious services and the other for entertainments, including lectures. On one occasion, a minister from Mississippi by the name of Brown, who offered letters of commendation from President Davis attesting to his credibility, delivered a talk on "Airships." He claimed to have invented a flying machine he called the *Artis Avis*, or Bird of Art. Brown's device was heavier than air but, unlike a balloon, required no gas to lift up.

Reverend Brown said he had devised an engine of minimum weight and discovered a new motive power that would enable his machine to sail through the air and be used to drop explosives on the enemy. He took up a collection in order to fund the construction of the machine, but the soldiers had not been paid in quite some time, and most of them believed in Brown's sincerity but regarded him as a crank. And now, here Davy Richardson sits, in just such a flying machine with a thousand-pound engine, just like the good Reverend Brown described.

Johnstone now descends to steer the craft low over the stands to huge, throat-cracking chants. Then the machine swerves, dips by the front and drops behind the artificial scenery in front of the grandstands. Thousands of people, already at the height of excitement, leap from their seats and sweep across the field from every direction. The throngs overwhelm police.

Policeman Atkinson and County Constable Baker are seated at the center, almost at the spot of the crash, and they run for the wreckage. They see the ashen-faced Richardson bent up under the engine with his feet straight before him resting on the broken foot piece. He remains restrained by the straps. Johnstone is upright, his hands still on the wheel.

His first words are, "How about it, Mr. Mayor?"

"All right," Richardson replies. "How are you?"

Florence Richardson bounds across the field and sees her husband, stretched back in his seat unable to move. He is alive, but she sags into a near collapse.

The police officers excitedly ask Richardson if he is hurt. "No," he murmurs, and then he does not respond to their repeated inquiries as they attempt to unfasten him. "Here boys, let me do it," Richardson says and in a moment he is up and out.

"I was not up high enough," is all Johnstone says before he begins to assess the damage.

The crowds are now all around the plane, clamoring, "Are they hurt? Are they hurt?"

Johnstone stands up straight alongside the mashed mess. He is calm and quiet, but seems as crushed as the machine. The forward lifting planes are busted, the woodwork splintered, the tail broken into pieces and both wings strained, bent and punctured. Fourteen ribs are broken—on the plane, not in the bodies of Johnstone or Richardson.

The aviator, in his initial distress, is ready to declare the $7,500 Wright Flyer a total loss. Then, upon closer inspection, in his mind's eye, he can see how repairs can make it whole again.

Mrs. Richardson takes her husband by the arm and leads him away, though questioners catch up to them. "I wouldn't have had it happen for a million dollars," he says. "It was the most delightful sensation I ever experienced, and I could cry." His replies are otherwise murmurs and a sorrowful shaking of his head.

Johnstone insists that the motor was in perfect running order prior to takeoff and he theorizes that it stopped when the mayor, waving at the applauding grandstand crowd, dropped his hand and caught the string that connects the engine—a kill switch. Richardson is certain that he touched none of the forbidden wires and strings.

"If I had been up higher, I could have glided down," Johnstone says. Had he pointed the plane's nose straight down, they would have been thrown out.

At the low height, no more than ten feet when the engine cut off, there was nothing else Johnstone could do except try to save their lives.

Richardson escorts his wife to her carriage and then returns to the crash site and again expresses his regret, and his intention and desire to fly again. What Florence thinks of this idea is not recorded.

Within an hour of the accident, Johnstone and a repair crew are mending the broken parts. He announces that he will fly the next afternoon, though not at the scheduled time. The Fair Association offers two expert carpenters to assist him, and electric lights are strung up in the hangar tent. Johnstone's manager, Thomas P. Jackson, and other officials scour Richmond and Manchester in a taxicab for lumberyards with the quality of spruce that suits the discernment of the head machinist. Eight carpenters under Johnstone's supervision work most of the night putting the Wright back together again.

The hangar is barred to visitors because there is no time for lectures, and an extra police detail keeps crowds clear of the tent and away from the plane when it does emerge. The only refreshment Johnstone takes is a bottle of cold milk.

This is Farmers' Day at the fair, the primary reason why the extravaganza exists. Some forty thousand people go through the turnstiles. Many are eager to see the airplane, but in the afternoon Secretary W. Douglas Gordon makes the glum announcement that, despite the best efforts of Johnstone, the carpenters and the Fair Association, the Wright is not deemed safe for flight by dusk. The farmers and the farmers' wives take the news without complaint; they are here to see the prize animals, crops and perhaps the horse races; this flying machine is a big distraction. There are automobiles and motorcycles to see, too.

If one's life and livelihood is determined by the seasons, the airplane will have its own soon enough, but meanwhile, there are more important matters of feed and irrigation. The acreage prize goes to N.A. Tulloh, of Alton, Virginia, who raised 163 bushels of corn on a single acre.

"He's Gone Off for a Visit and a Cup of Tea"

By late Friday afternoon, the Wright Flyer is transformed from its Wednesday night appearance, when it would have seemed that the smashed machine would best serve as kindling for a fair bonfire. The body of the machine is repaired, all its wires straightened and put in place and the motor reinstalled. A predicted torrential rain makes a triumphant late afternoon flight less probable. The exhibits remain open, but Ballyhoo Lane is forlorn and deserted by its camp followers and army of spielers. Some hopeful music

drifting through the rain fails to alleviate the drenched reality. This is the first time in the new fair's four years that weather has caused postponements.

Johnstone tells fair officials that he is ready to go up again in accordance with his contract. They confer and hit on a better plan, scheduling two ascensions on Saturday and then running a five-mile circuit race with a motorcar driven by W.F. Gordon, provided that the track's mud is not too deep for the car to negotiate. This will be the first such demonstration in Virginia.

"The mud doesn't bother me," Johnstone says. "It makes the landing soft. I am not afraid of getting wet, and will go up today in anything short of a dangerous wind, rain or shine." He boasts that next year he may come back to the fair and perform loop the loops for the crowd, and he's not joking. He and Walter Brookings and other Wright aviators have already stood their machine on end in the air. With a little more engine power and strong nerve on a good bright day, he is going to try the aerobatic maneuver.

Nature does not provide much respite for regular flying, much less the fancy stuff. Unrelenting rain falls most of the night and into the day, making quagmires of the paths and outlying trails. Yet two thousand people tromp out in these atrocious conditions to see whether Ralph Johnstone can keep his promise. Unless it was raining pitchforks, he'd told the papers, he would fly.

Some five hundred people gather in the grandstand for the best view, and others scatter along the rail. They are soaked and their feet wet. The rain pours in little rivulets down the backs of their necks, but they do not much notice the damp or the chill.

Johnstone is ready at two o'clock, but the flight is again delayed by an hour. The hangar's front wall is drawn away and the "aeroplane," almost rebuilt in its entirety since Wednesday's mishap, is ready to receive its visitors.

A crowd watches as Johnstone gets into his rubber suit, which makes him look like a diver rather than a flier. Some of the audience think this unusual attire is part of the show before hearing an explanation of the suit's usefulness in weather like today's. They do not know that Johnstone has not had any opportunity to test the flight worthiness of the craft since its phoenix-like resurrection.

Soon the Flyer is exposed to the rain, rolled out and fitted upon its launch rail. Several hundred of the curious try to enter the field for a closer look but are prevented by police. Johnstone makes a last check of the wires and tries the motor. Heavy rain patters on the Wright's taught wings and a shrill wind whistles through the ribs and wires. Johnstone sets his jaw with grim determination, facing west, and gives the signal. The propellers turn against the driving rain and now the plane lifts, taking off like a swan rising from the water, sliding down the single rail and springing into the stormy sky.

Fine needles of rain stab Johnstone's face, and his rubber suit provides little barrier to the chill breeze. He is down the field at an altitude of two hundred feet when something goes wrong. The motor quits. Johnstone veers the craft south and glides down fast like a tired swallow at the end of a daylong fight. Fair Manager Jackson and the crew of mechanics run into the muck toward the ship.

Johnstone jerks his finger at that nuisance cord that Mayor Richardson, with his excited crowd waving, yanked by accident. The rain has shrunk the cord and pulled it tight enough to shut the engine. The mechanic roustabouts get the plane back on its wheels and roll it to the launch site for a second go. Again the motor turns, the motor cord is given plenty of slack and the giant man-made bird glides down its rail and sails upward. The machine soars north, over the big field, heading for Ginter Park.

"He's gone off for a visit and a cup of tea," says someone in the crowd within earshot of a reporter.

Johnstone veers back, moves behind the main exhibition building and soars above the heads of those clearing up their things and preparing to decamp. Johnstone now is flying into the storm, the Flyer's wings pulled tight, and rising with majesty to meet the gale. Rain bites into Johnstone's face and courses down his goggles. Even his hands in their pilot's gauntlets are chilled and the mist almost blinds him. He then tacks, the wind on his port quarter, and flies over the sloppy earth, five hundred feet above mired vehicles and a soaked but elated audience.

The aviator now prepares for his landing and he brings his ship down the stairless steep as a bird to its nest. On the ground he says, "I think that will satisfy them. I have demonstrated that the aeroplane will fly. But it was mighty bad up there."

Police check spectators who want to rush the plane, but they can shout all they want, and they cheer Johnstone for a long while.

His flight lasted exactly five minutes. Any more and there would have been renewed difficulty. Water shorted one of the engine's four cylinders. "But it was alright," Johnstone says. "The machine was in perfect control. I was safe."

Back in the hangar, Johnstone shrugs out of his rubber suit and spectators line up to congratulate him and touch the plane. A man in rubber boots and overalls shakes the aviator's hand and says, "First time I ever saw an air machine. First time I ever believed in the thing. But I reckon I'll keep to the ground a while longer, yet. Got a fine horse at home."

Johnstone is contracted for a second flight, but the lateness of the hour, the deteriorating weather and the dwindling crowd cause officials to forego the option. The pilot seems relieved not to have to repeat his ordeal.

The undeterred P.Q. Taragarona continues his patter through his megaphone for anybody who may still be listening. The crowds hesitate for a last glimpse of the aeroplane and its master. But the fair is coming apart all around them, and the Wright Flyer is, too. Carpenters dismantle the craft for rail shipping to Belmont Park, New Jersey, where it will be used for exhibition flights. Johnstone is leaving on the eleven o'clock train for a St. Louis air show. He and Jackson, his manager, depart for dry clothing and dinner.

Trains of slow-moving wagons undertake the hauling away of the thousand and one things that go into making a fair. The earlier frivolity is replaced by the hustle and bustle of people who must now perform necessary tasks. Sad-eyed jockeys lead away their horses. Show folks pull up stakes and strike down their tents. The rain and mud make for a desolate scene; even the lowing of the cattle sounds mournful as they amble toward awaiting railroad cars. Ballyhoo Lane vanishes into the backs of carts and memories.

The foul weather cut into the profits of the show people. Spielers and fakers stand gaunt and lonely amid the deserting throng. They are as forgotten as things of yesterday. The gypsy children alone preserve an air of cheer as they trudge stockingless and shoeless around a crackling fire, while their elders work in the ruins.

The 1910 Virginia State Fair is over.

"Socialism Is Organizing"

Public support keeps *The Idea* functioning for a while. Publication stops for three months in late 1910 due to lack of money. The October 8 cover has but one word: "**D E A D!**" Yoder, sounding earnest and exasperated, tries in a dozen pages to take his final swipes at everybody while also urging supporters of the good work to prevent the demise and chiding them for their apathy. "The people seem too blind to see and we shall have to take our part in armed resistance towards which events are rapidly unnecessarily tending."

This tactic works because *The Idea* rebounds in January 1911 with a taunting cover, "The Cat Came Back," featuring an illustration of an arch-backed feline hissing at a fleeing, top-hatted grafter. On the wall are wreaths indicating two past deaths of *The Idea*: Lynchburg 1907 and Richmond 1910. Yoder seems feisty as ever, but his tone is a bit shriller. There are no ads, and just two news dealers circulate the pamphlet now, down from its 1910 height of forty. Yoder writes, "Do you know that they could make more out of THE IDEA than out of other papers and yet they cannot afford to sell it?"

Besides his editorial work, Yoder keeps busy printing the literature of three temperance organizations, four religious and secular papers, churches, Sunday schools, preachers and "moral leaders."

On the back cover of the March 1911 *Idea* is the announcement of "Orator-Statesman, Eugene V. Debs at the City Auditorium Monday Night, March 27th, 1911 The Most Gifted and Popular Speakers in America Today." Socialist avatar Eugene Victor Debs, presidential candidate and labor organizer, makes his first visit to Richmond with a lecture at the Richmond City Auditorium on West Cary Street. He is considered one of the nation's greatest orators in a time when speechmaking is regarded as an art form. General admission is a not inconsiderable twenty-five cents, and thirty cents for a reserved seat. The gallery is restricted for "colored people." More than 1,200 men and a number of women come to hear the man heralded as the Sage of Milwaukee, the nation's single uncorrupt city, or so claims the speaker. Yoder does not mention whether he is able to see and hear his hero; novelist Mary Johnston is in attendance.

During Debs's speech, spirited approval of his words is demonstrated by the audience's cheers, stamping of feet, handclapping and frequent interruptions from outbursts of applause.

Debs characterizes President William Howard Taft as "the messenger of J. Pierpont Morgan and playmate of John D. Rockefeller. Taft sent troops to the Mexican border because Morgan owns $10 million worth of interests there." Debs sneers at the United States Supreme Court and laughs about refusing to stand as a candidate for the U.S. Senate, remarking in a sarcastic way, "I would be in pretty company in the Senate."

He launches into a stem-winder with,

Capital is keeping the working man—you—in ignorance. From the political platform you are called intelligent. I stand before you and tell you that you are ignorant, and I do that that you may become intelligent. What Republican or Democrat do you know of would stand before you and tell you that you are ignorant?

The ruling classes have always been the few and the subject classes the many, because they have been kept in ignorance. The masses are still in darkness and the victims of tradition. They do not assert themselves, for if they did and the shackles would fall from their limbs and there would be a new order of things.

You my fellow workmen are in the overwhelming majority. If you will only use your heads instead of your hands, you will no longer be called mill hands, mine hands, shop hands and other kinds of hands.

Rockefeller makes more in five minutes than you do in five years. You make the automobile and he rides in it—except on Election Day. If you need him, keep on voting the Democratic and Republican tickets.

He describes poverty as "a rebuke to our Civilization" and he gives the example of wealthy Christians attending prosperous congregations while desperate grinding poverty and hunger exist two blocks away. "That is religion," Debs says in a dismissive manner.

Then, Debs, not meaning to sound alarmist, predicts a potential conflict with Japan because that nation is making fast preparations to invade the Philippines, Hawaii and Guam. "She is building great ship yards and hurrying the day when hundreds of thousands of our young men will have to go to be slaughtered. There will be talk of patriotism, Old Glory, but it is murder. I would not kill a man to save my life. I would not go to war. 'If that be treason,' in the words of Patrick Henry, 'then make the most of it.'"

Debs then makes a pitch to the women, referring to the disaster quite fresh in the minds of his audience: the Triangle Shirtwaist Factory fire in New York City that just three days earlier killed 146 women and girls who were locked in the building's upper floors, unable to escape the conflagration. Many jumped out of windows to save themselves, some holding hands as they plummeted, and broke their bodies on the street below. Debs poses, "Do you suppose that the girls in the shirtwaist factory in New York would have voted for the city officers who would not require owners to equip their shops with adequate fire escapes? Capitol is increasing and Socialism is organizing. It is only a question of time when the working man will govern in the country."

"A Brutal Exercise of Power"

On February 9, 1911, Councilman A.L. Vonderlehr, whose Henry Ward now contains much of what was for several decades considered Jackson Ward, introduces an ordinance to divide the city into separate black and white districts. Baltimore adopted a similar plan a year ago and was the first in the nation to do so. Richmond, in its perverse need to keep up with other cities, now must follow suit. The Vonderlehr modification orders that no blacks can move into a majority white neighborhood and vice versa. Nothing is said about one race owning a house that another race rents, and those who now own a house in one kind of neighborhood cannot be forced from the residence.

The proposal ignites Mitchell as of old. He uses his resources of writing, public speaking and persuasion to mobilize opposition and prevent the passage of the law. A letter to the *News Leader* emphasizes in candid terms that blacks are not intending to colonize Grace Street or Monument Avenue. Their sole intention is to move into houses in Jackson Ward left empty by whites. He concludes that blacks would spend large sums to combat such a law in the courts.

Mitchell speaks at a February 27 public hearing. Ann Field Alexander describes how the old firebrand is put off balance by getting placed as the first speaker, when he asked to go last. He again insists that blacks do not want to intrude on white neighborhoods, but that they want decent houses of their own, paved streets and effective city services. His presentation goes well until later in the evening, when a white Clay Ward resident offers into the record past *Planet* editorials that "served to counteract the effect of his remarks."

The Common Council approves the ordinance without a dissension and forwards it to the Board of Aldermen. Even white realtors, however, see the problematic nature of the law, though none makes an effective complaint. The white opposition comes to Progressive Movement partisan Mary-Cooke Branch Munford. She is an aunt of writer James Branch Cabell, and her older brother is John P. Branch, one of Richmond's wealthiest men. Munford advocates against this proposal. She marshals statistical data to illustrate the acute need for improved housing in Jackson Ward.

On March 15, when the Board of Aldermen is supposed to vote on the law, the body tables the issue for committee study about relieving Jackson Ward's housing issues. For a few days it seems as though Richmond will not go down this wretched path, even if many want to. In April, however, the aldermen give over to those who favor the ordinance and pass it. Mitchell describes this action as a "brutal exercise of power," leaving a scar upon the community that "time will not effect or eternity wash away." The *News Leader's* endorsement of the plan is unfathomable to Mitchell.

Making the law is one matter and enforcing it another, and the absurdities are not apparent enough. When a black property owner learns that his white renters are moving, he asks to move in while he searches for white tenants. He is told that occupancy will get him arrested. A Jewish shopkeeper is arrested when he moves his family, including his sick wife, into the apartment above the store in a building he owns. Cases pile up.

Mitchell gives himself full voice in the *Planet*:

We have been denied the right to vote, the right to hold office, the right to live on the same block with the white man, the right to ride in the same railway

*car, the right to occupy a streetcar beside a white man, the right to worship
in the same church, the right to drink at the same bar, the right to be buried
in the same cemetery, and still the cry against us continues.*

"What Section of Hell..."

Henry Beattie III is born on May 31, 1911. Henry Jr., his new father, still
manages to get out and about. Before his son's birth, he visits Norfolk for
the spring meeting of the Jamestown Jockey Club. Beulah Binford now lives
there with her mother. Henry resumes intimacies with Beulah in various
hotels. He wants her in Richmond, but Beulah demands that he divorce
his wife. That aside, he manages to set her up in May Stuart's house at 221
Mayo Street, one of Shockoe's seediest blocks.

In July 1911, things are hot and desperate in Richmond. The city is in the
grip of an unprecedented 100-plus-degree heat wave. Chief of Police Werner
faints in the street. People die of heatstroke. The Ice Mission, distributing
to the poor and needy, already shipped 142,000 pounds of ice during the
month of May. The demand for ice exceeds the production capacities of
regional manufacturers. Headlines scream: "Ice Famine."

The *Times-Dispatch* reports an almost ice riot:

> *A wagon of the Crystal Ice Company, making deliveries in the East End,
> was practically held up by a mob of would-be ice buyers at Thirty-third
> and Clay Streets last night about 9 o'clock. There were frantic efforts on
> the part of the men, women and children to secure the desired article, and
> though paying for all received, they all but fought for what they wanted.
> Many of those who managed to secure small chunks, or large pieces if they
> could, carried it for blocks. One man, the happy possessor of twenty-five
> pounds, lugged it in his arms from Thirty-third and Clay to his home at
> Twenty-fifth and M Streets.*

Those fortunate Richmonders with electricity place a chunk of ice in a
pan and switch on an electric fan to blow the cool air. Customers place a
card in their windows to tell the iceman how many pounds they want for
the box in the kitchen. The iceman, riding upon his horse-drawn and often
decorated wagon, is a familiar figure throughout the city.

Heat of another kind is generated between Police Commissioner Chris
Manning and the plumber. He is in court again explaining why he installed
pipes for the Woodland Heights Corporation without permission from the city.

The heat does not abate the doings on Mayo Street and in Locust Alley, a part of town where, as Yoder notes, one fears contracting a disease just by walking through. The music and sounds of carousing would tell even a foreigner, or a blind man, "in what section of Hell he was."

Yoder, during another ramble at 121 North Mayo, sees a door burst open and among other lewd females a girl perhaps of fourteen years in knee dresses accompanied by a youth of some sixteen or eighteen years. Their conversation at parting disgusts Yoder. Yes, he writes, in Europe legal segregated sections for vice are accepted. Here in Richmond, however, the experiment is in violation of the law, yet is protected by Chris Manning and other beneficent moral guardians.

In late April, the singing city collector Captain Frank Cunningham, under investigation for the misappropriation of funds, takes to his bed and dies. Yoder recalls in the May *Idea* how Cunningham swore two years ago that he would kill himself if *The Idea* held him up to scorn. He also said he blamed whiskey as the cause of his missteps. While Yoder is moved, the truth needs to be told, especially since the regular newspapers give the matter little attention. The cause of his death is not published, but word on the street is that Cunningham took his own life.

Yoder declares that his purpose is not to censure a dead man, but rather the system that allows sentiment to govern its better sense and permits criminal behavior among those who are supposed to look after the interests of the people. He blames the city's newspapers, and in particular the *Times-Dispatch*, for first having whitewashed Cunningham's earlier wrongdoing and for refusing to support throwing off the whiskey evil. Yoder says that the paper killed Cunningham for advertising dollars.

Shockoe's "Vile Chippy Chasers"

Sweating at this press, Yoder vents against the revelers careening through Shockoe in their honking, tooting automobiles between one and four o'clock in the morning, going to and from the red-light district down behind the governor's mansion. One citizen aroused from slumber—perhaps Yoder himself—at four o'clock in the morning observes "an automobile loaded down with six boisterous lewd women and three male bipeds, making the night hideous with their unseemly laughter and loud talk and unnecessary blowing of horns." This time of year, Yoder instructs, one has to crowd sleep into short, hot nights, which is made almost impossible by these vile chippy chasers. Yoder asks those who see this activity to note the registration of the automobile's license plates and what privileged part of town these revelers

are coming from. Henry Beattie Jr. fits the description of these arrogant young automobilists keeping Yoder up at nights. He sports a jaunty boater, chain smokes and plays the guitar—a raffish, ragtime Lothario.

On Wednesday, July 19, 1911, Richmonders sit bolt upright when they read the account of how Louise Beattie was shot in the head the night before. Her husband Henry struggled with a big, bearded highwayman who stood in front of their car near Midlothian Turnpike and Providence Road. But the thug got away. Neither Louise nor Henry III was in the best of health. She was staying with her mother at the Forest Hill house of Thomas Owen, Louise's uncle, a respected law clerk.

On the evening of July 18, Louise called Henry and asked him to drive her to the Washington and Early drugstore for needed baby medicine. The hour of eight came and went; Louise was dressed for bed when, at ten o'clock, the Buick pulled up in front of the fence. Henry's impertinence annoyed his mother-in-law, Etta Owen, as she was not feeling well either, and she declined Louise's invitation to join them. Henry explained that a punctured tire delayed him. He told Louise to put a raincoat over her kimono; the errand wouldn't take long and the heater was broken in the car, making a cool night for a drive. Louise's mother kisseed her daughter goodnight. She hoped that Henry's insistence on this drive foretold reconciliation.

Henry knocked on the door to wake pharmacist Henry Jett. He bought the medicine and a box of chocolates with almonds, Louise's favorite. Then he wanted to take his bride on a romantic night drive into Chesterfield County in his touring car. The cedars they passed, he observed, would make good Christmas trees.

The Highwayman

An hour later, several guests were bidding their goodnights to the Owens when the Buick jerked to a stop on the gravel path. They witnessed Henry holding Louise's limp body by the waist. Her head was smeared in blood and gore streamed down her clothing. Henry grasped in his free hand one of Louise's slippers, which he had crushed out of shape. He staggered into the front room and threw himself on a couch, where he stammered about a holdup. The jacket and pants of his gray suit were blackened with blood.

Dr. Wilmer Mercer, one of the guests, examined Louise. Her forehead was crushed and the contents of her skull had been forced out of her ears. The shot entered her left cheek and was fired at such close range that there was little scattering. He noted that her cold right hand grasped a handkerchief spotted by one drop of blood.

Death road. Portion of Midlothian Turnpike near Providence Road, where Henry Beattie murdered his wife Louise on July 18, 1911. *Author's collection.*

After his distress passed, Beattie regained composure enough to tell his story. The cut on the bridge of his nose came from a fight with the bearded assailant, who got away. Beattie blew the horn and shouted for help, but none came. He threw the gun into the back of the car and put Louise in next to him, but the Buick's rear doors had been removed for repair and the weapon must have bounced out. Finding the gun seemed uppermost in his mind. The grief Henry exhibited when carrying Louise's maimed body had vanished.

Police arrived by horse-drawn buggy and family members gathered. This was just after 11:00 p.m. on the warm night of Tuesday, July 18, 1911, as the investigators, newspaper reporters and curious neighbors clustered around the Thomas Owen house on North Street, just beyond Forest Hill. Coroner Loving appointed a seven-member jury that examined the corpse, concluding that the fatal wound was caused by a No. 6 cartridge, used most often in turkey shooting.

Scores of onlookers trampled upon the front lawn. They followed the coroner's inquest and then attended the court proceedings. Police chased from porches people trying to capture a moment of infamy with their Kodaks.

The Hat in the Road and a Gun on the Tracks

Speculation and accusation follow. Two years earlier, Thomas Hancock, an addled Chesterfield farmer from Bon Air, fired on the chauffeur-driven car of Richmonder E.L. Bemiss because of an apparent hatred for automobiles. The incident occurred almost at the same location as the Beattie incident.

Police haul in eighteen-year-old black farmhand Irving Brown after footprints are found in a cornfield that lead a mile and a half distant from the crime scene to the house where Irving Brown lives. He is taken to the site, where repeated questioning unnerves him. His feet are exact matches to the prints left in the mud. He gives conflicting recollections of where he was the night before, at home or picking blackberries, and at one point he speaks of hearing a gunshot. A search by detectives of the Brown house turns up a single-barrel shotgun. Brown's father insists that the weapon has not been fired for a year. With a suspect and a murder weapon, a motive is the only missing piece, and there is a rumor that Brown could have been a hired assassin.

Hobo and Topsy, two hardworking and eager state penitentiary bloodhounds, run their handlers, W.W. Burton and B.L. Lane, in circles between a blood splotch on the road and a nearby stump. Railroad detective Luther L. Scherer plucks from the road an almost new Dunlop-make straw hat. The hat's crown and brim are mashed, as though struck by an automobile. Scherer traces the label to the Richmond shop of O.H. Berry & Co., and that leads to the hat's owner. He turns out to have been a member of a two-car group of young merrymakers returning from a dance in Bon Air. The partiers testify that they saw a machine pulled over near Providence Road with a man underneath, as though trying to fix something, and a woman standing on the running board watching him. Driver Roland Sydnor remembers that he stopped his car and asked the man if he needed assistance, but he said no.

Then a black logger, Henry Jennings, working in the pre-dawn hours of July 19 along the Belt Line Rail Road tracks, found a gun. He gave it to the first white man he found, a neighbor, Mr. Pettigrew, who passed it along to coroner Dr. J.G. Loving. It was an old single-barrel, breechloading Shattuck Perfection with a worn-out trigger. Part of the stock was broken, either by a fall from the bridge or mashed by a train.

The coroner's inquest moves from Thursday to Friday because authorities cannot find a competent stenographer. Louise is buried Thursday morning

Over the hedge. A hasty shot grabbed of witnesses and the accused at Coroner Loving's inquest pertaining to the murder of Louise Beattie. Her accused killer, husband Henry C. Beattie Jr., is in the center, just right of the foreground figure. *Courtesy of the Cook Collection, Valentine Richmond History Center.*

in her wedding dress, with a ceremony officiated by the minister who married her and in the same church. The Beatties, father and son, follow the casket in. A greater number of witnesses attends the funeral than her wedding. The cortege stretches for blocks and makes its slow, wending way to Maury Cemetery. The gray coffin with antique silver bars is lowered into the earth of the Beattie family plot.

All day long, spectators throng the countryside near the vicinity of the murder. Many come in automobiles, others walk and more than a few show up on horseback, ready to follow Hobo and Topsy should they pick up a trail.

That same day, investigators declare Beulah Binford a witness and place her in the Henrico County jail, then on East Main Street. The coroner's jury, complete with a stenographer, convenes Friday morning on Loving's porch in Swansboro, deep in South Richmond. Several hundred people jam the rails of the fence to watch the process unfold. Due to the collection of lawyers, defendants and police on his porch, Coroner Loving must move tables and chairs into his front yard. Ropes are stretched to keep away the many curious and retain some measure of decorum.

The four-seat death car is brought up, and Beattie is asked to reenact what happened. He does so in a calm and collected manner. Harry M. Smith Jr. represents Beattie, and Judge James Gregory and bluff-faced commonwealth's attorney Louis O. Wendenburg examine the Buick from every angle.

A towel covers the right front seat and the gruesome remnants of violence. A *News Leader* reporter lifts the towel, and the sight is sickening. Blood has pooled underneath the seat and in some places has congealed. It has trickled into the hot machinery that blows it throughout the car. The car's inner workings are crimson. The ghastliness of the scene causes many onlookers to turn away.

Henry Beattie Jr. undergoes three hours of questioning. He tells the story of how he picked up Louise and their drive, interrupted by the bearded madman.

Later, Yoder will wonder why Coroner Loving, whom Yoder claims as a personal friend, chose to convene his inquest in such an unusual manner. He concludes that Loving is not a lawyer, and a coroner's inquest is not a trial. "Even Harry Smith had to confess he had never heard of such a proceeding," he says.

The $2.50 Rifle

While taking lunch with his father when the inquest takes recess, Captain T.J. MacMahon comes to the door of the Beatties' Porter Street home. The police officer bears sad news: Henry Beattie Jr. must be placed under arrest Not another word is spoken. Beattie stands up and goes to the door with the officers.

"I think I should tell you that Paul is in the car over there," MacMahon says.

"Paul who?"

"Paul Beattie."

"Well what of it?"

"Nothing, except that he has confessed everything and has told of the purchase of the shotgun he gave you."

Beattie takes in a low gasp.

Henry's first cousin Paul D. Beattie, twenty-one years old, has had an attack of conscience. In a state of emotional turmoil, he sought the advice of his grandmother, Elizabeth Black, who told him, "Tell the truth, my boy, and put your trust in the Lord." He then went to the police and signed a confession detailing how Henry called him a week ago and arranged with him to purchase a cheap shotgun from Weinstein's, a Sixth Street pawnshop.

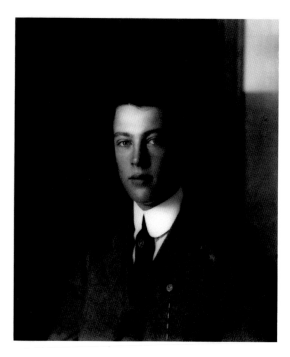

Star witness. Paul Beattie ran a strange errand for his haughty cousin, Henry, when he bought an old shotgun for him. When Henry's wife is killed, Paul has a sudden realization of what he's done. *Courtesy of the Foster Collection, Virginia Historical Society.*

When Paul asked why, Henry told him to never mind. Henry took Paul into town on July 15 and persuaded Paul to buy the weapon. He gave him four dollars. Paul went into the shop, the first off Broad on Sixth, and looked for the least expensive gun he could find. The one he chose was about thirty years old and almost useless, with a stock held together by two pins. Paul gave the young clerk a ten-dollar bill of his own, and he did not give his cousin any change.

Paul Beattie did not complete school past the fourth grade; his family were the poor relations. They did not even own a Bible in which to record his birth. His parents died of tuberculosis and he had been sick with it, too. He became a merchant marine, learning to cook shipboard, but he returned to Richmond and on June 10, 1910, he married Ruth Hoachens and they had a son. Paul worked odd jobs at the glass factory and as a streetcar motorman, though he was fired from those positions. He is now a night watchman at Mayo's Bridge.

During the questioning by detectives, Paul goes into a convulsive fit, screaming curses and kicking. The police tie him down and rush him to the city hospital. At one point he begins to shout, "I don't want any more money! I don't want any more money!" Paul may be an epileptic, and though this condition is never substantiated, Smith tries to use his condition to discredit the testimony. But Henry Beattie has other problems.

Seventeen-year-old Beulah Binford emerges from the coroner's house for questioning. A *News Leader* reporter describes her as a slight, beautifully rounded child-woman, her hair a mass of yellow, her eyes hard with a full, sensual mouth with the cynical twist of a woman who has seen too much. She partially raises her veil before the questioning begins. Binford tells of her affair with Beattie, including the child, and says that she has been out with other men because Henry never mentioned leaving his wife.

The coroner's inquest goes on for hours. When the dreary accumulation of facts is satisfied, the jury retires to Loving's offices. The spectators packed around the porch do not for a minute doubt the verdict, so they mill around, awaiting the inevitable. Beattie sits on a bench beside his father, whose hand caresses his son's shoulder. His brother Douglas is agitated and sees which direction this is headed. Through the windows can be seen the jury, the foreman and commonwealth's attorney studying papers and talking.

At 3:27 p.m., Loving gavels for order. Lawyers and reporters hurry to find seats. Loving reads the verdict in a clear voice heard well by those assembled, his tone reaching a dramatic tone as he wades through the legal phraseology up to the key sentence: Louise Owen Beattie "died as result of a gunshot wound, said gun being fired by her husband, Henry Clay Beattie Jr."

The onlookers are not noisy, and Beattie shows the least concern of all those present. Back in his Henrico County holding cell, he strums his guitar. When Foster studio photographers arrive, he joshes by holding his straw boater half over his face, then sets it in his lap and smiles for the camera. The papers trumpet how this crime is reminiscent of murder trials emblazoned in recent culture, those of McCue and Cluverius.

"Reasons for Her Daughter's Sorrow"

The Beattie trial convenes at the Chesterfield County Courthouse on August 21, three days before the first anniversary of the Beattie marriage. Judge Walter Watson presides. The evidence piles up through the sluggish heat for two weeks, resulting in two thousand words of testimony. Beattie is pictured in the Chesterfield County jail, a guitar on his knee, looking as though he is on a lark.

Lawyers from both sides give great orations. Women cry, though Judge Gregory warns them of the graphic nature of testimony and sends them out of the courthouse more than once. Paul Beattie chews gum and never breaks down, even when subjected to the relentless interrogation by Harry Smith.

Henry shows little emotion. He seems bored most of the time, except when Louise's mother takes the stand. Then he puts his face in his hands.

The prosecution alleges that Henry Beattie Jr., on the night of the murder, arranged to place the antique shotgun behind a stump off Midlothian Turnpike. When riding with Louise, he made as though something had gone wrong with the tire. He told his wife to get out of the car just as a couple of cars passed. He retrieved the gun and whirled on Louise, smashing her in the face with the butt, knocking her down and then shooting her in the head. He pressed the horn, shouting, but those living nearby thought nothing of the noise. He piled into the car, half-sitting on the blood-drenched body of his dead wife so he could shift and steer the right drive Buick. When crossing over the Belt Line Railroad, he tossed out the weapon.

The crime and trial hit Richmond with a media frenzy. The murder has connection to the automobile, adding a sense of novelty and danger to the story. A seventeen-year-old girl is part of the triangle. And an upper-class merchant family is getting wrenched apart and its secrets exposed in the most public manner. The *New York Times* sends correspondent Dorothea Dix to the trial. She describes that never since the Civil War has anything stirred staid and conservative Richmond in such a way. To her, Beattie, though twenty-six, looks like an underdeveloped boy of twenty, and from there she extols on how it is true that the purest of girls always marry the most rakish of men.

Richmond's newspapers are also for the first time able to reproduce photographs in a lavish way. The Beattie sensation gets ample illustrated coverage. Michael Ayers Trotti observes in his *The Body in the Reservoir: Murder and Sensationalism in the South* that big photos, sometimes mixed with crude art or montage, give the reader a greater sense of immediacy and drama. The disconnect is that both Beattie and Binford look like any other attractive, upper-middle-class couple who might appear in a special Sunday illustrated section. The obvious implication is that if these nice looking young people who look like you or your neighbors can be capable of such crime, how can one be certain about anybody's motivations? The killers are among us.

The press coverage of the salacious events also provides a cropper of what is considered suitable for public consumption. While the daily papers are rife with stories of axe murderers, mothers poisoning their children, despairing suicides, starving Richmond orphans (with ghastly pictures) and a black man trying to kill Chief Werner's son, the sexual component of the Beattie trial makes the post office nervous.

Some form of venereal disease afflicts Henry Beattie. The testimony of Etta Owen about Louise showing her Beattie's bloody underpants proves to be the decency litmus test. The *Times-Dispatch* averts its readers' eyes, describing the "exhibits which contained the reasons for her daughter's sorrow." The *News Leader* allows Jessie Binford to speak of

her daughter's lifestyle. The *Evening Journal* of August 28 describes how Beattie's underwear is stained on front and back. The government indicts both the *Journal* and the *News Leader* and, though it will take another year, the U.S. district court rules that newspapers cannot be prosecuted for printing testimony in open court.

The Beattie trial drags on. Hundreds of people surround Chesterfield's little red brick courthouse. Officers form a cordon to keep order. The trolley line running the dozen miles between Richmond and Centralia puts on double service to handle the demand. At the station, farmers line up with buggies and wagons to transport spectators. A trio of pretty girls sells lemonade on the courthouse lawn. Photographers are banned from the stifling, packed courtroom.

Yoder knows the exact causal chain that caused Henry Beattie Jr. to kill Louise and spells it out in the August 5 issue:

> *Back of murder was adultery.*
> *Back of adultery was greed.*
> *Back of greed was crooked politics.*
> *In place, back of Midlothian Turnpike was West Main Street,*
> *Beyond West Main Street was Mayo Street,*
> *Beyond Mayo Street is City Hall,*
> *In person, back of H.C. Beattie was Beulah Binford,*
> *Back of Beulah Binford was May Stuart,*
> *Back of May Stuart was Chris Manning and the police board.*

> *It was the coalition of crime with police that permitted this May Stuart to acknowledge herself on the public witness stand the keeper of an assignation house and still hold up her head and go free.*

> *And Beulah Binford, tho' charged with no crime, is put in jail, contrary to all law. Paul Beattie too, not even charged with being a suspect of any crime, and sick, with only one lung left, is not only deprived of his liberty but confined to a criminal's cell, deprived of his right to make a living for his family, all because, perchance, somebody's reputation as a lawyer is at stake if the suspect is not convicted.*

Is Ola Thaxton Buried or Hacked to Pieces?

If the Beattie case for Yoder distills itself into the essence of all that is wrong in Richmond, the fate of Ola Thaxton running concurrent with the Chesterfield trial gives Richmonders an additional dose of tragedy.

The story begins some seven months before, in Raleigh, North Carolina, at the home of a successful contractor who employs a carpenter named Robert Riley. The contractor's daughter is twenty-three-year-old Ola, a striking beauty, five feet, six inches tall, possessing masses of golden hair and large violet eyes. Ola expresses to Riley a desire to make her own way in the world. Riley tells her that with his connections in Richmond, she would have no trouble finding employment.

They both move to Richmond, and she boards on Seventeenth Street and gets a stenographer position at a tobacco factory. But, as the tale is told in the papers, Riley soon abandons her. She loses her job. The young woman knows no one else in Richmond and, for whatever reason, cannot or will not seek assistance from home or return.

On March 20, 1911, she is arrested in a wood yard for vagrancy by Sergeant C.A. Sherry and Policeman F.A. Campdonico. The two men recall "the girl's remarkable beauty." They press her to explain how it is that she came to be this way, but she reveals nothing of her history. The one thing she tells Judge Crutchfield is that she has slept in the streets for the past five days. She seems glad to get her ninety-day sentence.

Perhaps the effects from exposure, the wretched jail or both compromise her health, for five days later she is diagnosed with pneumonia. She is delirious when taken to the city home. While there a Thaxton family friend has reason to find her, and the friend requests of city home management that they write to the family in Raleigh. Ola Thaxton dies on March 30.

The city home contacts Raleigh, and her father, John Thaxton, replies to ship the body. A half hour later, according to officials, he countermands the request. Thaxton's body is sent to the Joseph W. Bliley Undertaking Company and messages pass back and forth between Richmond and Raleigh without a resolution. Time runs out, and Bliley sends the body to Oakwood Cemetery, the city's potter's field.

On July 16, Ola Thaxton's brother Lee arrives in Richmond in a furious state. Though Chief Werner can produce telegrams saying the family refused shipment of the young woman's body, Lee Thaxton says the family did not learn of Ola's death until three weeks afterward. He says nobody connected with the case will speak with him.

Bliley, also a city councilman, insists that Thaxton's story is not true and that he made every effort to contact John Thaxton, who, says Bliley, "would have nothing to do with the body. Later we got into communication with her brother, telling him that she probably could be buried decently for $15 or $20, but received no reply to that letter." Bliley held the body for three more weeks and contacted Lee again, informing him that according to state law, the remains must now go to the anatomical board. Lee advised the mortuary

to wait, as he would be in town in a few days. He did not arrive or contact Bliley, and thus the firm complied with regulations.

City health office records differ with the Bliley story; documents indicate the transport of Ola Thaxton's body to the University School of Medicine on May 10.

Lee Thaxton claims that the family learned of Ola's death on April 23 and his father sent money to Bliley, but a second message indicated some kind of mistake, and the Thaxtons were told more funds were needed. Then word came of the body's transfer to the medical college, which the family tried to stop by letter and telegraph. Newspaper queries at the medical college turned up an unnamed employee who attested to the familiarity of the name Ola Thaxton.

Lee Thaxton says in the *News Leader*, "Now, I am here, and I don't know whether my sister has been buried or her body hacked to pieces by medical students." He declares he is going to find his sister's body, or make someone suffer.

Ralph McCauley, the registrar at the Medical College of Virginia, provides Thaxton with the needed information. He takes Thaxton to the acid vats where unclaimed bodies are kept. He uses a long pole to poke around in the tank, and in a few moments hoists up blackened remains. Little is left recognizable of her features, but written on a card attached to the neck is Ola Thaxton. Her brother turns away, says nothing and leaves the place. He later says the body will be taken to Raleigh for burial in the family plot. Then he is gone.

Parts of this gruesome tale don't jibe. Yoder breaks down the code of the mincing descriptions provided by the newspapers in the July *Idea*. This is in example, he says, of the white slave trade. Ola Thaxton was brought to Richmond by a worthless rake who deceived her and "kept" her here in a miserable joint on Eighteenth Street. "One night in her misery and shame and grief and distracted condition she slept in a local lumber yard, and for this grave offence, Justice John sent her to jail for ninety days."

The first check from Thaxton's father "for double railway fare was returned by Bliley because the bill was not paid in advance. So the body was sent by Bliley to a local Medical College for in this way, no doubt, Bliley's bill was paid, and we are unable to learn just how much the consideration is for bodies thus delivered to the doctors. The point is that Bliley gets all this work by virtues of his political connections." Due to the graciousness of an unknown woman, the body has at last been sent home to Raleigh.

In this same issue, Yoder writes of trying to recruit a brothel denizen to assist him in revealing political connections to the red-light district. Some time ago, an offer was made to a woman dissatisfied with her lot in a house

of ill fame to start up a house of her own and, by doing so, find out from one already running such a place how best to proceed. Yoder's proxy was told that she should rent a house and she would be shown the next steps.

What she learned was that a house that would in ordinary circumstances rent for ten or twenty dollars would, for this business, rent for fifty dollars a month. "She returned discouraged," whether to Yoder or to the madam is not quite clear, though one supposes the latter. One of them told her that such a house as she is proposing would take in more than the rent on any Saturday or Sunday night. Thus encouraged, she "returned to the older proprietor to learn how to 'get protection.'" The madam offered to make an arrangement with a man who "stood in" to make things happen. When the appointed night came, the proxy met with the man, who requested to know her financial backers and her references. When no names looked familiar to him, he suspected a trap and cried out, "You get rid of that woman and d--m quick."

Yoder then sent his proxy away for her own safety, though he later went to further interview her. She identified the would-be protector as a well-known politician. Yoder can no longer find the woman, and papers that would have proved the connection of the city official to vice district profiteering were seized during Yoder's December arrest. He notes in his rueful, disappointed fashion that the individual remains in power and earning a tidy sum off the trade.

"Dig Up Their Bodies and Apologize to Them"

In the stifling Chesterfield County Courthouse, the prosecution files witnesses to the stand, each adding a little worse against Henry Clay Beattie Jr. The hardware dealer testifies about seeing Beattie purchase shells, and an unused one found near the scene of the crime is identical. A dairyman tells of seeing Beattie near the murder site prior to the event, where it is supposed he placed the old shotgun. Etta Owen speaks of marital frictions, though there are several instances of people witnessing Henry kissing Louise goodbye as he went to work.

On the trial's eleventh day, Beattie takes the stand for seven hours of questioning. He is cool to the point of exasperating attorneys, who cannot get a rise out of him.

The rafter-ringing oratory of prosecuting attorney Louis Wendenburg follows this strange performance. He begins, "When the silence of that fatal night was broken by the screams of that poor, defenseless woman, as she realized that the man who had sworn to protect her was a fiend incarnate,

and he silenced her scream with the report of that death-dealing gun, God frowned and the law shuddered." He goes on about how while there is a cheapness about this particular crime, it is the greatest under the roof of heaven. Beattie has sealed his own name in blood so that generations will slowly go by it until it is blotted from memory. The dark and bloody annals of the past have nothing to equal this crime.

"But there is an invisible power somewhere and that same power made Paul tell the balance of that secret in his heart. He had nothing to fear. He knew he was an innocent agent. But here he has been vilified, and the worst character has been attributed to him. But I tell you, Paul Beattie, that God, who made him disclose that dreadful secret, will look after him. He has nothing to fear."

Wendenburg winds up in a flourish.

> *They tell you to let him go free. Let him go free, and I tell you that every unpunished murder takes something away from every man's life. Let this man go free, and I say to Virginia, "Go to the grave of Cluverius, go to the grave of McCue, and to the grave of Jeter Phillips, dig up their bodies and apologize to them, and place a band around the escutcheon of Virginia, to remain there through all eternity."*
>
> *Justice must be satisfied and a broken law must be vindicated. Go, gentlemen of the jury, and render your decision so that the verdict of this state will be: "Well done, thou good and faithful servants."*

Wendenburg sits and Beattie leans forward, picks up two letters and lays them down, yawns and smiles. His father throws an arm around him and somehow whispers encouraging words.

The sheriff escorts the jury to the lawn for a brief rest before they go to the stuffy upstairs conference room. Onlookers jump out windows and pour through the doors to observe every move of these twelve men. Left in the courtroom, Beattie settles in with the newspaper.

In less than an hour, the jury of Chesterfield farmers convict Henry Clay Beattie Jr. of murder. A little after 7:00 p.m., Judge Watson pronounces the sentence: death by electrocution. Beattie takes the news standing straight while his father, bent and gray, stares into space. A woman sobs.

Telegraph keys strung through the courtroom windows clack the news as soon as the jury foreman reads the decision. Even the *London Times* has sent a reporter.

One of the defense lawyers, the scruffy but talented Hill Carter, rises to ask that the verdict be set aside as contrary to law and evidence.

Henry smiles and says, "I'm not a dead man yet and the Supreme Court will see this injustice reversed."

Beulah Binford is released from custody. She catches the 12:01 a.m. train for New York, where a contract awaits her from an enterprising promoter. She is to appear between reels at movie houses for four months at $100 per week. Her reputation precedes her, though, and even in New York, some theatre managers refuse her entrance.

The news of the verdict seeps into the consciousness and conversation of Richmonders. Young lawyer John Cutchins returns home with the evening paper that announces Beattie's fate. He remarks to his grandmother, "I'm glad they are going to electrocute the brute."

His grandmother says, "My son, I am ashamed to hear you talk that way!"

"He certainly deserves it, taking his wife for a ride and bludgeoning her to death!"

Her reply astounds him. "Killing him now won't do her any good, and I *have no doubt she was very provoking at times.*"

Throughout the Beattie trial and its aftermath, letters arrive to Police Chief Werner and Mayor Richardson that either admit blame for the murder or indicate knowledge of the true killer. A Lynchburg woman writes in early October that her father, who died a few weeks earlier, had confessed of his desire to slay Beattie, not his wife, and that Louise's death was accidental.

The accused remains defiant. He proclaims to the *News Leader*, "I'll show them how a man should die if that's what they're waiting for. The electric

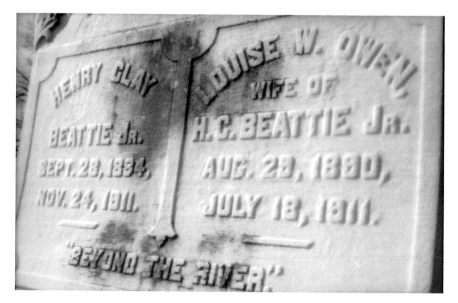

Together in death. The final resting place of Henry and Louise Beattie, forever side by side, at Manchester's Maury Cemetery. *Author's collection.*

chair, what's that? Nothing, I tell you. If the lever on the switchboard is near enough to me, I'll turn on the current myself."

Beattie's lawyers cite seventeen exceptions to the verdict and file them with the Virginia State Supreme Court on November 8. The main thrust of the objections is that Henry Beattie is a man of intelligence and that to have done as Paul testified is to show him to be stupid. Wendenburg's emotional address to the jury is criticized, but none of this works. On November 13, Judge James Keith upholds the verdict as being "plainly right, the writ of error is refused."

By November 22, thousands of people are asking permission to watch Beattie's execution although, by law, not even newspapermen are allowed to witness his death. He maintains a self-possessed demeanor during the walk from his cell to the electric chair. Henry Clay Beattie Jr. dies at 7:20 a.m. on Friday, November 24, 1911. He is the thirty-sixth person in Virginia sent to the chair since 1907. Four days later, at the Murphy's Hotel lobby, a signed confession by Beattie is read to the press. He admitted his guilt but disputed the truth of many published details.

On a frosty Sunday morning, Beattie's body is placed in the Maury Cemetery family plot next to the wife he murdered.

"Dear Fellow Criminal"

The October 7, 1911 *Idea* is vintage Yoder: the incompetence and corruption of the police board make it complicit in recent killings; a tweaking of the *Roanoke Times*'s Alfred Williams for a recent unflattering editorial about Yoder's efforts; the umpteenth demand for a commission government; and an appeal to socialism that links its tenets to the teachings of Christ and a better world. "We believe that in no way can man more effectively help to bring about this consummation than by preaching and teaching and voting for the co-operative commonwealth for which Socialists stand."

The final two pages, printed on the back of the cover, however, is a valedictory. *The Idea* is discontinuing. The reasons are not because the publication never paid or due to the troubles attending the effort to switch on the light and expose a rotten system. Two women have come forward with means and others interested in creating a fund to allow *The Idea* to keep going. Circumstances have decreed otherwise. The already frail health of the editor's wife has been assailed by tuberculosis and she is now at the new state sanitarium at Catawba, in Roanoke County. Physicians advise that Annie must not return to Richmond. In addition, a sick child is staying with Lynchburg relatives, all of which demands the relinquishing of work in Richmond so that Yoder may provide for those dependent on

him. *The Idea* print shop is now for sale at one-half what it cost, sacrificed to pay creditors.

The final image is that of Adon Jr., "three months after harvest," to illustrate a Yoder poem, "The Virginia Crop." The last stanza: "Virginia's Boast is not the Hog/ Nor Horse nor Cow nor Hen/ The Old Dominion's Bumper Crop/ Is Sturdy Valiant Men."

Yoder drops a note to his acquaintance, the journalist Evan R. Chesterman. His joking salutation, "Dear fellow criminal (Indicted for indecent stuff in the mails)," refers to the *Evening Journal's* legal trouble regarding the printing of dirty details about Beattie's underwear and Yoder's difficulty with his reporting about his walks down Mayo Street. He tells Chesterman that he wants to get out one more issue, but doubts the possibility. Would Chesterman make some notice of *The Idea's* passing?

On October 11, scrunched underneath an account by Virginian Harvey Baker's ascent to the peak of Mount Baker in Washington state and a filler joke from the *Chicago Journal* ("Why wouldn't I marry him?"—"He's poor. You may get better chance some day."—"Well, I can cross that bridge when I come to it, can't I?"), is printed, "Adon A. Yoder to Discontinue 'Idea.'" Chesterman repeats the *Idea* farewell and borrows a line from Yoder's note: "It is the purpose of the publisher to engage in farming hereafter."

Watchful and Beatific

Maggie Walker's Penny Savings Bank moves into a three-story office building designed for this purpose by black architect Charles A. Russell, at First and Marshall Streets. Its large windows on the first floor allow the community to see in, and those working there understand the business in which they are engaged. The teller's cages are brass; there is marble ornamentation and Walker's framed portrait high on the lobby wall, both watchful and beatific, an imprimatur and an assurance of consistent financial strength.

The bank opens October 31, 1911. Walker stands near the door and greets each customer with a welcoming, assured smile. Initial deposits are $103,293, and $376,288 by 1919. Walker has more activism ahead of her, and the strange June 1915 shooting death of her husband Armstead by her son Russell, who believes he is firing at a prowler.

"Peculiar Habits"

Mary Johnston's *The Long Roll* treats the Civil War in frank terms uncharacteristic of contemporary male writers. Her subject is the unusual

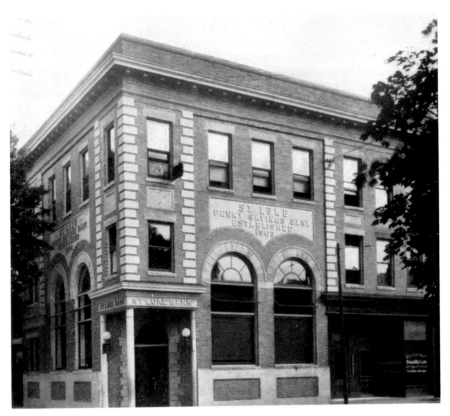

Add it up. The St. Luke Bank and Trust Building, which stands at First and Marshall Streets from 1911 to 1976. Amid the Great Depression in 1930, the thrift merges with two other black-owned institutions to form Consolidated Bank and Trust, with Maggie Walker serving as board president until her 1934 death. *Courtesy of the National Park Service, Maggie L. Walker National Historic Site.*

winter 1861–62 campaign of Stonewall Jackson that bogged down in snow, caused near mutiny of soldiers in his command and caused Jackson to offer his resignation. As Wallace Hettle writes, "Jackson's reputation as a ruthless commander meshed with the author's conception of a cruel and unrelenting war." He is depicted as a zealous, lemon-sucking eccentric, a Cromwell in gray.

The Romney campaign is not one of the more glamorous chapters in Confederate annals. Johnston does not romanticize war. A fearful soldier vomits and field hospitals are charnel houses. The obligatory romance in the middle of all this does not resolve with bliss. Johnston's editor wants the plot line of these fictional characters given a satisfying ending, for commercial purposes. Johnston refuses, saying, "I want money, but I have never wanted it that badly." She is not in the business of burnishing Confederate myths. But even Johnston's prescience has its limits; while slavery is denounced as an evil, blacks are tangential characters written in such a way that does not offend

her white readers. Perhaps Johnston understood that if she created notable and individual black characters, her books would not get published.

In *Cease Firing* of 1912, Johnston describes a "United Colors of Benetton" ethnic variety among the female defenders of Vicksburg: "Aryan immigrants, women of the dark Teutonic forest, Pictish women, women of a Roman strain, Angle and Dane and Celt and Saxon, Gaul and Iberian and Hebrew,—yes and women of Africa."

The Long Roll goes to the eleventh position in the bestseller list and earns such reviews as the *New York Evening Globe* gushing, "*The Long Roll* is not a novel, it is history; it is not history, it is war itself." Johnston, preceding Gore Vidal and E.L. Doctorow, intersperses imagined characters interacting with historical figures.

One dissatisfied reader is Mary Anna Jackson, whose half-century survival of her famous husband has made her the sanctified "Widow of the Confederacy." She is not a self-aggrandizing public figure but works in quiet to vouchsafe her husband's reputation in the Lost Cause firmament. Jackson demonstrates her dispute of Johnston's narrative with a full-page denunciation in the October 29 *Times-Dispatch* and *New York Times*. She objects to the portrayal of Stonewall's "peculiar habits" and an over-emphasis on his harshness toward subordinates. He was a military man who conducted himself by the book. Johnston's account is false.

The writer raises a spirited defense in the pages of the *Confederate Veteran*, which carried a tough-minded review by Captain James Power Smith, Jackson's lone living staff officer, who remains close to Anna Jackson. To respond, Johnston quotes an anonymous veteran who relates that Jackson was regarded as "a rude, impetuous man, absolutely arbitrary, with a singular, penetrating mind...but no man to be loved." Johnston never denies Jackson's brilliance, and indeed, feels that it was in part the cause of his peculiarities. In the end, the *Times-Dispatch* defends Johnston.

Many years later, she writes, "The infinite small and great conflict of wills out of which is woven drama—is it not plentiful in Richmond?...A whole Comedie Humaine might be placed in Richmond. I see a volume named Franklin Street and one named Grace, and one Clay or Marshall, and one Monument Avenue, and one Church Hill. One might be named Jackson Ward. The life of the coloured folk in Richmond awaits its delineator."

She will produce twenty-three novels, thirty-eight short stories and one play.

A Change of Government Is Necessary

On November 6, 1911, as though to spite Adon Yoder, the City Council Special Joint Committee releases a report calling for a "radical" restructuring

of the city government. The proposal details the dismantling of the byzantine city council committees, a shrinking of council and the reduction of eight city wards to four. An administrative board of five members elected at large for four-year terms would take on the major responsibilities of prior committees. The board's primary oversights are of city works, utilities and the engineer's office. Council is to retain control of the purse strings and of lawmaking.

After the General Assembly grants Richmond permission to alter its government, a labor-progressive coalition triumphs in the fierce 1912 election. The administrative board irritates Richmond's conservatives by preventing the monopoly of the streetcar system by the Virginia Passenger and Power Company and blocking the sale of the city gasworks to a private corporation. The board wants the city to retain ownership of its utilities.

And thus begins what entails three additional charter changes and shifts from strong mayor to city manager–council to the present mayor-at-large with a nine-member council.

"Cruel and Foolish Prejudice"

The success of the Edison recordings of Polk Miller and his Old South Quartette causes Miller to leave making presentations with them. Within

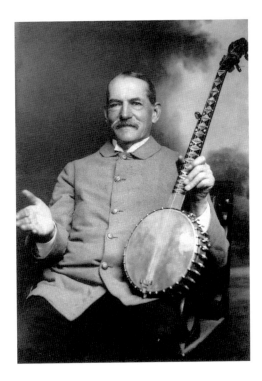

Sit a spell. James A. "Polk" Miller invites you to listen to his songs of the "Old South," presented in his version of antebellum black dialect. This image is from around 1911, when the slavery apologist quit touring with his Old South Quartette—in part due to concern about the safety of the African American musicians in prejudiced towns. *Courtesy of the Cook Collection, Valentine Richmond History Center.*

the year, he tells the *News Journal*, "I could get a dozen quartettes from the good singing material among the Negroes in the tobacco factories here and for local purposes (entertaining here at home) I will perhaps organize a good one, but I shall never again take a Negro quartette on the road with me." Miller explains that he has encountered prejudice toward the blacks of this group, in the North and South, and has at times believed them to be in danger of physical harm.

He says that his mission was to demonstrate the distinction between street corner entertainers and counterfeit minstrelsy Negroes by carrying his quartette into "the most cultured and refined people of the land." In the North, they encountered people who held a "deep-seated, cruel and foolish prejudice." Perhaps the "bad nigger" who left the South and went north has made a poor reflection on the entire race. Whatever the case, Northern towns wanted the quartette to come, but Miller was warned that a number of the residents did not like Negroes. At some Southern venues, Miller required police protection for his men. His concern for the quartette moving from the train to their quarters caused him such great worry that it "unfitted" him for his work.

He never considered what they did a "show," and few in the audience understood that these were not his companions, but his servants, just like the men he employs at his home in Bon Air.

Thus, he bows out of the quartette portion of his career to tour with his friend Tom Booker as the Two Old Confederates. Miller dies at the age of sixty-nine on October 20, 1913.

The Artist's Life

Ferruccio Legnaioli, during the course of the years, achieves singular distinction among the decorative plasterers and sculptors of Richmond. His expertise, the resilience of his skill and his shop's diverse commissions produce all manner of work, from decorative benches to a bust of Judge John Crutchfield. This is a revealing piece of an old Southern courtroom Machiavelli, carrying a devious yet somewhat amused smile. For many years he gazed down upon the doings of the juvenile and domestic relations court, which was his final duty.

Legnaioli places meditating nymphs over the State Office Building's entrance and adds flash and dash to the designs of the National, Colonial and Byrd Theaters. His creativity is displayed in many of Richmond's most public buildings of the early twentieth century and an unknown number of private residences. He makes the Christopher Columbus statue that

after great controversy is placed in Byrd Park, the First Virginia Regiment Frontier Soldier at Park and Stuart Avenues, the Fraternal Order of the Eagles monument in Hollywood Cemetery, General Francis Smith at Virginia Military Institute and the state's Zero Milestone in Capitol Square. Legnaioli installs the ornamentation in the Capitol Theatre, now gone, which stood across from Union (Broad Street) Station. This was the first "atmospheric theatre" in Richmond, designed as a "Spanish garden" replete with statuary, decorative urns and terrace balconies.

He marries Ada Dinni in a lavish 1922 Washington, D.C. cathedral wedding and remains busy through the 1930s, working, teaching and raising a family, until his health deteriorates and his business declines, as he is not as much in demand during the less-ornamented 1940s. He is not a good businessman. If someone comes to his yards and expresses earnest appreciation for a bench, he will give it away. Busted or imperfect pieces are hauled behind his shop at Belmont and Moore Streets in Scott's Addition, and then passersby cart them off to decorate Richmond and suburban lawns and gardens. He does not keep good records and retains few documents. By the time of his 1958 death, Legnaioli is all but forgotten.

"I Will Have to Come Back to Richmond"

Adon Yoder takes Annie to Colorado, where he writes for a mining correspondence school. The children are left with relatives back east. Her health worsens, and they return to Catawba. Annie dies there on May 7, 1915, in Yoder's arms, and he never recovers or ceases rewriting his poem, "To Annie in Heaven." He tries publishing in Charlottesville and then moves to Illinois, where he edits agricultural magazines and earns a reputation for being able to sell advertising like nobody else. His three sons live with various relatives.

Yoder makes money, loses money and steadfastly refuses to bend to authority. During a baseball game in Chicago, family tradition says he walked up to gangster Al Capone's personal box. Even if this didn't occur, it sounds like it could have, or should have. The image of the teetotaler, anti-vice campaigner and socialist turned advertising salesman grasping the hand of the symbol of Prohibition's failure shows the nation's puritan-libertine split. He has two other marriages, including one to an opera singer who left him for the stage. He starts a second family with a third, much younger German woman named Kaethe Sieloff, whom he meets as a nurse at a doctor's office. They settle in California and raise four more children.

He speaks with some frequency about his Richmond experience, though never in a painful way. His bitterness is directed toward Carter Glass, who,

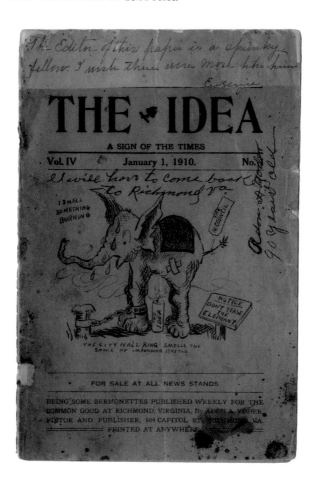

A fan's note. One Eugenie expresses her admiration for Adon Yoder fighting the power; but the circumstances of how she obtained an apparent Yoder autograph—perhaps kidding about his advanced age—is unclear. *Courtesy of the Virginia Historical Society.*

among other endeavors, is considered the architect of the Federal Reserve System. The 1947 formation of Israel brings Yoder back to religion. He dies in San Jose on November 14, 1958, eighty-one years old.

On the cover of a battered *Idea*, dated January 1, 1910, is a eulogy of sorts for Yoder's Richmond days. This is Eugenie's elegant hand: "The Editor of this paper is a spunky fellow. I wish there were more like him." Along the cover's edge is craggier handwriting: "I will have to come back to Richmond Va. Adon A. Yoder 90 years-old." How did Eugenie or perhaps a relative know how to find Yoder in his old age, and why did this person still care about something so long ago? Perhaps Yoder was making one more sarcastic joke. He was not ninety, but perhaps felt he should be, and he never came back to Richmond. Adon Allen Yoder is buried in his native city of Lynchburg.

Bibliography

In addition to the sources cited here, indispensable to the research of this book were the newspapers of the day: the *Richmond Times-Dispatch*, the *Richmond News Leader* and the *Richmond Evening Journal*. Of particular use was the Library of Congress's "Chronicle of America" project, which is aggregating the collections of newspaper archives of libraries throughout the country. This undertaking has thus far made the *Dispatch*'s pages of 1909–10 available online.

The Library of Virginia's Special Collections possesses the entire run of *The Idea*, beginning from the first issues in Lynchburg in 1906. I have to thank one General Roller, Yoder and Evan Chesterman for ensuring that these pamphlets have been preserved for their passage through time and space.

Alexander, Ann Field. *Race Man: The Rise and Fall of the "Fighting Editor" John Mitchell, Jr.* Charlottesville: University of Virginia Press, 2002.

Bailey, Fred Arthur. "Free Speech and the Lost Cause in the Old Dominion." In *Virginia Reconsidered: New Histories of the Old Dominion*, edited by Kevin R. Hardwick and Warren R. Hofstra, 196–320. Charlottesville: University of Virginia Press, 2003.

Bass, Scott. "Mrs. Atkinson's Place." *Style Weekly*, March 9, 2005.

Beverly, Walter. "That Merry Christmas of 1910." Reprint of Beverly's 1911 account in *The Spider* of the Richmond College fire. http://magazine. richmond.edu/spring07/bonus_feature/index.html, 2007.

Branch, Muriel Miller, and Dorothy Marie Rice. *Pennies to Dollars: The Story of Maggie Lena Walker*. North Haven, CT: Linnet Books, 1997.

Brown, Elsa Barkley. "Constructing a Life and a Community: A Partial Story of Maggie Lena Walker." *Organization of American History Magazine* 7, no. 4 (September 1993). http://www.oah.org/pubs/magazine/africanamerican/ brown.html.

Cabell, James Branch. *The Cords of Vanity: A Comedy of Shirking.* New York: Robert M. McBride & Co., 1920.

Carneal, Drew St. J. *Richmond's Fan District.* Richmond: Council of Historic Richmond Foundation, 1996.

Chesson, Michael B. *Richmond After the War—1861–1865.* Richmond: Virginia State Library, 1981.

Cutchins, John A. *Memories of Old Richmond (1881–1944).* Verona, VA: McClure Press, 1973.

Driggs, Sarah Shields, Richard Guy Wilson and Robert P. Winthrop. *Richmond's Monument Avenue.* Chapel Hill: University of North Carolina Press, 2001.

Fuller-Seely, Kathryn. *Celebrate Richmond Theater.* Edited by Elizabeth and Wayne Dementi. Richmond: Dietz Press, 2002.

Glasgow, Ellen. *The Romance of a Plain Man.* New York: The MacMillan Company, 1909.

Goodman, Susan. *Ellen Glasgow: A Biography.* Baltimore: Johns Hopkins Press, 1998.

Green, Bryan Clark, Calder Loth and Williams S. Rasmussen. *Lost Virginia: Vanished Architecture of the Old Dominion.* Charlottesville: Howell Press, 2001.

Green, Elna C. "The State Suffrage Campaigns: Virginia as a Case Study." In *Virginia Reconsidered: New Histories of the Old Dominion*, edited by Kevin R. Hardwick and Warren R. Hofstra, 321–52. Charlottesville: University of Virginia Press, 2002.

Heinemann, Ronald I., John G. Kolp, Anthony S. Parent Jr. and William G. Shade. *Old Dominion New Commonwealth: A History of Virginia 1607–2007.* Charlottesville: University of Virginia Press, 2007.

Hettie, Wallace. "Mary Johnston and 'Stonewall' Jackson: A Virginia Feminist and the Politics of Historical Fiction." *Journal of American Historical Biography* (Spring 2008), www.ucfv.ca/jhb.

James, Arthur W. *Virginia's Social Awakening: The Contribution of Dr. Mastin and the Board of Charities and Corrections.* Richmond: Garrett and Massie Inc., 1939.

Jenkins, Bill. "Ferruccio Legnaioli: Decorative Artist and Sculptor." Unpublished monograph, 1995.

Kollatz, Harry, Jr. "The Driving Story Behind Richmond's Kline Kar." *Richmond Surroundings*, December 1992–January 1993.

———. "The Great Beattie Murder Case: A Tale of Love Gone Wrong On The Turkpike." *Richmond Magazine*, April 1998.

———. "Legnaioli's Legacy." *Richmond Magazine*, November 1995.

———. "On the Turnpike." *Richmond Magazine*, April 1998.

————. "Richmond in Ragtime." *Richmond Magazine*, November 1999.
————. "Send the Rascals to the Tall Timber: Adon Allen Yoder." *Virginia Cavalcade* (Summer 1996).
————. *True Richmond Stories*. Charleston: The History Press, 2007.
Lebsock, Suzanne. *"A Share of Honour": Virginia Women, 1600–1945*. Richmond: Virginia State Library, 1987.
Lewis, Sean C.D. "Lila Meade Valentine." Monograph. Archives of the Valentine Richmond History Center.
MacDonald, Edgar. *James Branch Cabell and Richmond-in-Virginia*. Jackson: University of Mississippi Press, 1993.
Marlowe, Gertrude Woodruff. *A Right Worthy Grand Mission: Maggie Lena Walker and the Quest for Black Economic Empowerment*. Washington, D.C.: Howard University Press, 2003.
Pope, Ben. "The Beattie Case." *Virginia Record*, June–August 1955.
Seroff, Doug. "The Enigma of Polk Miller: A 'Negro Delineator' In His Own Words." Part of booklet accompanying re-release of Polk Miller recordings by Ken Flahuerty Jr. The article originally appeared in *78 Quarterly*, 2006. See also http://polkmiller.com/.
Silver, Christopher. *Twentieth-Century Richmond—Planning, Politics and Race*. Knoxville: University of Tennessee Press, 1984.
Treadway, Sarah Gioia. *Dictionary of Virginia Biography: Volume 1 Aaroe-Blanchfield*, edited by John T. Kneebone, J. Jefferson Looney, Brent Tarter and Sandra Gioia Treadway, 237–38. Richmond: Library of Virginia, 1998.
Trotti, Michael Ayers. *The Body in the Reservoir: Murder & Sensationalism in the South*. Chapel Hill: University of North Carolina Press, 2008.
Tyler-McGraw, Marie. *At the Falls: Richmond, Virginia, and Its People*. Chapel Hill: University of North Carolina Press, 1994.
Unknown. "John Wilbur Chapman, 1859–1918, Evangelist." http://www.believersweb.org/view.cfm?ID=116. 2003.
Virginia Historical Society. "Looking Back: The Jamestown Negro Exhibit of 1907." http://www.vahistorical.org/news/pr_lookingback.htm.
Waldrep, Christopher. *Vicksburg's Long Shadow: The Civil War Legacy of Race and Remembrance*. Lanham, MD: Rowman & Littlefield Publishers, 2005.
Weisiger, Benjamin B., III. *Old Manchester & Its Environs, 1769–1910*. Richmond: William Byrd Press, 1993.
Winthrop, Robert P. *Architecture in Downtown Richmond*. Richmond: Junior Board of Historic Richomnd Foundation, 1982.
Yoder, Adon Allen. *The Idea*, varied articles. Monthly 1906–April 1907, January–April 1909; weekly (irregular) June 1909–October 8, 1910; monthly January–October 1911 (except July, semi-monthly).

About the Author

This is Harry Kollatz Jr.'s second book with The History Press. His first, *True Richmond Stories*, was a collection of anecdotes and anomalies of Richmond's past. Harry is the senior writer of *Richmond Magazine* and is a lifelong Richmond resident. He is co-founder of the Firehouse Theatre Project. Harry shares his life with his wife, partner-in-art-for-life Amie Oliver, and their two cats, the perpetually annoyed Miró and the antic, youthful Flannery.

Harry Kollatz Jr. at Richmond Old City Hall, location of Adon Yoder's trials. *Photograph by Jay Paul* (jaypaulphoto.com).

Please visit us at
www.historypress.net